COLLEGE LIBRARY

The
Knowing Body

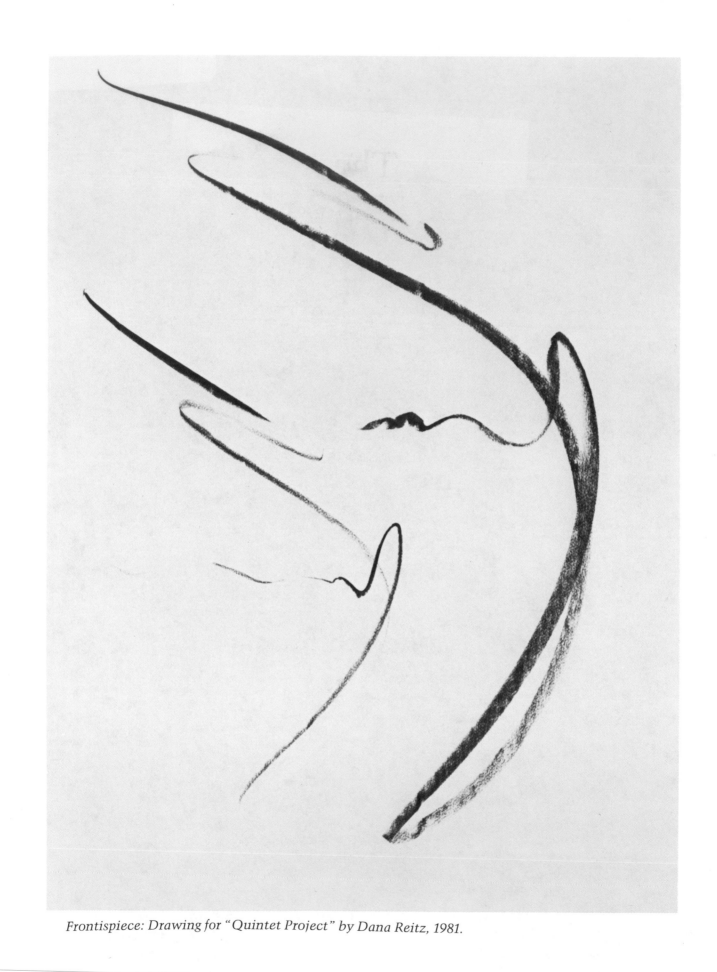

Frontispiece: Drawing for "Quintet Project" by Dana Reitz, 1981.

The Knowing Body

The Artist as Storyteller in Contemporary Performance

Louise Steinman

 North Atlantic Books
Berkeley, California

To the memory of my grandmother,
Rebecca Steinman, a storyteller,
and to the memory of Collin Walcott,
whose music we can still hear.

The Knowing Body

Copyright © 1986, 1995 by Louise Steinman. No portion of this book, except for brief review, may be reproduced in any form without written permission of the publisher. For information contact North Atlantic Books.

Published by
North Atlantic Books
P.O. Box 12327
Berkeley, CA 94712

This book was originally published as *The Knowing Body: Elements of Contemporary Performance and Dance* by Shambhala Publications, Inc. in 1986.

Cover photo by Michael Mathers
Printed in the United States of America

The Knowing Body is sponsored by the Society for the Study of Native Arts and Sciences, a nonprofit educational corporation whose goals are to develop an educational and crosscultural perspective linking various scientific, social, and artistic fields; to nurture a holistic view of the arts, sciences, humanities, and healing; and to publish and distribute literature on the relationship of mind, body, and nature.

Library of Congress Cataloging-in-Publication Data

Steinman, Louise.
 The knowing body : the artist as storyteller in contemporary
performance / Louise Steinman. — 2nd ed.
 p. cm.
 Originally published : Boston : Shambhala, 1986
 Includes bibliographical references and index.
 ISBN 1-55643-202-X (trade paper)
 1. Performance art—United States. 2. Avant-garde (Aesthetics)—
United States—History—20th century. I. Title.
NX504.S74 1995
700'.973'0904—dc20 95-31018
 CIP

2 3 4 5 6 7 8 9 / 07 06 05 04 03 02

Contents

Acknowledgments

I was not able to use all of the abundant material generated by the response of the many artists whom I interviewed in preparing this work. In addition to performers who are quoted, or whose works are discussed, I would like to express my gratitude to Corey Fischer of The Travelling Jewish Theatre, Rachel Rosenthal, Nina Wise, Alan Ptashek, Steve Clorfeine, Rob List, Jock Reynolds, and Sylvia Whitman.

Heartfelt thanks are due also to those who supported my work on the book in other ways. Lindy Hough Grossinger gave me the idea to begin with, and was a perceptive critic throughout the process. Richard Posner saw to it that I signed the contract, and also read drafts. Marga Rose-Hancock was of great help as a reader and editor. To Susan Banyas I owe many thanks for insights into the heart of the book, specifically the second, fourth, and fifth chapters. This book is an extension of our exploration into performance over the years. Suzanne Edison, Charlotte Hildebrand, Mark Johnson, Nancy Stark Smith, Steve Shehorn and Gail Turner all read sections and gave comments. Nancy De Louise assisted in photo research. Barbara Hoffman and Kelby Fletcher provided legal assistance whenever necessary, at one point keeping landlords at bay so that the book could be completed. Christopher Rauschenberg and Janet Stein lent a temporary home and encouragement toward creativity after my accident, as did Drs. Joan Kreiss and Roger Perlmutter. My parents Anne and Norman Steinman have lent continual support of all kinds—critical, material, emotional. Other colleagues whose work has contributed particularly to my effort are Michael Bowley, Rebecca Engle, Ralph Elder, John Marron, Dan Mathews, Bob Mendelson, Ron Stephens. My thanks also to Emily Hilburn Sell, editor at Shambhala Publications.

The staff at The Kitchen Center for Music, Video, Dance and Performance in New York City was very helpful in allowing me access to videotapes. Also I wish to express gratitude to the staff at both the Dance Collection and the Theatre Collection at the Lincoln Center branch of the New York Public Library.

Among the many others who gave so willingly of time and information—Meredith Monk, Trisha Brown, Ping Chong, Simone Forti, Joan Jonas, Leeny Sack, Helen Dannenberg, Joanne Kelly, Laura Simms, Deborah Slater, Barbara Dilley, Bob Ernst, Whoopi Goldberg, Susan Banyas, Margaret Fisher, Pooh Kaye, Dana Reitz, Ruth Zaporah, Doug Skinner, Wendy Perron, Lydia Yohay, Lanny Harrison, Marjorie Nelson—my deepest thanks to you.

Preface

This book looks at ways performing artists "acknowledge the wonder" that is life. I begin by studying the most fundamental element in the making of performance—the performer's relationship to his or her body. By comprehending this simple yet essential fact (so simple that it sometimes gets lost) the other elements of performance are then accessible to the performer. Further chapters explore the phenomenon of transformation, the performer's "taking on" of another persona; the body/mind as source for theatrical images; improvisation, the artform of paying attention to all that is happening in the body and the mind; and lastly, the performer as storyteller.

This is an age of genre crossover and interdisciplinary borrowings. The types of performance discussed in this book are drawn from the genres of dance, theatre, performance art, vaudeville, and storytelling. A performance may mix many disciplines in the creation of a unique form, or it may work within the accepted boundaries of one of them, for example, dance or theatre. What I am trying to show is how performance is a path towards knowledge and how that knowledge is shared with an audience. I write both from the perspective of an insider, a creator of performance, and from the perspective of a watcher, an observer.

Performance is a *live* form, by which I mean enlivening. In the energy exchange between performer and audience there is potential for a tremendous amount of learning, potential to stir up powers beyond evident human capacity. Performance began as a religious ritual, and I believe I can say that all of the performers whose work is discussed in this book still consider the making of their art to be spiritual practice. The performer is a vessel, made empty to receive by years of diligent training and letting go. There is no one way to become a creator of performance. On the basis of many disciplines, the performer creates an individual synthesis. Fifteen years of studying ballet may make a ballerina. Fifteen years of studying movement, understanding

the voice, learning to pay attention to your psyche and the world around may make a good creator of dramatic performance. Training may be eclectic, and so may the form.

The end result, in any case, is a performance which is a theatrical exchange requiring a live performer and a live audience. It cannot be reduced to a written script. In it, there are no rules except rules to be broken. Performance is that malleable form which can contain the great spillover of energy when traditional artforms—painting, sculpture, dance, theatre, music, film are mixed, intercut, overlapped.

I've chosen for discussion performers whose work interests me, although I've been able, by no means, to include all who do. My words referring to live performance are, of course, a translation of a medium which derives from and affects all the senses. Still I hope that these discussions will prove of use for those who venture forth to some small theatre or loft to see experimental performance, new dance, visual theatre—whatever the artists have decided to call what they do.

In work that is considered experimental or "avant-garde" because it doesn't fit into traditional categories, one is very likely still to find the values that are at the root of traditional art forms. The playwright Ionesco has commented that "to be avant-garde is not to be 'far out,' but to return to our sources, to reject traditionalism in order to find again a living tradition."[1] This living tradition is rooted in our first breath, in the transformation of childhood and dream, in the acknowledgement of our ancestors and our animal selves. It is this living tradition that new performance addresses.

At times I've used my own experience as a performer to illuminate certain points. I consider my own journey from the study of a traditional form, modern dance, into the uncharted realms of new performance to be akin to the journeys of many other artists. This book provides an opportunity to look at some of the guideposts on the journey, and to consider the discovery of fundamental values in performance through intuitive exploration. I have had the opportunity in questioning other artists to feel the community of many questioners—performers and audience joined together in a question. In an age of media manipulation, the age-old exchange between the watcher and the watched remains, practically speaking, an act of faith.

LOUISE STEINMAN
San Francisco, California
June 1986

A NOTE ON THE ILLUSTRATIONS: I have included with the text photos, journal excerpts, and working drawings by many different artists. I suggest that you think of the visual text as telling a complementary story, but in a different medium.

Preface to the 1995 Edition

While I was writing *The Knowing Body* ten years ago, I was gripped by Walter Benjamin's pre-World War II essay, "The Storyteller." In this seminal piece, Benjamin describes the interconnection between storytelling and death. I read and studied the essay carefully, and wrote my chapter "The Storyteller" with Benjamin's edict as its central premise. But did I yet know what I was talking about?

I've been going to a lot of memorials lately, for writers and directors and performers who have died of AIDS. As I sat in a darkened theater last week at the service for theater director Reza Abdoh, watching images from his startling and abrasive theatrical spectacles on the video screen, I wondered how Reza's work will continue to live. Already people were telling stories about him: how he cooked elaborate Persian meals for his dedicated troupe, how he stood in the wings right before curtain and asked his actors to do impossible things ("but Reza," one actor protested, "humans can't fly . . .") The stories were already taking life in the wake of Reza's untimely death, a theatrical giant at the age of thirty-two.

Those of us in the arts in the late twentieth century are in the presence of death all too often. Not the natural deaths of our elders, but the deaths of thirty-two year old poets, forty-four year old choreographers. Communities of friends take care of the dying. They soothe their fevers and become guardians of their stories. *"Death is the sanction of everything that the storyteller can tell. He has borrowed his authority from death,"* wrote Benjamin.

Last fall, the dance critic Arlene Croce wrote a piece in *The New Yorker* about why she would neither see nor review "Still/Here," the acclaimed multimedia show by choreographer Bill T. Jones. Her refusal was based on the fact that Mr. Jones himself is H.I.V. positive, and that his multi-media performance piece addresses the reality of people with life-threatening

illnesses. Their testimony, displayed on video screens, is an integral part of the work. Croce explained that she couldn't possibly write about people she felt sorry for, and she disparaged the piece, sight unseen, as "victim art." I was dumbfounded. Can you demand that an artist not make art from his or her experience? Would one dismiss Spalding Gray's autobiographical theatre trilogy as "victim art" because he explores his mother's suicide? Is it not reasonable to trust that a mature artist is capable of exploring death, disease, misfortune as a cause for revelation, rather than self-pity? Is not the role of a critic to look at and write about whatever a serious artist makes? Kurt Jooss made one of the most powerful artistic statements about war (his ballet "The Green Table"). It would be ludicrous for critics to deem the subject "too political," and then skip their comments on that piece. Art about death and disease has been proliferating because of the AIDS epidemic. Many artists are forced to confront their mortality while in their artistic prime. Death is all around us, as it has always been, and we need the shamans and storytellers to help us make sense of it all.

<p style="text-align:center">* * *</p>

It's nearly a decade since I wrote *The Knowing Body*. My body knows "differently" now than ten years ago. I spend more time sitting in front of the computer writing, than I do in a studio moving and making theatre pieces. Yet the issues which preoccupy me in my writing are the same ones I explored as a performer: the interface of family history with cultural history, the voice of my dreams, the role of faith in a fractured, troubled world. I still feel the urgency to tell stories, to "make sense" of life.

I continue to listen to other writers and performers who have gathered wisdom from experience and crafted their knowledge into stories. Twelve years ago I watched with awe as an unknown performer named Whoopi Goldberg, performing in a punk cabaret in San Francisco, assumed the persona of ten different social outcasts in one mesmerizing hour. Since that time, solo performance has proliferated as a genre. Critic Stephen Holden wrote recently in the *New York Times*, "*At a time when society seems atomized into stridently contentious religious, ethnic and sexual factions, the chameleonlike solo performer who portrays many different characters may be the closest thing in contemporary theater to a social healer.*" At a recent festival called SOLO/L.A., performers such as Luis Alfaro, Eric Trules, Sandra Tsing Loh, Keith Antar Mason and Kedric Wolfe all illuminated the rich cultural heritage of this city through their solo performance. One of the festival performers, Vicki Judith, commented, "*I write and tell true stories about experiences that*

have changed me. . . . I find that examining ordinary events sheds light on big issues. Changing the world starts with changing yourself. My 'L.A. Stories' invite people to reach out beyond their neighborhoods, beyond what is comfortable. "

In Los Angeles, ravaged by racial tension and natural disaster, listening to one's neighbors' stories can be both healing and a radical act. In my own neighborhood, I've listened to the Armenian shoe repair man who escaped the earthquake in Yerevan; over the years I've learned what happened to the proprietor of the watch repair shop who has numbers tattooed on her arm. The history of the world is contained in the ten square blocks around my apartment. In the writing workshop for teens which I teach at a middle school in South Central L.A., the air outside the classroom frequently crackles with gunfire. The stories the students tell inside that room are the hearth around which we warm ourselves. I wholeheartedly agree with anthropologist Frances Harwood, who participated in a Southern California conference on storytelling at the Ojai Foundation not long ago, when she said: *"Sharing stories involves a whole set of cultural values that are genuinely subversive: sharing stories builds a sense of community. It triggers, informs, inspires and gives the psyche the strength, the courage and the connection to take action in the world."*

* * *

I have not tried to "update" *The Knowing Body.* It is a portrait of performance as an art form and its practitioners at a certain time in its evolution. The artists described in this book are ten years older and their work has developed in a number of directions. They have been joined by new generations of artists creating significant work now. However, I believe these five essays still hold their weight as guideposts to performance for both students and spectators of the form. I am pleased to have the book back in print.

Louise Steinman
Los Angeles, 1995

one

THE BODY AS HOME

Road to Recovery

At the time I am writing this chapter I am one year from a car accident which nearly claimed my life, and which very seriously injured my body. The road to recovery has taught me many lessons not dissimilar from those I learned from creating performance. Both experiences have to do with "making whole"—bringing together bone, bringing together the disparate experiences and sensations of one's life.

It was the accident which brought me, startlingly enough, to the realization that the mind holds the image of the body's recovery. Several weeks after the crash, when my broken bones had as yet shown no signs of knitting, I had a very disturbing dream. In the dream there was a woman about to descend into a swimming pool, in which I knew existed a poisonous, amphibious snake. A spectator of sure disaster, I watched the woman enter the water. As there was nothing I could do to help, I turned away. Later, I went to look in the water and saw a terrible sight—the woman floating in the water with the snake wrapped around her body from head to toe. Soon there was nothing left of her but pieces. I awoke greatly alarmed. I drew a diagram of the woman with the snake wrapped around her body. Later that same day it suddenly occurred to me that the shape made by the snake and the woman's body was that of the staff of Asclepius, the physician's wand, the symbol of healing. My body seemed to fill with a kind of light and at that moment I knew that deep in my body tissue and unconscious mind, a process intent on my healing had commenced. I knew I was on the road to recovery.

Epidaurus, in Greece, to which pilgrims from all over the ancient world traveled in hope of cure, was the center of the cult of

Figure 1. Snake dream drawing, Louise Steinman.

the Greek god Asclepius. It was not a mere facility for physical healing. Here at Epidaurus was the sanctuary of the god. Under a gigantic statue of Asclepius, after purifying fasts, the pilgrims spent the night. They slept amidst the harmless snakes of the region awaiting the apparition of the god in a curative dream. The serpents were the living symbol of the god, thus the god's staff is always shown with a serpent coiled around it. In the amphitheatre outside the temple, an audience sat and listened to masked actors, who danced and told the old legends. For at Epidaurus, theatre—music, dance, poetry, dream—was a tool used in the healing process, used for the restoration of health to mind and body.

That mind and body are a unity is as evident as the process by which the human infant, progressing through the basic developmental movements, acquires fundamental knowledge of its environment. Physical and mental information are inseparable, the warp and the weft of the individual's whole sense of reality. Each stage the human infant progresses through, in a process radically slower than that of other creatures, records fundamental knowledge onto his or her thinking cells.

The infant's *intent*, its impulse to move, is controlled by a very primitive part of the brain, the hindbrain or "old brain." We come to experience our individuality initially by our movement, our sensual investigation of the world around us. Philosopher Suzanne Langer noted, "When the hand of a little child closes as tightly as it does on an object it grasps, that is less from fear of losing the object than in order to feel its own strength."[1] To describe the individual's inner impulses to move in certain ways, movement theoretician Rudolf Laban uses the German word *antrieb*, which has the sense of a "drive onwards." It is the urge of the organism to "make itself known."[2] Movement is assertion, and assertion is one of the primary acts of the mind.

I use the example of the infant's unity of body and mind here, because it is to the restoration of this unity, to this basic body-knowing which this chapter addresses. But first, if we are going to speak of restoring a unity, let us first consider the rift it heals.

The noted anthropologist Claude Lévi-Strauss suggests that it was probably necessary, for the history of mankind, that the world of the senses as well as the world of mythical thought be denied—for it enabled scientific thought to constitute itself.[3] Descartes' assertion in the seventeenth century that our bodies were merely machines, for example, won scientists the right to perform autopsies, previously prohibited by the Church.

It is optimistic of Lévi-Strauss to speculate that such a schism was necessary. There is certainly plenty to be done to heal the damage in its wake. We live in an era which has undergone more far-reaching change than previous eras, changes

which have taken our culture far from the wisdom of the body and the rituals which arise to express that wisdom. The need for a return is very apparent, very pressing. Within our lifetimes we have experienced the results of a scientific equation ($E = mc^2$) making possible the destruction of the entire planet as we know it. We have within the lifetimes of many of us also experienced the discovery of a cure for polio. Soon there may be cures for multiple sclerosis and cancer. The field of genetics has uncovered possibilities for replicating and altering the processes of procreation. Phenomena that have long belonged to the realm of fantasy have become a reality: frozen embryos awaiting wombs, horses giving birth to zebras, infertile couples offered the hope of becoming parents. Yet our technical prowess far eclipses our moral and ethical grasp of the consequences. Our values are in disarray and our bodies have been neglected. In his essay, "The Storyteller," written between the World Wars, cultural observer Walter Benjamin wrote:

> Never has experience been contradicted more thoroughly than strategic experience by tactical warfare, economic experience by inflation, moral experience by those in power. A generation that had gone to school on a horse-drawn streetcar now stood under the open sky in a countryside in which nothing remained unchanged but the clouds, and beneath those clouds, in a field of force of destructive torrents and explosions, was the tiny, fragile human body.[4]

The dance and performance that I discuss in this book all has at its core a trust of the wisdom of the body, a respect and curiosity about the natural world, an embracing of the value and communicability of unitary experience. Beginning with their own bodies, the performers have concluded and gone on to communicate that our physical, mental, spiritual realities are intertwined, inseparable.

We now have philosophers of the body and they are not called athletes. They are performers, and they are also researchers/teachers from whose work many performers have drawn. Together, the work of these art/science investigators represents a return to performance which is, as Richard Grossinger called it, "a ceremony and a medicine."[5]

In the rest of this chapter we will look briefly at some of the ideas and motivations of these philosophers of the body. We will see how they draw from an understanding of our relationship to animals, how they draw from an understanding of developmental movement, as well as from the healing powers of dream and visualization in their efforts to help us to know and to integrate mind and body individually and collectively.

Looking at, Talking To, Being— Animals

Ogotemmeli was a wise man of the Dogon tribe in Africa. In his book *Conversations with Ogotemmeli*, anthropologist Marcel Griaule records the old man's description of the Nummo, God's first offspring, according to the Dogon cosmology:

God created them like water. They were green in colour, half human beings and half serpents. From the head to the loins they were human: below they were serpents. Their red eyes were wide open like human eyes, and their tongues were forked like the tongues of reptiles. Their arms were flexible and without joints. Their joints were green and sleek all over, shining like the surface of the water.[6]

For the Dogon, the fish is a symbol of the human foetus; once every sixty years Dogon dancers dressed as fish enact the regeneration of mankind in a great festival.[7]

Our sense of movement goes back to the evolutionary level of spinal creatures in water and progresses to that of limbed creatures on land. Those evolutionary patterns are mirrored in the movement development of the human infant. *In utero*, once we have developed a spine, we move as fish, propelled by the movements of our spines. Next, because of gravity and surface friction, our movement is amphibianlike, or, homologous (both arms together or both legs). Next we pass through a movement phase which recalls the movement of reptiles, homolateral (left arm and left leg together, right arm and right leg together). Finally, the movement pattern is that of mammals, contralateral (initiating the movement alternately; starting, for example, with a front limb and followed by the opposite hind leg).

"What is the pattern that connects all creatures?" asks Gregory Bateson in his beautiful essay of the same title.[8] Like Bateson, many performing artists today consider that they are working within the community of all living things. They are aware of the relationship of parts within themselves, of upper arm to lower arm and thigh to lower leg. They are aware of the rhythm and repetition within the structure of their own bodies that they share with all living creatures. As embryology has proved of each species of mammals, our heads are older than our tails.

On our evolutionary journey we have gained a remarkable intellectual heritage. We have also lost whole areas of our experience. We could not survive, most probably, in the world which our primitive ancestors found sustaining. Our symbiosis with

the planetary forces is mostly vestigal, like the twenty-eight day lunar cycle of menstruation. All our advanced technology cannot yet explain the secret navigational art of sea turtles who swim thousands of miles across open water to lay their eggs. These are secret arts which we are just beginning to fathom.

Mircea Eliade wrote in his classic book on shamanism of a paradisal time when:

> Man lived at peace with the animals and understood their speech . . . While preparing for his ecstasy and during it, the shaman abolishes the present human condition and, for the time being, recovers the situation as it was in the beginning.[9]

Moreover, Eliade notes, it is "friendship with animals, knowledge of their language, transformation into an animal" that are the signs that the unity before the rift has been re-established.

After a Huichol Indian kills a deer on a ceremonial hunt, he asks the deer's forgiveness and explains that the shaman's power will cause it to be reborn from its bones. In order to kill the deer, the hunter stalking his prey must *become* the deer. Lévi-Strauss quotes Canadian Indians as saying that their understanding of what animals do and of what other creatures need came from the time when "our men were married to them and they acquired this knowledge from their animal wives."[10] The connection with the natural world offered by the hunting and worship of animals was a recognition by man of fact central to his existence—that humans and animals are close kin. We are like and we are not like, animals.

In the last few centuries, except for pets, animals have gradually disappeared from our daily lives. We reserve our roads for machines, not horses, one need never be aware that the meat bought in the supermarket came from a live cow. The fact that we are both like and unlike animals is no longer a reality to most of us. The dualism between animals and humans, as John Berger points out, was internalised by Descartes *within man*. "In dividing absolutely body from soul, he (Descartes) bequeathed the body to the law of physics and mechanics, and, since animals were soulless, the animal was reduced to the model of a machine."[11]

To re-establish contact with animals, and to investigate our own animalness is a theme that echoes from the earliest days of dance and theatre into the present. It manifests in many, many different forms. Our attention will focus on the cross-disciplinary form of performance discussed earlier.

Meredith Monk, to create her "Songs from the Hill," spent days sitting on a hilltop in New Mexico listening to natural sounds—the drone of an insect, songs of birds—and experiencing

them as a part of the landscape. This was a way of finding her own songs and dances to reflect that place, those creatures. Simone Forti is a dancer for whom animal studies have been primary investigation since 1968. It is not uncommon at one of Forti's dance concerts to watch her explore the simple shift of weight from leg to leg in a way that has the same tireless inevitability as the movement of an elephant in his pen at the zoo. In a workshop with Forti, one might work for a period of time on evolutionary studies. Lying on your belly on the floor, you might explore how extending your limbs out to the sides causes the spine to ripple fishlike to move the body forward.

Figure 2. "wings lift back," journal drawing by Simone Forti.

Forti was first drawn to observing zoo animals during a period of time in Rome, when she felt she was "starting over from scratch." John Berger speaks of animals in zoos as seeming "like an image out of focus."[12] What you are looking at seems out of focus then, Berger says, because "you are looking at something that has been rendered absolutely marginal." There are times when, as a dancer/performer one feels the research one does alone in a studio is an endeavor that would be considered marginal by society. Forti has written of these early experiences:

I got a sense of communion with some of the animals and I'd go there to make friends . . . I was interested in that part of myself too that would always be there. I was struggling with identity and getting some insights about how you shave away all the things and you still have the identity there, you can still reach out and establish some communication. And it seemed easier to establish some communication with other beings who all had everything pared away. And there we were, looking at each other.[13]

Figure 2B. "tail in the air" journal drawing by Simone Forti.

Animals in the zoo are indifferent to their surroundings, so often have they seen the gaping people stream by their cages. To bring them into focus, to communicate with those beings is a way of claiming what our culture has bypassed. Forti's animal studies, or "zoo mantras" as she has called them in her inimitable *Handbook in Motion*, are in one sense an act of empathy with animals.

It was not always uncommon to communicate, or empathize, with animals. As animals have been rendered increasingly marginal to our lives, the opportunities are rarer. We live long after Noah's Ark, which was, as John Berger pointed out, "the first ordered assembly of animals and man."[14] Now we live after the great departure. The eagle, the condor, the wolf, the buffalo may soon be no longer of this earth.

That animals observe *us* is a fact that primal peoples of the world have taken account of, but which has lost its significance in our own culture. We are separated from animals, from the experience of our own animalness. In her work, Forti clearly inves-

tigates that essential look between humans and animals that confirms the fact that we are, and are not, alike.

I held a large grasshopper in my open hand. It swayed from side to side as we gazed into each other's eyes. We sustained this alignment of sight through an exact correspondence in our movements, which created a certain resonance between us. We danced together like this for many minutes.[15]

As Simone Forti's quote implies, the search is for a sympathetic alignment, be it between creatures or between one's own body parts. To be in alignment is to allow one's body structure to be in a relationship that maximizes movement efficiency and our general sense of well-being. To be out of alignment is to feel something is wrong, out of place, gone awry.

When Simone Forti dances with a grasshopper, when Meredith Monk sits on a hill in New Mexico listening to the cry of a hawk, their motivation stems partly from the desire to be in communion with the natural world and partly from the desire to find movement and sound corresponding to the human form in the same way that the animals' moves and sounds correspond to their form. Isadora Duncan wrote in her essay, "The Dance of the Future":

> The movement of the free animals and birds remains always in correspondence to their nature, the necessities and wants of that nature, and its correspondence to the earth nature . . . The movements of a beetle correspond to its form. So do those of the horse. Even so the movements of the human body must correspond to its form. The dances of no two persons should be alike.[16]

Forti, and other performers like Pooh Kaye and Margaret Fisher, try out animal movements on their own structures. Fisher, for example, choreographs frequently for the horizontal posture. Her main interests with this area are:

the lessened strain upon the muscles, discovery of any discernible effects of gravity upon the system and the movement of the eyes away from the earth and from the horizontal line, the "forward direction."[17]

Fisher's insect positions in her visual theatre work "Il Miglior Fabbro" are, to say the least, most arresting.

The ability of artists like Fisher or Forti to change their spatial orientation, to investigate movement or images inspired by animals is voluntary, unlike Franz Kafka's nightmare of animal transformation in his parable "Metamorphosis." His protagonist, Gregor Samsa, goes to sleep a man, a traveling salesman to be more specific, and awakens as a giant beetle:

Figure 3. Margaret Fisher's insect movement in "Il Miglior Fabbro."

Hardly was he down when he experienced for the first
time this morning a sense of physical comfort; his legs had
firm ground under him; they were completely obedient,
as he noted with joy; they even strove to carry him forward
in whatever direction he chose; and he was inclined to be-
lieve that a final relief from his sufferings was at hand.[18]

For Kafka, animal existence is in conflict with the rational world
of work. Our animal existence is usually present just as a mem-
ory, or only in childhood, or in our dreams where rational con-
sciousness is excluded. Once Gregor Samsa is a beetle, he is no
longer human. There is relief from his usual drudgery, but the
relief is in the form of a calamity. What would represent a true
victory for us would be to create a union of the conscious exist-
ence which arranges, plans, and controls and the freer, more in-
stinctual unconscious level represented by animals.

In animal dances, which lie at the core of both dance and
theatre, the human embraces the animal form while remaining
at the same time, wholly human. In their explorations of animal
as well as human movement, dancers and other performers are

Figure 4. "Untitled drawing," ink on paper, 1981 by Pooh Kaye.

today fulfilling Isadora Duncan's prophecies. They are finding movement unique to themselves as well as finding their connection to the origins of dance and theatre. As well, they are finding their connection to peoples of the world who have not lost their relationship with the wisdom of animals. For example, Laurens van der Post, the eminent South African explorer and writer, recalls his Bushman nurse talking with the Bushman deity Mantis. " 'How high is the water,' she would ask the long narrow-waisted insect. And the mantis would put down its tiny hands."[19]

Many performers are drawn to the marvels of technology and are using film, computers, synthesizers, and methods of image projection in their performance. But at the same time there is an ongoing fascination with the basic—with animal and infant movement, with our relationship to the natural world. While they crawl on the ground and communicate with grasshoppers, these performers are affirming values they find essential not marginal. They are helping to keep alive what John Berger called "that look between animal and man, which may have played a crucial role in the development of human society, and which in any case, all man had always lived until less than a century ago."[20] That "look" might otherwise be completely extinguished.

How poignant also, that science sometimes turns to dance to accomplish its aims. Dr. George Archibald, a biologist, in his efforts to assist Tex, a female of the endangered whooping crane species to ovulate, over a period of time spent seven days a week with her. He helped her to build a nest, looked for worms with her, and frequently danced the crane courtship dance with her.

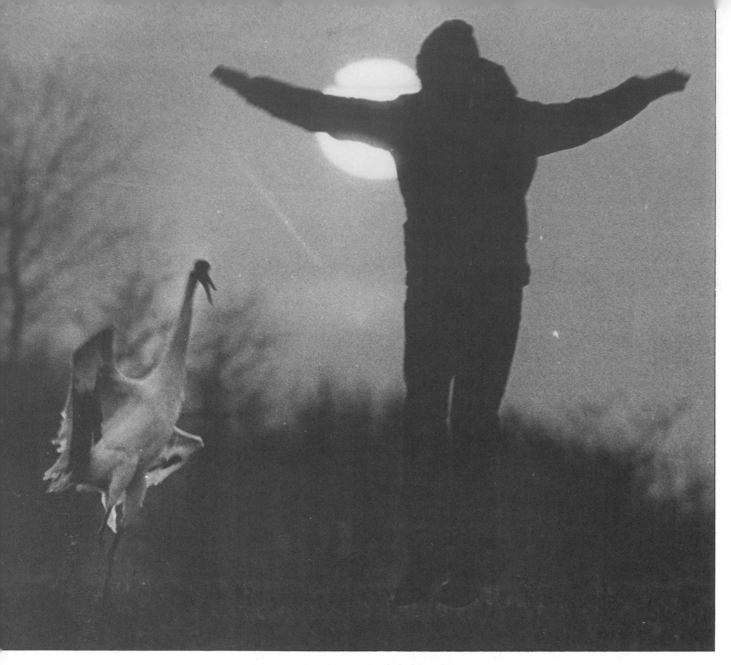

Figure 5. Dr. George Archibald and Tex.

The photograph of Tex and Dr. Archibald facing each other, several inches off the ground, with arms and wings outstretched, silhouetted against the full moon, is the kind of image of which myths are made.

I have posited that dance and theatre share a common root, a common home. Because of this, though they are different forms, they can overlap, can incorporate elements of each other. The most essential difference between them perhaps is that dance is intrinsically of the present, of the moment. At its most pure it deals with the immediate expression of sensations experienced by the body/mind. Theatre develops out of this expression when there is also an urge present to restore a sense of the

past, whether the events of a day, a life, or of an imagined prehistoric past. To restore experience creatively is the province of theatrical performance. As we acknowledge that our experience is an assemblage of events, of stories, of movements, of memories, then we find the form appropriate to the expression of that knowledge.

In a performance called "Jackdaw Songs," Simone Forti (whose concerns have generally been in movement rather than theatre) assembled a number of tableaux which explored the theme of communication. These tableaux expressed communication between individual and group, among members of a group and experimented with the difference in how aural and visual messages communicate. In her program notes Forti wrote:

> The title of the piece was suggested by naturalist Konrad Lorenz' observations of several generations of jackdaw birds. The jackdaw has a language of meaningful calls—a flying-out call, a flying-back call, a call made at the sign of danger. When it sings, it strings all of these together, with their accompanying gestures, a recapitulation of the day's events in song and dance. I've been looking over the movements that I've gathered over the years, from the point of view of what they mean to me, of what their content is. I'm putting them together in a new way, moving towards theatre.[21]

This is an example of performance fusing dance and theatre, dance's element of direct expression and theatre's sense of looking back or projecting forward. We wish to look at both of these elements in the context of creating interdisciplinary work. Memory is an essential element here; and memory, whether of a mythical past, last night's dream, or this morning's conversation at the breakfast table, begins in the body.

Proprioception

Proprioception is, literally, how we "sense ourselves." There are three main sources of input into our proprioceptive system: *kinesthesia* is the feeling of movement derived from all skeletal and muscular structures. Kinesthesia also includes the feeling of pain, our orientation in space, the passage of time, and rhythm. *Visceral* feedback consists of the miscellaneous impressions from our internal organs. *Labyrinthine* or *vestibular* feedback, the feeling of our position in space, is provided by the cochlea, an organ of the inner ear.

In the beginning, before we emerge from the amniotic waters, movement *is* perception. To the foetus floating within the

womb, the development of the senses and the perceptions are not separate from the development of movement. Studies of the sequence of myelination (the process by which important nerve pathways are surrounded and insulated by the fatty substance myelin) suggest that the earlier a nerve myelinates, the more important that pathway is for survival. The first of the foetus' cranial nerves to myelinate is the vestibular/cochlear nerve, which registers movement and position in space. Later, the motor and sensory nerves, which control the muscles, develop.

From the fishlike spinal movements of the foetus in the womb to the child's first walking steps, the natural sequence of a child's motor development establishes essential neurological patterning.[22] These developmental sequences unfold according to an inner time clock in relation to the child's environment. Here the kind of handling the infant receives from its parents plays an important role. If the natural sequence of a child's development is interrupted, even with the best of intentions, faulty patterns may result.

Our culture is in a hurry. Perhaps the potential nuclear deadline makes us want to grow up fast (though we also want to age slowly). The human infant is ready to push back to a sitting position after it can already support its whole spine on four limbs. However, in our culture, usually a baby has been *sat* before it can push back to sitting and sit by itself. Children may be urged to walk too soon, before they have prepared for it by creeping and crawling, which establish the neural patterns and the strength of musculature necessary to achieve verticality, to cope with gravity.

Most philosophers of the body who have created teaching systems use developmental movement as a touchstone in their work. Irmgard Bartenieff, who established a system called the Fundamentals based on principals of Rudolf Laban; Moshe Feldenkrais, whose investigations are referred to as Awareness through Movement; the Alexander technique established by F.M. Alexander; and the provocative and visionary work of Bonnie Bainbridge Cohen at her School for Body/Mind Centering— all these stress the importance of the movements we learn in the first year or two of our lives. To re-experience these early patterns of moving is one way we can rediscover some of our basic proprioceptive "errors" and reclaim the integration of body/mind that is our birthright.

The poet Charles Olson, in a beautiful essay titled "Proprioception," influenced a whole generation of artists when he declared the fundamental necessity of the integration of physiology and psyche. In his essay he remarks "that one's life is informed from and by one's own literal body, the gain being that movement or action is home."[23] In the beginning, this is truly the case. As we mature however, in our culture, an estrangement

Figure 6. Journal drawing by Sylvia Whitman.

from the movement which was home is not uncommon. In an era of uprootings and much moving about from place to place, the return to the body which is home fulfills a primal need for shelter, for grace.

For many contemporary performers, studio time begins with lying on one's back on the floor. One experiences the organization of the body around the spine, the level (shallowness or depth) of the breath pattern, the connection with the ground. In most of the systems of body awareness also, one begins on the ground, relieving the body of the need to work against gravity. The work starts low and slow.[24] In the Bartenieff Fundamentals much attention is placed on the relationship between the heel and the lower spine, or sacrum. The weighting and release of the foot on the floor is to be felt smoothly throughout the body as it carries its effect to the position of the head balanced on the spine and headed outward into space. This too, begins on the floor. The fundamental patterns—crawling, undulation of the spine, walking—all contain intricate and essential information. In Barbara Dilley's "walking" classes we used to spend an hour walking in circular patterns. Paying attention to this basic rhythm of footfall one could perceive the necessary connections between ground, foot, ankle, knee, thigh, sacrum, lumbar spine—up through the head. To *know* that you are walking *on the ground* can be a radical sensation.

That dance could express the most commonplace ideas and activities as well as the most exceptional is a concept not lost to most primal cultures. The term "dance" refers in these cultures to a larger sense of ritual where body and power and history are celebrated by all members of the community. In our culture, the beginning of the reclamation of dance from its role as divertissement begins with Isadora Duncan and continues with the blossoming of modern dance through the genius of Martha Graham, Doris Humphrey, and Mary Wigman. The challenging creative climate centered around Judson Church in New York in the sixties and early seventies, and Yvonne Rainer's statement at that time that said "no to virtuosity, no to spectacle" were key moments in the new development. Present central themes are the reintegration of dance and theatre and the exploration of the boundaries of performance art where the commonplace as well as the mythic are subject, inspiration, and source.

Bonnie Bainbridge Cohen researches the physical manifestation of mind. Performance artist Suzanne Hellmuth speaks of her interest in the "manifestation of natural or instinctual expression." Their interests are allied, though their chosen forms differ. Bainbridge Cohen's field is research and teaching, Hellmuth's is visual theatre and interdisciplinary performance. "There's an interesting balance between what's abstract and what's natural movement," Hellmuth commented when I inter-

viewed her at home in San Francisco. Imagine the speaker as I saw her—hoisting one child onto her lap, giving the baby a suckle, rising to see what the ruckus was in the yard, making tea. None of this interrupted the flow of her thoughts:

I'm interested in the crossover. What people conceive of—making the transition between what's abstract, what's natural. I'm interested in very habitual, but very skillful and understood kind of movement. I think of the people in Paris who wrap up the pastries, people preparing food, handling babies—where there's an extreme care and also an offhand manner. I'm interested in the manifestation of natural or instinctual expression.[25]

Classical ballet is based on the idea of "how the body should look." The shift towards movement based on inner awareness in our culture, as I have stated, began with Isadora Duncan. Isadora danced from the most expressive part of her being, the solar plexus, the center of her body. Martha Graham did also, but instead of just dancing it, she codified it into a technique—the angular "contraction," which is a hallmark of her form. This is a hollowing out of the torso with all the attendant connotations of *angst* and suffering. It is a technique offered to the urban industrial age. Isadora sought the native expression of her own, womanly body. Martha Graham offered her interpretation, based on her own body and ideas, to subsequent generations.

That each body speaks its own native language, given to us at conception and forgotten by most by adulthood, is a premise shared by the philosophers of the body, teachers and performers both. It is not that performers today are rejecting dance and movement techniques. For example, Cunningham technique (based on the work of the dancer Merce Cunningham), or Martha Graham technique, or even ballet are not rejected. Any discipline can have its own usefulness in strengthening and training one's body. The point is, however, not to accept someone else's revelations about their own body instead of finding one's own movement sources within oneself. The various body therapies ask the individual to guide their own physical and mental change. Barbara Dilley asks her students to "acknowledge the voice" of their bodies. Instead of following the master-apprentice model, where one attempts to take on someone else's highly individual movement style, you work from the inside to recover your own body's native language. And the best teachers, it has seemed to me, ultimately encourage their students to make their own searches.

I am reminded of the great *t'ai chi chuan* teacher Da Liu, with whom I had the great fortune to study at one time. When I began my course of study he told me he had five secrets and that by the end of the classes he would tell me what they were. On

Figure 7. Gesture drawings by Dana Reitz for "Quintet Project," 1981.

the last day I reminded him of his promise. He smiled. "Yes," he said, "I have five secrets: the top of my head, the palms of my hands, and the soles of my feet." Performer and Alexander teacher Remy Charlip performed with Merce Cunningham for eleven years. When he felt it was time to create his own performances, he immersed himself in a study of his own movement. He was looking for his own sources. He comments:

Often in ballet, they're heading for pictures. They're very secretive. All my dance teachers were unwilling or unable to explain where the energies came from or how they were released. And, speaking of Cunningham, the movement speaks for itself. In it, there is something he (Merce) worked out for himself on his own body. The way he did it was always very clear and very mysterious at the same time. You see clearly what he's doing, but you don't know where it came from.[26]

Where does one's own movement initiate from? What does it look like? feel like? To help herself visualize what her own energy-flow patterns were, dancer/choreographer Dana Reitz began drawing gesturally, first with charcoal, later with pen and ink. Like the classical Japanese calligraphers, she realized that the commitment to the gesture, to the brushstroke, is what is essential. What Reitz dances is based on her own sources, not templated on anyone else. She holds deep respect for Cunningham's own "brushstroke," without taking on his gesture as her own. In time, Reitz' gesture drawings became blueprints for her dances. After she has established the quality of energy pathway she wishes to explore in a piece, she improvises:

I was interested with what would happen if I took one move and played with it. What would it be? I wanted to get away from the space/shape theories in dance, what you look like as an image. When I was taking t'ai chi, there was a new viewpoint of the energy through the body for me. I hadn't figured out for myself what my source of energy was. I had to figure it out for myself. It was often very difficult to lift my leg in an image-oriented sort of way. So I started tentatively drawing, to get it outside of my body and look at it.[27]

This aim is also paralleled in the movement hieroglyphs of Nancy Stark Smith (Figure 8). Like Dana Reitz, Nancy Stark Smith attempts in her drawings to externalize an interior process. In these spontaneous gestural drawings the performers make visual the body's knowledge.

As part of listening in to one's own body's voices, finding one's own native language, so to speak, there exists an ongoing endeavor to sharpen one's proprioceptive messages or, put more accurately, to be quiet enough to hear more of them than one would have thought possible. In forming a complete self-image, one wants to collect as much data as possible. Bonnie Bainbridge Cohen has commented:

Generally, when anatomy is taught as I learned it and as I see it taught elsewhere, you're given visual pictures of it. We have an image of it, but we don't have the kinesthesia of it within ourselves. Maybe we'll even say, "Oh I have this bone or this muscle in me," but it's an intellectual concept, rather than the information coming through viscerally from the proprioceptors of that thing itself. The information is always coming in viscerally, but each person is selective in terms of what they choose to acknowledge. At the school [which she founded] we go from one system to the other—now we're going to acknowledge the information from the muscles, now from the organs, from the glands, from the brain, the blood, etc . . .[28]

Bonnie Bainbridge Cohen is not implying that we should be aware of what our thymus gland is doing at every moment. And it is true, as a neurologist pointed out to me, that if the great pianist Horowitz were aware of the circuitry between his fingers and his brain as he played a Haydn sonata, he would not be able to play. But to learn that we can choose to be aware of information we are continually receiving from our body is to have access to insights we had not thought possible. By acknowledging all the different inputs of information once thought only under autonomic control, "we see that they are channels that can be acknowledged by choice," says Bonnie Bainbridge Cohen.

Figure 8. Movement hieroglyphs by Nancy Stark Smith.

"Once they've been acknowledged consciously, we can utilize that information without it remaining primary."[29] It is quite possible for the conscious mind to become aware of the involuntary nervous system without interfering, but it is an unfamiliar activity. For instance, it is difficult to focus awareness on one's breathing without disturbing the rhythm of the activity. But with practice we can learn to stay out of the way and to use this awareness as a fast route to becoming intimate with ourselves. And the more we explore the structure of our bodies, the greater awareness we can gain. Moshe Feldenkrais wrote: "To gain a complete self-image would involve full awareness of all the joints in the skeletal structure as well as of the entire surface of the body."[30] Knud Rasmussen wrote of the shamans of the Iglulik Eskimo,

> Though no shaman can explain to himself how and why, he can, by the power his brain derives from the supernatural, as it were by thought alone, divest his body of its flesh and blood, so that nothing remains but his bones. And he must then name all the parts of his body, mention every single bone by name.[31]

Becoming conscious of our structure, becoming conscious of our movement habits and bringing them to the attention of the conscious mind, allows us the opportunity to change our patterning. Changing movement patterns can have resonance for our emotional and spiritual lives as well as our physical well-being.

Sometimes relearning is undoing, or learning not to do tasks in the way to which we have grown accustomed. Both Feldenkrais and Alexander techniques make use of this principle. By bypassing our normal and often inefficient way of accomplishing tasks, a new neuromuscular pathway can be discovered. If, instead of jerking your body out of a chair, you "allow" your head to lead, then your knees will respond, reflexively. If one allows the body its native intelligence, there is less effort to everyday life and less stress on the body. Performance artist Margaret Fisher speaks to this when she describes the seemingly unorthodox way she "keeps in shape" for her performances:

I don't have to practice everyday because I'm reliant more upon the structure of my bones . . . My main activity is to keep my joints healthy, not allow tension to "lock up" a joint in any particular way. So really, the maintenance program at rock bottom is not doing *certain things. You want to keep the joints in a neutral position with a full range of action.*[32]

The Feldenkrais method is to introduce a series of movements which work to affect a particular muscle group by working with

its antagonists (muscles that limit its movement) rather than with agonists (muscles which initiate the movement). Felden-krais lessons are, in the words of one student, "neurologically sneaky." Alexander technique helps one to remember to consciously direct the head forward and up, counteracting gravity. One learns to become aware of one's own habitual movement pattern, to inhibit that pattern, and to substitute a new one. This awareness is facilitated through a one-on-one contact with a skilled teacher and communicated largely through that teacher's sense of touch and choice of language images. An Alexander teacher spends a good part of his or her training (three years of training are required) learning *how* to place his or her hands on the student so as to communicate kinesthetic information.

As I mentioned earlier, how an infant is touched and handled is part of what determines an infant's developmental patterning. One Alexander teacher confided in me that she had spent the first year of her life in a foundling home. "The reason I mention my history," she said, "is that the source of identity for an infant is the touching when it's being held. They don't really exist unless they're being held." In the skilled and deft touching this teacher practices in her work, she is able to return to a sense of the identity she felt she missed as a child. This teacher has developed eyes in her fingers, her touch reveals to me where to pinpoint my own attention in my body. "Your eyes," she says," can get in the way. If you look at something, it can look completely different from how it feels. How it feels is more important than how it looks, because looking can be very deceptive." Bonnie Bainbridge Cohen also communicates her insights via touching. She describes "working" on someone:

I would say that I'm in a state of awareness. If I'm working with any area of someone else's body, I will go into that area of my own body to see. In the process I become more open also. It becomes like two bells ringing on the same pitch. We can resonate each other.[33]

Through her sense of touch, Bonnie Bainbridge Cohen and other body workers, as they're sometimes called, have the ability to direct their attention and healing force beneath the outer layer of the body.

Just as touch has always been an important aspect of healing in non-Western cultures, so also are dream and vision. Richard Grossinger called them "far and away the most common source of medicinal knowledge on this planet."[34] Drawing on research in anatomy, physiology, neurology, and psychology, Dr. Lulu Schweigard pioneered a technique called *Ideokinesis*, which relies on the coordination of mental imagery to release and acti-

vate muscles. For example, Schweigard's students might be asked to visualize movements within the deep structure of their bodies while they are lying still on the floor. Through visualization—seeing a movement executed accurately in one's mind—it is possible to change the habitual patterns of messages being sent from the brain through nerve pathways to the muscles. Of course, this is very simplistically expressed, and even if it were not, the process would sound simpler than it is. Moreover, the imagery can work well only if the practitioners understand anatomical structure, and if they become practiced at distinguishing the subtle sensations of muscles relaxing and tightening.

Irene Dowd, a dancer/researcher/teacher who studied with Schweigard, has integrated Ideokinesis into her own work of communicating the relationship between the aesthetics and science of movement and the "language of perception." Dowd calls visualization a way of "warming up the neurological pathways."[35] She finds images from her own concentrated movement practice, from her dreams, from her work with students. Here's one example of a visualization she suggests to aid the functioning of the spine:

Sometimes I imagine that . . . there is a lake in the bed of the pelvic floor. Beneath the lake is a fissure in the earth through which volcanic fire erupts. Meeting the water in the lake, the fire creates steam that sends a geyser out of the once mirror-calm surface of the lake, out through the center of the torso, and up through the top of the head, leaving a sun-lit veil of spray all around the body.[36]

This is quite a contrast to the images my ballet teacher used in classes just a decade ago, like "imagine you are wearing a steel corset and a whalebone collar." Finding a language which expresses the rich kinesthetic experiences that are available to us is a concern for Dowd.

Typically, one might practice visualizing movement within the body while lying on one's back on the floor with one's knees up, feet resting flat on the floor. In this position one's body does not have to work against gravity. After creating a relaxed and peaceful state, perhaps focusing the attention on the breath as a starting point, visualization work can begin.

We can use visualization to effect change within the body. We can also use images generated by this state, or by our dreaming state, as messages from our psyches. There may be images here to theatricalize, to bring from the unconscious out into performance. Images can be used to effect the interior workings of the body, and the body is the effective home of the psyche's drama.

The "technique" of natural movement is the knowing application of insights about one's own body/mind. We can learn to be more aware of what is happening within us physiologically, psychologically. We can slow down and pay attention on our own; or the touch of a healer's hands, a teacher's suggested imagery, the impact of a performance image or experience, may focus our attention. When Meredith Monk asks her students to "pay attention to your distractions," she is suggesting that the flicker of the mind, the distraction of our consciousness, are potential and potent sources of insight. We can choose to pay attention to messages from our lymphatic system or we can choose to ignore them and our lymphatic system will go right on functioning. We can choose to observe the stream of thoughts filling our minds, or we can try to ignore them, to focus on something else, on nothing. But if we are quiet enough to listen we might hear/learn something essential, essential to ourselves, and to the well-being of our urban industrial-age tribe.

"*Out of the Cradle, Endlessly Rocking. . . .*"

The most familiar landmark; the shadow of my buggy wheel. Round and round it went. Never moving from my line of vision as the lines of the squares in the sidewalk measured my rocking.

SIMONE FORTI, *Handbook of Motion*

Sometimes just being horizontal to the ground can bring back the memory. I think it is my earliest childhood memory—I fall out of my crib. I have been placed in the crib again, covered lovingly. As I lie there on my side, the encompassing circle of vertical adults surrounds me, warms me, I am able to fall back asleep. It is the posture which brings the memory to the surface.

Recently I read of a scientific experiment that struck me as truly poetic. To determine whether or not a chick would remember how to hatch after it has already done so, biologist Anne Bekoff placed a few-days-old chick in a glass egg. Remember now, for the chick, hatching is something it needs to do only once in a lifetime. Is the memory still there? At first, Dr. Bekoff reported, the chick was very quiet. Then it began to kick, the motion which rotates it into position for hatching. When its neck was bent far to the side, the position which apparently triggers the signal to the brain for the hatching process to begin, the chicken began to peck at the glass shell. Having done something once, apparently, we do not forget. The body has its secrets, and touch and movement are often the potent keys.

Falling is one of our earliest experiences. How do we fall out

of the birth canal? How are we lowered into the crib? How are we handled? The memory of this universal experience is "recorded," so to speak, in the cells of the hindbrain. The more basic and autonomic the reflex, the further back the memory, the older the part of the brain it is encoded within. Memory of early movement experiences are easily triggered by repeating those moves. Even the release of certain patterns of muscle tension can flood one's mind with fragments of memory from the distant and/or recent past.

This is not really suprising when we contemplate how complexly intertwined our memory and our kinesthetic perceptions are. How are we able to determine, for example, that a table is five feet away or a ladder ten feet away? Our eye muscles convey a multitude of impressions in focusing the visual images on the retina. The impressions of the work done by these muscles as they move are conveyed to the brain, where they are interpreted as indicating a certain distance in space. But this interpretation is effected through an association of ideas and memories of various cumulative experiences, both muscular and tactile. Memories of the visual impressions of color and size figure in here as well. These also are due to memories of former experiences of moving towards an object and reaching it, movements of the eye, the tactile impressions of the shape, dimensions, texture of the object from having handled it. How we see is in part determined by how and what we have seen before; how we know is determined in part by what we have felt (experienced, perceived, come into direct contact with).

Where the memory is stored, or what exact movements or images will bring it to the surface cannot be accurately foretold. Consider this instance, as related by choreographer Trisha Brown. Brown, a figure central in the evolution of contemporary dance and performance, was a founding member of the Judson Dance Theatre in New York in the early seventies. She has been creating work for and touring with her company for the last fifteen years. In one of my favorite early pieces of hers, a solo called "Accumulation," Brown tells two stories simultaneously—one through gesture and abstract movements of the body, the other narrated in words. The latter may vary, but it is usually a personal story and often it involves the history of her making of the work. In an interview with Yvonne Rainer she described one particular performance:

Figure 9. Journal drawing by Bob Ernst.

I try to go for fifteen minutes, to establish the beginning of the piece, how it evolved, and then I move into all of the elements that I am using now. I say I tell two stories at once; I don't say I'm doing two dances at once . . . The first time I talked while doing "Accumulation" I said, "My father died in between the making of this move and this move." Which knocked me out.

Figure 10. Trisha Brown's drawing for "Glacial Decoy," 1980.

I was amazed that my body had stored this memory in the movement pattern . . . I became silent and composed myself. I was devastated that I had said that.[37]

From my own experience I might generalize that the different works performers make at different times of their lives can be likened to the developmental moves propelled by the "inner clock" of the infant. For the infant, each new movement receives ritual confirmation through surprise, approval, celebration. For the performer, the discovery of a new level of movement, psychological/physical may find in the making of a work its rite of passage.

In 1976 I created, in collaboration with poet John Marron, a performance piece that was to my artistic and emotional development what crawling was to my motor development. In this

work, called "brother/sister," John and I explored basic movement and emotional patterns which took us back to our roots as older brother/younger sister. I remember hours we spent crawling on the floor, sparring, bickering, name-calling, wrestling, hugging. I remember the moment when a frenzy of moves and sounds culminated, startlingly, in being cradled in his arms. The sibling pattern was there in our friendship and it was there in our movement work. We wanted to explore it, exorcise it, celebrate it. The moves we explored together brought me to a level of potency in memory of childhood I had not before thought possible.

The work the performer does in the studio is the part of performance the audience does not see. It is the self-directed part of the process: lying down and being still; feeling the spine against the floor; touching into the breath; releasing further into the floor; rocking gently; mobilizing oneself through the transitions from horizontal to vertical. In the work we do alone in the studio we sometimes recapitulate our own developmental moves. When we are confident we are hearing the feedback from our own bodies, the awareness extends to our partners, out to space itself. If one's eyes are closed when one begins to work, then it's time to open them, to integrate the outer experience with the inner, kinesthetic one.

From the inwardness necessary to reclaim our breathing bodies, so often ignored in the course of everyday events, the performer readies him- or herself to extend outward towards the audience.

There is a certain humbleness that comes with working with one's body. Every day one must start anew. Every morning the body is slightly stiff; one begins slowly to find that day's voice, that day's movements.

After warming up on their own, performers in one of Meredith Monk's performance works meet together in a circle in the performance space. The house has not yet opened, the audience is still outside. There is a palpable feeling of excitement alternating with one of calm. In the circle they acknowledge their relationship to each other. It is an extension of the acknowledgement each finds alone—of spine to pelvis, of top of head to soles of feet. They have remembered. They have prepared. They are ready for transformation to occur.

two

PERSONA

What the saturos *travestied, or represented on the hinter side, was all that is now dubbed ancient or hidden knowledge. But which was, I'm convinced from the evidence, a danced (or crawled) sung (or with ratchets, loud as thunder) witnessed (everybody in it) Theatre Performance.*

CHARLES OLSON, "Notes on Language & Theatre"

Overview

As a teenager in Los Angeles I often took walks on the beach. One afternoon on the boardwalk in Venice, a small boy, perhaps age eight, approached my friend and myself. He introduced himself as Frank, and asked if we would like to come see his circus. Intrigued, we followed the boy to the nearby garage of his family's home. He showed us to our seats and then stood up on a trestle table, stretched a bicycle inner tube over one shoulder and under one foot and danced on the table a sort of hopping, shuffling dance during which he would move the inner tube to different spots on his arm and shoulder at the upper end, and to the other foot, knee and so on at the lower. In carrying out these acts, with utter solemnity, Frank became the Bearded Lady, the tightrope walker, the lion, the lion-tamer, the midget and the giant. His one-boy circus created a transformative world of performance before our very eyes.

In Western culture, the desire (and ability) to transform oneself into someone or something else is something reserved for childhood, preserved in myths and fairytales, and remembered nightly in our dreams. In non-Western or primal cultures, transformation is a respected method of seeing, part of growing, part

Figure 11. Drawing of Little Frank.

Figure 12. Notebook sketch for work-in-progress by Charlotte Hildebrand.

Figure 13. Drawing by Meredith Monk for "Plateau."

of the way one attains the powers of adulthood and the attendant responsibilities of a member of the tribal community.

Imagine entering a performance hall and encountering a small woman, her hair in long braids, standing on what forms in your mind as a desert landscape. Her straw sandals are planted firmly on the ground and her eyes look straight at you as she scans every inch of the room looking off into imaginary distances. Her simple costume consists of a flouncy white skirt over loose white pants, a simple white shirt. The woman is Meredith Monk, and when I first saw her perform this solo, "Songs from the Hill"—in 1976 at Naropa Institute in Boulder, Colorado—I felt I was in the presence of a true magician. Through transformations of gesture, posture, and voice, Monk seemed huge or small, hearty or withered. She became all the inhabitants of this desert place: an old man sleeping, a Pueblo woman screaming for her child, a visionary on a quest, a deer being pursued. I felt the room fill with the spirits of fifteenth century corn people.

In Zen Buddhism a teacher gives a student a seemingly unsolvable riddle to solve. These paradoxes are called koans. That summer at Naropa, Monk gave her students the koan to stand still, then, revolving slowly in place, to become a messenger, a warrior, a mother, a murderer, a goddess. I had no idea how to do it, nor did most of the others, yet in watching them try and in trying to find these characters in my own body, I *felt* these beings come into focus. When I watched Monk perform her "Songs from the Hill" I *saw* her substance change from bawdy sailor to buzzing wasp to old crone. I didn't know how she did it, but I saw it happen.

What I am trying to communicate is not best communicated through the medium of words. I have to ask you to remember when you were a child, able to transform an ordinary stick into a host of characters, able to become the horse or the rider depending on what was needed for that particular moment of play.

Many performers retain this connection to childhood's ability to effect transformation in imagination, in play. I love performer Whoopi Goldberg's response when I asked her about her Chelsea, New York City, childhood:

I watched a lot of movies when I was a kid, so the people like whom I regard in my head are people like John Garfield, Spencer Tracy. In my head I could see myself dancing with Fred Astaire in fancy gowns and coming down stairs, accepting Oscars; and so I turned into these different people in my head and I talked to myself, quite *a bit. I didn't so much "dress up" but I was always in performance "up here" (touches her head). The curtain would open up and I'd be in the middle of something.*[1]

Both traditional dance and theatre training provide techniques for transformation. Goldberg's performances, her range of characters and method of presentation are completely different from Meredith Monk's. Yet the capacity (and commitment) to transformation are shared by both, and draws me to their work. Goldberg was trained as a classical actor, Monk had years of training as a dancer, both have followed their own paths away from the literalness and commercialism of most contemporary theatre. In their transformations Monk and Goldberg form a link with the earliest origins of dance/theatre/performance.

In the ancient Greek satyr plays, of approximately the fifth century B.C., the celebrants wore masks and danced in ecstasy before the image of the god Dionysos, the Great Transformer. The god's blessed wine helped, with the masks, to effect the transformation into satyrs, half-human/half-goat characters. Carl Jung wrote that the Dionysian mysteries were "to bring people back to the animal, to the animal within, before consciousness."[2] The word tragedy comes from the Greek *tragos* meaning "goat" and *oide*, "song." Though academicians debate this endlessly, it is thought that the 'goat-song' refers to the early satyr plays, the worship of Dionysos, "looser of care and grief."

Figure 14. Drawing of the Sorcerer of Trois Freres.

One of the basic tenets of the practice of shamanism in primal cultures is the capability of man to assume animal form. Through dance and often drug-induced trance, the shaman explored the animal world, singing animal songs and finally assuming animal powers. A phenomenal painting of one of these prehistoric masked dancers is buried deep in the cave of Trois-Frères in France, accessible only by tortuous descent. The so-called "Sorcerer of Trois-Frerès" is a magnificent creature, poised on dancing legs. Part human, part beast, the round eyes of the Animal Master stare out at the viewer from under stag antlers. His full human beard rests on a massive animal chest. Awesome animal wall paintings such as this one found in caves in Europe, Africa, and Australia are conjectured to have been part of religious ceremonies which included dance, music, as well as the taking-on of animal forms and powers. To ensure the success of the hunt it was sometimes essential for all the tribe's hunters to take on the spirit and form of an animal. But the shaman was the Animal Master, most practiced in the techniques of transformation. He or she was the master or mistress of ceremonies, the one specially chosen (by dint of natural disposition or "strangeness" sometimes) to communicate with the animal world and the world of the divine and departed ancestors.

Figure 15. Working sketch by Corey Fischer of A Traveling Jewish Theatre. Preparation for carving a mask for the shaman woman in "A Dance of Exile."

Performance is a vehicle by which the performer may be transformed into a heightened state of consciousness, into someone or something else. It is also a means for performers to transform aspects of their lives, their dreams, their experience in order to give them meaning or to find their meaning. Not all contemporary performers are equally interested in transforma-

tive work, and not all performances call for the same degree of transformation.

In this chapter we'll look at some of the methods contemporary experimental performers use to effect transformation, one of the most basic elements in performance. Also in this chapter, we have added another element—the spectator. The process of inner awareness described in the previous chapter, must be accompanied at the same time by the performer's awareness of the audience. Performance may initially be a private act in the sense that it is spiritually nourishing to the performer. But it must also become a public act, done with the intention of including or affecting an audience or simply sharing an experience with them.

Among the Swampy Cree Indians who live near Lake Winnipeg in Canada, there is a cycle of oral poems called the Wishing Bone cycle, a poetry of transformations in which one might become a turtle or a chair or a porcupine or an empty coat. One of the Swampy Cree storytellers described the discovery of the wishing bone in this manner:

> One spring near Lake Winnipeg, a single snow goose appeared high in the air. It glided down on a smaller lake and swam to shore. Nearby and quietly, a lynx crouched as the wind shifted the goose's scent onto his nose. For a brief moment the goose lifted its head, listening. But before it could rise again safely, the lynx had it in his teeth. The lynx feasted down to bones and feathers. Then, just as he began to crack a bone for marrow, a man called out and the lynx was quick into the trees. Only the artifacts of the goose remained, but among them the man found a bone said to protect the heart—a "wishing bone." He examined it slowly. Later, he found that the bone was a tool of metamorphosis which allowed him to become a "trickster" capable of wishing things into existence, and himself into various situations.[3]

The wishing bones are our own bones. We can find them in our body. But they are not a birthright of our culture; we have to go against the mind-set of our culture to find them.

Sounding Through

In ancient Greek theatre the actors wore masks depicting expressions of happiness or grief. The actors' voices, with their individual nuances and vibrations, could be heard from behind the rigid coverings. The "sounding through" of the actor's own voice gave a sense of the individual behind the mask's firm outline. The word *persona* means literally "sounding through." In a society which calls for set roles to be projected to the outside world,

the word persona has also come to mean that sense of self which we choose to project. We each have myriad personae, some of which we may prefer to keep hidden.

One of my first experiences of the theatrical phenomenon of sounding through was in my first performance work. I was unaware at the time of the historical precedents, but I was drawn to this act of sounding through as a rite of initiation into seriously considering myself a performer.

"Face Value" (the name of the piece) was quite simple. I entered the space with my back to the audience. My face, my essence, was withheld. When I finally turned towards the audience my face was distorted with grimaces. I was "making faces." I slipped behind a piece of blank paper suspended from the ceiling of the gallery by two ropes. I unclasped the paper and placed it over my face. With a soft black crayon I made a rubbing of my features, literally a "face map," a primitive mask. I stood behind the mask but in the end tore through it. I simply stood and faced the audience, allowing for recognition of our mutual presence in the space. It was a vulnerable, charged moment.

Figure 16. Author in "Face Value," 1976.

What parts of ourselves do we choose to reveal to others? A performer picks different facets of his or her own persona, in an attempt to reveal the whole self.

When the Kwakiutl shaman placed the heavy carved wolf mask on his head, when the ancient Greek actors assumed their tragic masks, when the Dionysian celebrants put on theirs, a link was formed between the living and the divine ancestors. Masks were the magical instruments through which the individual effected his or her transformation.

The modern performer seldom wears a mask. Instead, now a mask or the principle of maskness, as director Robert Benedetti calls it, is "any object or pattern of behavior which is designed to project a sense of self." Since the character or role the performance artist creates is usually predicated on an aspect of his or her own self, there exists a confusion of identities. It is a "happy confusion," as actress Ruth Maleczech of the experimental troup Mabou Mines put it. The performer's real identity and the life of the created character exist at the same time, creating a sort of dual consciousness.

In traditional theatre, the actor is handed a script written by the playwright. In the Stanislavskian method, the actor finds the motivations for the character's behavior in similar moments from his or her own life, and then transfers those feelings into the moment of playing the character. Most of our naturalistic theatre is based on the Stanislavskian model, and put simply, it attempts to reveal inner truth by showing life in its everyday form, on the surface. Rather than focusing on the character's motivation as in naturalistic theatre, the experimental performer shares identity with the age-old role of the storyteller,

who fills his or her story with extraordinary events, miraculous events and in no way tries to explain the psychological connection between them. Performance artist Laurie Anderson commented, "In traditional theatre if a character wants to talk about an earthquake he or she has to give the motivation for talking about an earthquake. If I want to talk about an earthquake, I talk about an earthquake."[4] I'll borrow that permission later on in this chapter—I'll tell you about an earthquake.

In experimental performance the performers reveal a vision of the world that goes beyond the cultural assumption of "ordinary reality." What we thought to be a fish might be a fowl, what one second ago was a young child is in the blink of an eye a withered old woman. As much new performance is more physically based than naturalistic theatre, transformation is a more expected outcome—dance and other movement forms are in their essence metamorphic, fluid. The transformations of character and body are visible to the audience. It's no coincidence that many of the performers whose work I've been attracted to and whom I discuss in this book, have studied and practice the ancient Chinese movement form *t'ai chi chuan*. The shape-shifting which is so elemental to the performance of which I speak is formalized in *t'ai chi*.

The ancient Chinese philosophy of change is predicated on the concept of polarities: heaven and earth, light and dark, the feminine and the masculine, empty and full, receptive and active. These are the active principles which hold the universe in balance, which hold society in balance, which hold our bodies and minds in balance. Two not-easily translatable words: yin and yang designate these polarities in Chinese. In practicing the form one does not move abruptly from one position to another, each movement *transforms* organically into its opposite. An aggressive move becomes a yielding one. As one "empties" force from one's hands, one "fills" the same weight into one's feet. Understanding these principles of change and exerting one's will within the continual flux of energy lends a great deal of control and power to the performer. The concept of changing into one's opposite finds a philosophical base in *t'ai chi*. Bob Ernst, a West Coast performer commented of his work:

I'm very concerned with the androgynous elements, the mix, the both. It's like in martial arts you be hard and then you be soft. Professor Chung, the first t'ai chi teacher I ever had, could do "push hands"—he had the softest skin—and his whole being would turn to steel, like concrete, for just a moment, then he would be soft again. It was that discharge that would knock you off balance, and then he'd grab you soft as hell. just a moment. just that moment. He knew the range of his energy, he knew where to put it.[5]

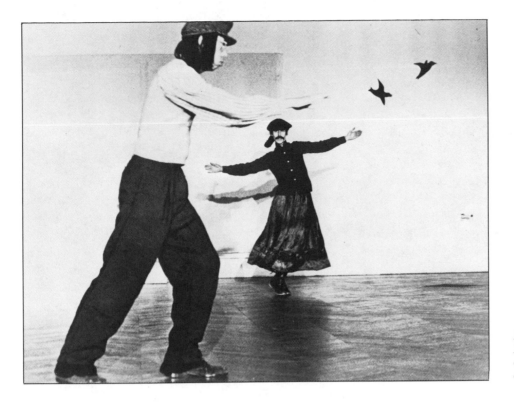

Figure 17. Ping Chong and Meredith Monk in their collaborative travelogue duet, "Paris."

If one understands the range of one's energy, the range of personae and characters one contains within oneself, the potential for using that range is enhanced. Transformation from male to female within one performance, sometimes within one character, is not uncommon in transformative performance.

In their collaborative theatre duet "Paris," Meredith Monk and Ping Chong are a couple strolling around a Paris of the imagination. They witness poignant scenes out invisible windows and make us imagine them also. The woman suddenly skitters whimpering across the floor, the man comforts. Within each of them we see strength and vulnerability, hardness and softness. The man has straight black hair, wears a blousy shirt, is delicate yet solid. The woman is thin, almost frail, yet sturdy in her hiking boots, Mao jacket, student's visored cap. She also sports a jaunty moustache. Monk explains her choices:

I want to be brash, blunt, delicate and internal . . . There is definitely a male part of my being that I feel very close to and a female part I feel very close to. I want to express both, as a prototype of what I think a human could be. I still believe in the goal of a whole human being with all the parts expressed . . . The goal is an integrated self, as opposed to different parts. Everything I do, even bringing together different art forms together into one form, tries for synthesis and integration.[6]

Figure 18. Lanny Harrison as La Professora in "Nite and Day."

Monk and Chong's "Paris" couple, singing eighteenth century hymns from the top of the Eiffel tower, are a union of integrated complexities.

Lanny Harrison is a performer who has played major roles in Meredith Monk's work and has also been creating her own work for the last decade. In "Nite and Day" she plays a professor on sabbatical in Hawaii. Throughout the course of the play, Harrison (who is sometimes called "the cosmic comedienne") changes into many other characters—a Jewish grandmother stirring soup with an enormous ladle, a Sioux matriarch with outstretched arms, a bawdy nightclub entertainer. In the final scene of the piece, La Professora, the main character, turns into a man. I asked Harrison what precedents she felt for transformation of this nature:

There's a tradition in Commedia and vaudeville, like the harlequin character. He's always a man, except there's one story where Harlequin has a baby, and it's fascinating and it's very funny. It's a great source of humor, but even more basic than that I think it's a natural state that Commedia and vaudeville have always commented upon. You have these desires to play both male and female. People want to transform into their opposite. It's very satisfying.[7]

Transformation is the nature of the work, and discovering the male and female aspects of oneself is part of that process of discovery of which performance is the catalyst.

The Varied Routes toward Transformation

Fundamentally, dance and theatre share a common source. The ancient masked dancer and masked actor were the same. In his *World History of the Dance,* Curt Sachs defined as actor "every dancer who with acute powers of observation, feels himself into the living, even into the lifeless forms of nature and re-creates with his own body their appearance, actions, and their essences."[8] The dancer/actor felt himself into the soul of the deer he pursued, or into the soul of the ancestor who had died by means of a phenomenon known as *possession.* The person, spirit, animal, god that the dancer/actor represented took control of the dancer's body.

Bob Ernst is an actor/dancer, a creator and performer of experimental theatre who is based in Berkeley, California. He and his fellow performers Whoopi Goldberg, David Schein, and Cynthia Moore are the core of a troupe called the Blake Street Hawkeyes. The Hawkeyes have been offering inspirational new performances to Bay Area audiences for nearly a decade. In their small, funky, homey studio behind a mechanic's garage and next door to a parking lot, Ernst and other Hawkeyes teach, and perform their works.

Ernst uses the term "possession" in teaching performers about character work. He feels, that in order to get possessed, to let a character enter your consciousness from your unconscious, you have to get to what he calls "neutral." For just perhaps a few moments, you have to abolish the "profane human condition."

My first day in Ernst's workshop in 1979 began by sitting with the other participants in a circle on the floor. We closed our eyes and began to vocalize resonances, deep sounds coming from our bellies. Our tones blended together in a satisfying harmony. During the drone I heard the man sitting next to me murmur, "earthquake . . . earthquake . . ." and I thought to myself what a profound collection of syllables to choose to utter. Then I realized the ground was moving under my haunches. It was moving a lot. In fact, there *was* an earthquake happening right at that moment. We all opened our eyes, smiled at each other, felt earth moving. It was one of those strange moments when you really don't want to be anywhere else. Ernst rose from the circle and ran to the doorway where he knew it would be safer and yelled for us to follow. But we all just sat there smiling and feeling the earth moving. We had collectively and silently decided to GO

Figure 19. Notebook drawing by Bob Ernst.

THROUGH WITH IT. Bob came back and sat down again in the circle with us.

Years later, interviewing Ernst for this book, I asked him jokingly if earthquakes were still a recommended method for "achieving neutral." He laughed and said he didn't advise such drastic techniques any more. The idea in attaining neutral is to outwit your usual thinking patterns. You can outwit them by tuning into your body, watching your breath, running until you're exhausted, chanting, or sitting still in a chair. You forget your preconceptions about what character you wish to create. "I'm not so much interested in what someone's ideas are as what their subconscious is," Ernst says.

Ernst likens his concept of "getting to neutral" to the martial arts concept called "mu-shin" or "no mind," meaning no separation between mind and body. Knowing a series of movements, as in *t'ai chi*, is one way to achieve this unity. He also feels that everyday movements, done with efficiency and no

wasted effort, like the garbageman's hoist of the trashcan or the fry cook's flip of the egg, can also embody this state of mind.

The performer's act of possession differs from the shaman's in that the performer tries to maintain a dual consciousness—a sense of being in control at the same time as giving in to the sense of character. The performer must learn how to control the phenomenon of possession. That's where craft and technique are needed. Ernst says it this way:

Possession in any culture is a risky business. You've got to be able to know to be that person/character when you are that person, but then to develop the facility to say "that person is over there." To do this takes a lot of control, and you develop control by letting go. Possession is that you've got to trust yourself to know that you can dive off the high dive. Of course you learn how to dive off the edge first before you go up there, that's what technique is all about.

Curt Sachs distinguished between two main lineages of dance. One he called "image" dance, the other "imageless." The performance theatre of our study may use either kind of dance in its composition, and both kinds may entail the use of possession. Image dancing is mimetic. The dancer takes on the spirit of the being he or she is to mimic. I have described how the hunter takes on, or is possessed by, the spirit of the animal which he pursues. In "imageless" dance an act of possession may take place also. The dancer's consciousness is changed by the state induced by movement. This too, is a kind of transformation, even though it does not imply the appearance of characters. Chapter Four will focus on improvisational or imageless dance in greater detail. Here I am including movement as one of the routes to transformation which either a dancer or a theatrical performer may use.

When Sachs describes the kind of possession made accessible by dancing he points out that during the Boer War the Bushmen of the Kalahari Desert often allowed themselves to be surrounded in the midst of their passionate moonlight dance and shot down in hordes. Sometimes, Sachs noted, "the exhilaration might bring a certain anesthesia, the extinguishing of all feelings of exertion and fatigue."[9] Maya Deren, the filmmaker and anthropologist who is known for her study of Haitian voodoun, also studied trance dancing in Bali. She describes the amnesia which the Balinese trance dancer experiences for the period of the possession. This amnesia seems to affect the audience as well. Afterwards they treat the little girls just like any other little girls, not the little girls who just danced so well. The Balinese performers are, in a sense, anonymous, because what they have just performed has been done by "someone, or something else":

I think it has something to do with those two stages of trance which I have noticed: the stage in which the body of the little girl is emptied of "moral individual content," so to speak, and only after it has been emptied, are the holy clothes draped on her, for now it is not the little girl any longer, and now they decorate the house (the body is a tube) and hope a deity will move in. And the caprices are not of the little girls before they are vacuated, but the caprice is of the deity or angel who enters her body for a moment, makes a movement using her arms, then darts out again and leaves her standing empty and waiting, and then comes in again, and then out again, and then eventually comes in, takes over the body, does a dance, and then is sent back to its regions.[10]

Contemporary performers may also regard themselves as vessels for information or unconscious content, but they can never entirely forget where they are or become amnesiac like the Bushmen; because if their experience becomes completely private, they risk losing the audience's attention. If they're dancing, they also risk breaking their necks. For example, I first experienced what Ernst calls "possession," not through assuming a character, but by losing myself in improvisational dancing. It was at a time in my life when I needed to cast out some demons, and movement seemed to be the key. Another dancer (Ralph Elder) and I would go to the studio late at night. There, in the dark, we would work at high speeds, running and flinging ourselves, very miraculously catching, tumbling, luckily never being hurt. The state engendered by this recklessness was a revelation, but it became clear to me that I needed to learn control rather than count on risk.

Many performance creators use techniques of ecstatic, or imageless dancing within the larger framework of their vision. Choreographers Laura Dean, Meredith Monk, Andy De Groat and others have explored spinning in their dances, a practice used for spiritual worship by the Sufi dervishes for centuries. Theatre director Robert Wilson, who makes large-scale architectural operas, has used trance movement techniques all along in his work. His loft in New York, the Byrd Hoffman School, was a place performers could go to experiment with improvisational dancing in a communal situation in the early seventies. I didn't experience Wilson's work firsthand, but I have worked with Cindy Lubar and John Marron, performers of his who have gone on to do their own work. John and I would spend hours in an empty room "letting anything happen." We might crawl together in slow motion for an hour, babble until we were blue, spin or turn upside down. Together we created a piece "Sinai/Sinai" that evoked images of a journey to the Middle East. I found myself going through these metamorphoses at one practice session:

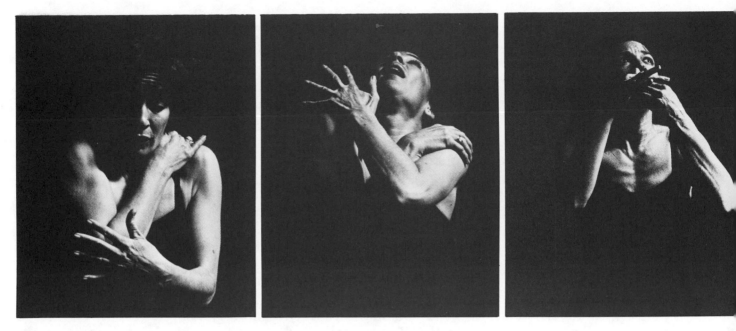

Figure 20. Photo of Ruth Zaporah in performance.

> I am an old man asleep in the desert
> I am a young boy running after tourists asking, "Hot tea?"
> I am the horror and beauty of sudden sandstorm
> I am the swift reprisal of SAVAK
> I am a nomad gazing into the distance
> I am a rock on the red desert

The pace of the movement made for rapid changes of personae.

Both Ruth Zaporah and Dana Reitz, whose work I consider more fully in Chapter Four, are performers for whom movement is a key to transformation. Ruth Zaporah was originally trained in modern dance. Now she performs improvisational theatre which is kinetic, verbal, possessed.

It's as if I hypnotize myself. I work myself into a mental state that transcends the state I usually operate in. The material that comes through me then never ceases to surprise me. I become characters that I didn't know were in me; I use vocabulary that I didn't know I knew. I enter an internal space which is kinetic. Gradually ideas appear which I dip into. I develop situations, characters, and as I move back and forth between them I see connections.[11]

When Dana Reitz dances, it is not her stated purpose to embody characters. She concentrates on her movement, ranging with fluidity through different speeds and tensions. From standing still, her long torso stretching upwards, she might suddenly

crease forward, touching her hands to the floor and kicking her feet out behind her. Like Zaporah, who also performs improvisationally, she is often surprised at what manifests as she dances: "You have no idea what's underneath as you start this rhythm, but you hold on to some structural thing that can evolve and then you see what happens and then all sorts of different moods or characters come out of it, different characters within yourself."[12] Reitz's transformations are prepared for, but not rehearsed. For many hours prior to performing she works slowly with her body. Sometimes she sleeps in the performance space, slowly releasing her muscles so that by the time she performs there is no tension to block whatever forces move through her.

Whoopi Goldberg is a Bay Area performer who enters into her characters initially through an act of empathy. A black, a woman, a Buddhist, Catholic, Jew, she defies stereotypes while capturing the essence of characters. Her humor is sincere and outrageous, her characters as improbable as the people who sit next to you on the subway. Among her characters are Ugmo the Wino (who celebrates Uncle Ben Day), a junkie on a tour of Europe who meets up with the spirit of Anne Frank, a thirteen-year-old Valley Girl who aborts herself with a wire hanger, an appealing black ghetto child who fantasizes that she'll grow up white and rich. These characters are the disinherited, the members of our society who maintain dignity though they may lack hope. Goldberg has listened when people talked to her, she has paid close attention to individual mannerisms. She has an acute visual sense that allows her to construct a character in her imagination as she observes:

You have to look at people and take the way that your mother walks, the way she moves her feet from her knees to her toes, and connect it to the way a policeman on the block moves his hips and thighs. So that's a whole new character you know. And taking the torso and putting someone else onto that, and building it, layering it. That's how I build my characters. Not in the studio, but in my head.

Goldberg says she generally feels a clear separation between her self and her characters. She does not like Whoopi Goldberg to appear on stage at all; it has to be pure character.

As well as using empathy as a *modus operandi* to construct her characters, Goldberg's personae really don't come into being until she is in front of an audience. Her characters gain life through their interaction with the spectators. Like the ancient Greek *phallophoroi*, the clowns who traveled from town to town insulting their audiences, Whoopi Goldberg's outrages are in the joyous spirit of Dionysos. In ancient Greece the raillery and abuse towards the spectator were thought to ward off evil.

Figure 21. Whoopi Goldberg as Moms Mabley.

Goldberg is not abusive, but she makes her audience at times extremely uncomfortable or at least quite alert. The audience comes to see Whoopi Goldberg because they trust her skill, her expertise, her intentions:

I'm responsible to them [the audience] and they're responsible to me in that they have to participate the way I want them to participate. That's why I scream, "Wake the fuck up: you know, participate, challenge me. You wanna see how bad I am? Give me some shit. Throw something at me and we'll have a great time." I like that. I feel like I'm training audiences in the Bay Area to actively participate; to speak back. You can yell at me, I don't care. It's my characters. They can handle it. I want people to wake up. I want them to come and be a part of the experience of theatre. That's what the Greeks did. They came and said, eh, we're living in a piece of shit here, don't you think so? And the audience would say, "Yeah!" And they'd travel to another town. They had no Athens Chronicle, *you know, so it was up to the actors to get information across, educate and entertain, which is what I want to do. I want people to take responsibility for themselves and not take anyone's word for what's going on.*

When Whoopi Goldberg says she doesn't like any Whoopi Goldberg to appear on stage, that it has to be pure character, what she means is that her real life identity is no longer visible to us when she appears as a character. Though she doesn't literally use a mask, Goldberg's mask is thicker than those of other performers who choose to let their own identities coexist in the audience's view with that of their characters. In Japanese Noh theatre the actor is provided with a mirror room *(kagami no ma)*. At this transformation site the costumed actor sits on a stool before the life-size figure reflected in the mirror—his "other." From this place, behind the curtain, out of sight of the audience, the transformation takes place. After exiting from the performance, even after the curtain has been lowered, the actor continues in character until he comes to a stop in the mirror room. In Goldberg's performances, the only time that the audience sees Whoopi Goldberg is in those split seconds when one character metamorphoses into another.

Ventriloquism is a traditional technique of creating new personae that a few contemporary experimental performers are exploring. It is clear when we watch Doug Skinner perform that we are watching Doug Skinner, performer. The mask is translucent and Skinner usually aims to be as neutral as possible, sweetfaced and deadpan. His other self is a dummy named Eddie, around whom he has created a suite of pieces. Working with a dummy allows Skinner the interplay of two characters. Skinner may appear to be an inept, out-of-control adult to his dummy's suave self-possessed persona. Skinner often uses his relationship to the dummy to illustrate aspects of parent-child relationships. The ventriloquist has traditionally opted to be a father figure, sort of a super-ego to the dummy's id. "None of the adults I know are in control, though," noted Skinner, "instead, their lives are falling apart, they're confused and self-destructive. And the children aren't disruptive brats, they're trying to figure out what the status quo is more than they're trying to undermine it."[13]

Economics must also be noted as another factor in the reasons why many performers learn to become many different characters. In our culture, if you're going to work outside the commercial system, learning to be flexible is essential. Being an independent performer does create *character*. I was amazed when I discovered that Whoopi Goldberg's characters were not rehearsed in the studio but were instead, born in performance. When I asked Goldberg when or how she had discovered the ability to work this way she replied, "When I figured out how much I'd have to pay in childcare for studio time." Doug Skinner told me he learned ventriloquism initially because "that way I don't have to pay another actor."

Also, if you're going to do solo work, you have to be everybody. The craft of transformation, the control one evolves to

shift from role to role then is most essential to the performer.
Bob Ernst explained:

When you're doing solo work you have to be the actor, the director, the writer. And it's important to know yourself in all of those roles and to know when one of them is taking over. So I can be out there improvising, working up a sweat and it feels real good and then all of a sudden the writer takes over and I start hearing words and I start moving less and I think, "Oh, I'd better go write this image down." And what's different now, from when I began this work, is that now I can go right back into it, right back into it. And if it's time for the director to take over I'll stand back and look at the aura that's left in the space a little bit . . . And all of this in contrast to all the early anxiety and self-consciousness, all the courage it took just to go in the studio alone and get over the self-consciousness.

Whoopi Goldberg builds characters as composites of people she sees, social types. Doug Skinner uses a dummy as a projection of his own persona, own concerns. Ruth Zaporah lets unknown characters emerge from her kinetic meditations. In her beautiful theatre work "The Education of the Girlchild," director/composer/choreographer Meredith Monk cast women who were all longtime friends, real-life companions. Together they created a vision of womanhood that is powerful, clear, capable. Monk chose the women in the cast for who they already were and for the archetypal qualities they evoked in real life. Each of the women built a *personal character* which was herself as well as a created persona. Monica Mosely, calligrapher and librarian, is a scholar; tall, long-limbed, outgoing Lanny Harrison is a warrior; solid, nurturing actress Lee Nagrin is an earth mother. In fusing the personal and individualistic with the archetypic in her work, Monk made a radical move that has influenced generations of theatre experimenters.

In Monk's theatre, archetypal characters do what masks did for the Greeks. They typify a link with the eternal. Yet we do not have to look far for these elemental characters, they are embedded in our everyday life, in our most essential patterns of behavior and perception.

The word archetype means, literally, "the first pattern." Within the consciousness of each of us dwells a common repertoire of images, themes, characters. The Old Man, the Sybil, the Teacher, the Fool are characters common to the psyches of all people in all places in all times. Neo-Jungian James Hillman, in further developing the use of archetypal symbology to encompass what he calls "the imaginal," says that archetypal means "fundamentally human . . . Archetypes are root ideas, psychic organs, figures of myth, typical styles of existence, dominant

Figure 22. "Education of the Girlchild." Standing, from left: Blondell Cummings, Lanny Harrison, Meredith Monk. Seated, from left: Coco Pekelis, Lee Nagrin, Monica Moseley.

fantasies that govern consciousness . . . the deepest patterns of psychic functioning."[14]

The women who created "Education of the Girlchild" with Monk—Lanny Harrison, Coco Pekelis, Lee Nagrin, Monica Mosely, Blondell Cummings—developed their characters as enlargements of themselves. A gesture characteristic to Harrison in the play, for example, came originally from the way she actually swung a scythe in the tall grass of her upstate New York home. Monk commented on her choice of performers:

> The interior richness of each performer contributes to the making of sequences and I want the audience to have a profound relationship with their female personality. Each person uses her own familial, childhood, social and ethnic backgrounds.[15]

"Education of the Girlchild" is in two main sections. Part one begins with Mosely sitting and reading alone, intently, at a large round table. The other four women, wearing combinations of

white clothing of no particular identifiable era enter and gather at the table. They are like female knights sharing stories before setting off on their quest for the Grail. At the same time as we perceive them in this mythic light, we see also old friends sitting around a kitchen table the way these old friends really do. While traversing the stage in an eccentric parade (Monk carrying a replica of a small house on her head; Harrison swinging her imaginary scythe; Cummings carrying some strange, stuffed reptile), they come across a sixth companion lying in stony sleep under a cloth. They uncover her from her timeless nap and bring her back to the table as "one of the family." Monk, made up in chalky whiteface, is the young Girlchild who watches the action unfold and who is also swept up in the adventures of the clan.

Part Two of "Girlchild" is a journey backwards through life, through time. Before exiting at the end of Part One, the companions dress Monk in an apron, white wig, and glasses and seat her on a raised platform. They have unfurled a highway of white cloth from the platform down towards the audience. Monk remains seated throughout intermission—an ancient immobile icon. When the audience reenters she begins a solo journey from old woman to childhood, effecting her transformation by changes in body and voice. She sheds the wig, glasses, apron and loosens her long dark hair. She becomes a young girl once again.

Ten years after the creation of "Girlchild," Monk and her company The House reconstructed the piece for performance in Japan. In those ten years the lives of the performers had undergone many changes—the birth of children, sickness, changes of career, mates—yet the work itself proved timeless enough to encompass those changes. One of the performers, Lee Nagrin commented:

I remember Coco looking up at me in Japan and saying, "You know, you always used to be so fierce when you looked at me at the table and now you're ecstatic—you're in some other place completely." And of course this happens to be true. We're ourselves in a way that we are now and not as we were then, but that material is still part of our history. This is very different from performing a character. You fill it in a different way.[16]

What is different from performing a character in a traditional sense is that the performers' own lives are woven into the lives of their characters and the changes in their own lives have room to be expressed in the way these performers perform. The performance itself is an ongoing ritual of transformation for the cast. "Education of the Girlchild" offers them a structure in which to experience their individual growth as well as an opportunity to affirm their community. The characters' development is spiritual research for the performers.

Wanderers

The characters portrayed by Monk and her companions in "Education of the Girlchild," not unlike Dorothy and her Companions in *The Wizard of Oz,* journey as part of their quest through a strange landscape full of physical obstacles and psychic challenges.

The archetypal theme of journey is a natural one for the performance artist to explore. There is no set path for experimenting theatre artists, no security, no easily definable successes. Most of the artists in this book began their work without their sights set on the standard goals labeled Hollywood or Broadway. They have turned instead to their own resources after experiencing what felt like a spiritual emptiness in the commercial entertainment of our time. In that sense, they are outsiders.

The identification of performer with wanderer or outsider has its historical antecedents. Robert Benedetti writes that

> after the fall of the Roman Empire, the Church (both Western and Eastern) declared theatre a vulgar, and therefore, a prohibited profession. The actor was literally expelled from the theatre, and through the Dark and Middle Ages the exiled stage actors took refuge with their fellow performers, generically called minstrels—keepers of the oral, rather than the literary tradition.[17]

"Emigration, forced or chosen, across national frontiers or from village to metropolis, is the quintessential experience of our time," wrote John Berger.[18] We live in a world of constant change and upheaval. Daily we hear of refugees washing up on the beaches of our country, crawling through sewage pipes, on their journey away from economic and political oppression. Our world is continually viewed through the eyes of the newly arrived, making us reconsider our standard perceptions of ourselves, our culture.

I am attracted to ancestor figures who journeyed. My grandmother came to the New World from across the sea. In my first image theatre work addressing character, "Last Earthwords for Awhile," I wanted to embody the spirit of that specific journey as well as the archetypic one. I wanted to evoke the spirit of someone who traveled from a tiny Ukrainian village very far away, yet so familiar that, seventy-five years later in a condominium in Los Angeles, she can describe in exact detail the layout of her garden.

In "Sitting Ghost Walk" which I based on Maxine Hong Kingston's novel *The Woman Warrior,* I was attracted to the main character Brave Orchid for similar reasons. Brave Orchid

was the author's mother, who had emigrated from Kwangtung Province in China to Stockton, California. Brave Orchid's world was very far from our own, but so was my grandmother's. My own grandmother did not travel alone in the mountains as Brave Orchid did, but creaked out of Russia at night in an oxcart covered with straw. For payment to the driver she gave our family samovar. Who I am and what I am doing now is as much a result of that journey as my own conscious choices. In a later work, "Sinai/Sinai," I found satisfaction in creating the character of the Dream Peddler, based on a figure from Eastern European folklore, who journeyed from town to town selling books which contained the meaning to all one's dreams; meeting your longlost brother in the forest, dancing in a moonlit beetfield, looking into a volcano's crater with your body hot on one side and cold on the other.

If, as performers (or filmmakers, sculptors, or painters), we chose to wander outside the standard avenues of the entertainment industry, then perhaps we too can be the lens through which the precarious conditions of the planet are made vivid.

The Watchers and the Watched

In its earliest forms, performance was an ecstatic release for an entire tribe. There was no need for onlookers, because the dance drama was a rite in which all participated. Dance historian Curt Sachs speculates interestingly that it was the use of the mask, in essence the beginning of character and specialization, that hastened the development of a tribal form into a spectacle, into what we now define as art:

> As long as the demonology is taken seriously, one person is closer to a certain spirit than the rest and is specially qualified to represent him and become one with him. In this sequestration lies the germ of the spectacular dance: every dance divides the tribe into active members and passive, into performers and spectators.[19]

Performance today usually uses trained performers whose skills set them apart from the audience. Like the shaman, their job is to perform in the service of the audience. The principle of shamanism in cultures in which it is practiced, is that the shaman/performer "goes somewhere else" for the sake of healing the individual or tribe. The shaman goes into a trance. The word "trance" comes from the Old French *transe*, which has the basic sense of passage, especially from life to death. It also has the sense of extreme dread or doubt. The associated verb *transir* means to depart or be benumbed. In such risky business one had

better have a form, a structure for the ritual. The word "form" in "performance" is derived from the Latin word *forma* meaning form, figure, model, or mold. The prefix *per* is derived from the Latin and means completely, thoroughly, intensively. This refers to the shaman's or performer's courage in journeying to the "other side" in order to bring back something of value to others. One completes, finishes, brings about, in effect *goes through with it*.

The audience *goes through with it* too, if you have them with you to begin with. Is performance capable of changing the audience? This subject has been debated by theoreticians of the theatre from Aristotle to Ibsen to Brecht to the Becks (of the Living Theatre). This may seem hopelessly romantic, but I do believe transformative theatre is capable of transforming its audience. How a performer engages the audience, how they think of and relate to their audience, is an issue for each performer to resolve for himself or herself. And resolve it they must if they wish to perform. The Living Theatre actively confronted their audiences, inviting them onto the stage, pursuing whatever events the confrontation generated. On the West Coast in the early seventies, I took part in a participatory ritual performance called "The Simple Art of Eating," devised by Al Wunder and Terry Sendgraff, in which the performers served the blindfolded audience an entire meal.

There are ways though, ever since there have been specialized members of the community called performers or storytellers, that the audience can be engaged in the performance without literally touching or feeding them. We may no longer have common rituals in which all members of the community participate, but the performance rituals we do create can potentially "stop time" for a spectator.

In the Kachina dances of the Pueblo tribes of the American Southwest, the meaning of the characters and their actions in the dance are comprehensible to every member of the tribe. The dances have arisen anonymously from the spiritual life of an entire people and are complexly interwoven with the values of that people, as noted by Jamake Highwater.[20] Lacking such cohesiveness in our own society, performers are, each in their own way, reestablishing rituals and trying to relate them to the often-buried values of our complex, polyglot tribe. This is the New World we are seeking in performance today. As D.H. Lawrence wrote:

> . . . the difference between Indian entertainment and even the earliest forms of Greek drama . . . is in the onlooker, if only in the shape of the God Himself, or the Goddess Herself, to whom the dramatic offering was made . . . And in the long course of evolution, we ourselves become the gods of our own drama. The spectacle is offered to us. And

we sit aloft, enthroned in the Mind, dominated by some one exclusive idea, and we judge the show.

There is absolutely none of this in the Indian dance. There is no God. There is no Onlooker. There is no Mind. There is no dominant idea. And finally, there is no judgment: absolutely no judgment.

The Indian is completely embedded in the wonder of his own drama. It is a drama that has no beginning and no end, it is all-inclusive. It can't be judged, because there is nothing outside it, to judge it.

The Indian . . . has one commandment:
Thou shalt acknowledge the wonder.[21]

Figure 23. Drawing by Joan Jonas from her video performance work, "Organic Honey's Vertical Roll," 1973.

Postscript to Chapter Two (After the Volcano)

I saw performance artist Joan Jonas perform her solo "Mirage" in Berkeley in 1981. In one section she stood in a circle of red light on the darkened stage, her back to the audience. In front of her a movie of a volcano erupting was projected. It must have been Etna. She began to dance, violently hopping from side to side as if on hot coals. She danced for a long time in the red light as the lava spilled over the mountainsides in the film. I didn't know what her intent was, but there was something going on that was hard to ignore. The next morning St. Helens erupted with more than the force of the bomb at Hiroshima.

The blast was terrifying to animals in the vicinity. My dog of eleven years was living then just miles from the epicenter. After the explosion, he simply disappeared. I felt greatly off-balance, and to help myself regain some equilibrium after the explosion, I set about in collaboration with Charlotte Hildebrand, to make a performance about volcanos, severance. We wanted to contact the dog spirit.

In many mythologies, the dog appears as a guide to the land of the dead. To "take on" the dog character was to make a crossing, a transition to the other side. The dog character began to enter me in a series of dreams and this was the first:

I dreamed I journeyed to the hot springs at the base of St. Helens. I wanted to see how the configuration of stones that forms the pools had been trans-figured by volcanic time. As I peered into one of the pools, a noble Great Dane, lying on his side, floated into the field of my vision. A man standing beside me (whom I had not noticed at first) reached into the water with a long stick which had a knife taped to the end. He stabbed the dog without warning.

The huge dog continued to float on his side. His wise brown eyes watched me as he sank deeper and deeper into the water. His eyes beamed to me the knowledge that he would continue to live, but on a deeper level than before.

As D.H. Lawrence wrote, "Thou shalt acknowledge the wonder."

three

THE FORESEEN

We're basically interested in the immutables . . . We're trying to foresee or be like divining rods, trying to sense what's in the atmosphere, what needs to be looked at or what needs to be dealt with . . . the forces in this society not generally acknowledged, or there are no channels to acknowledge them.
PING CHONG, speaking of his own work and the work of Meredith Monk

"Know thyself" means also—know thy peculiar images.
JAMES HILLMAN

Casting Shadows

Today there is much speculation as to why our Upper Paleolithic ancestors began to create art on the walls of caves. We can try to imagine how it was. Access to the caves was not easy, the descent itself was an ordeal. A group assembles, men, women, and children. The organizers begin the descent. Through an opening in the ground, one by one the individuals work their way in and then forward, often on hands and knees in total darkness. Suddenly at a precise place a word is whispered, then a torch brought around a bend to illuminate huge red horses on the cave walls. In the shock of sudden light they seem to stream past the viewer. The observers are caught in the narrow passage, able to face in only one direction. There is nowhere else to look but at the events unfolding in front of them.

Figure 24. Rob List's drawing for solo woman in corner from his performance work "At the Falls," premiered New York City, 1983.

After climbing on his own hands and knees down into the caves of France, Spain, and Australia, writer John Pfeiffer wrote that what is most important about the remarkable paintings of bison and horse, horned dancer and emu found on the cave walls is their "precision."

Looking up at the panel was like hearing a shout in an utterly alien tongue where even the quality of the intonations is strange and unfamiliar . . . The individuals who drew the forms on the wall knew exactly what they were doing, and the individuals who came to look knew exactly what the forms meant . . . This is the one message that comes through."[1]

The journey down into the chambers of the caves was a journey by a physical route from everyday reality, to a special realm where specifically chosen images were forcefully presented to the viewers. Pfeiffer reasons from the evidence, that the planners created ceremonies which used dance, rhythms (objects pounded on ground or walls), and carefully controlled lighting. All the senses were addressed, thereby causing the audience to form powerful associations with the images and the place, associations that might be remembered for a lifetime. This was essential, Pfeiffer believes, because an information explosion was underway, necessitating new ways to store information in the mind. The old ways were no longer sufficient. These new spectacles utilizing dance and song, paintings on the contours of the cave walls, the tortuous descent—were all a deliberate design to prepare the audience to receive information essential for survival.

Orchestrating these events in the caves of Lascaux or Trois Frères or Altamira was a task of great responsibility. The individuals who organized the descent and painted on the walls were in a position of significant power. They determined what was to be transmitted to the rest of the population. Now the power to impart or withhold vital information is left to military strategists, generals in the Pentagon and the Kremlin, to our "Commander in Chief," who is followed everywhere by the black attaché case within which are the codes to activate nuclear weapons.

But power, of a different but equally essential kind, is claimed by the artists of our time. Lacking briefings by the government, they have access to a part of themselves which briefs them daily, nightly. As one surveys the fragile state of our planet—the nuclear stand-off; the polluted air, water, and food; the rush to consume; and the spiritual emptiness—one wonders where the information is that we need to work with this critical situation. As Carl Jung wrote,

Since nobody seems to know what to do, it might be worthwhile for each of us to ask himself whether by any chance his or her unconscious may know something that will help us. Certainly the conscious mind seems unable to do anything useful in this respect.[2]

Perhaps the caves where our ancestors' ceremonies took place

could be thought of metaphorically. Perhaps it would be worth-while to regard them as symbols for our own unconscious.

My own dream of approaching the cave came when I began my first solo image work, called "Last Earthwords for Awhile." In the dream I was exploring a city and I came to the opening of a cave. In front of the cave was a ticket-taker in his booth. I told him I wanted to go inside the cave because I knew it was one of the holy places. At first, he was reluctant to allow me to enter. He reminded me that I didn't know the language in use there, which was true. I finally convinced him to let me inside. And, once inside, though I couldn't understand the words of the prayer of the people inside, I felt the meaning of their ritual.

My understanding of the dream is that, although we may no longer understand the language of the cave, if we decide to make the journey nonetheless, the images within might speak to us in a language a part of ourselves still knows.

"Theatre of images," or "visual theatre" are some of the terms which have been applied to the work of experimental performance artists like Meredith Monk, Kei Takei, Ping Chong, Robert Wilson, the Mabou Mines troupe, Squat Theatre, Margaret Fisher, Winston Tong, Jock Reynolds and Suzanne Hellmuth, and others. What is a "theatre of images?" Where do the images come from? How do they evolve from the mind and body of the creator onto the live stage? What does it feel like for the performer to "inhabit" an image? How might the image affect the audience? Though the images used in this kind of performance theatre may be arrived at by a process of improvisation (in movement or verbal), the final outcome is as carefully controlled as the crucial ceremonies in the caves of our Upper Paleolithic ancestors.

In this chapter, I will mainly concentrate on the work of two artists of the theatre of images, Ping Chong and Meredith Monk. I have experienced their work both as a spectator and as a participant. The imagistic creations of Ping Chong and Meredith Monk illustrate the same kind of precision of effect and urgency of content as do the masterfully calculated beasts painted on the walls of Lascaux, Altamira, Trois Frères.

In addition, we will look at some of the routes of access—memory, dream, visualization—that we may use as lanterns to light the descent into the cave.

Ping Chong, Master of Ceremonies

A recent work by Ping Chong, "A Race," begins with a light coming up to highlight a red neon tube. This is the inanimate master of ceremonies. Then lights come up on an extremely tall thin man behind a podium. This is the living Master of Ceremonies. He is entirely red—hair, body, clothes. He announces

that the "Final Regional Testing of this Cycle" is about to begin. Then with a nod to the sound booth he mutters, "Let's get started."

Up in the sound booth is where one is likely to find Ping Chong during the performance of one of his visual theatre works. Although he performed earlier in the works of Meredith Monk and in some of his own pieces, he now strictly creates and directs his own pieces. He plays the role which poet and prophet Antonin Artaud espoused when he wrote of a theatre which "eliminates the author in favor of what we would call, in our Occidental theatrical jargon, the director: but a director who has become a manager of magic, a master of sacred ceremonies."[3] The "master of sacred ceremonies" is not a director in the sense of one who interprets a playwright's script. Instead he is the creator of his visions. Like Ping Chong, he can be found in the technician's booth, or, like Meredith Monk in "Turtle Dreams Cabaret" (discussed later), she can be found as our host on the stage.

The red animate M. C. in "A Race" echoes Chong's persona as the creator of spectacle. It's a matter of creating magic, to be sure, by carefully controlling what happens in the theatre as soon as the audience steps into the theatre space. Music is playing before a piece begins, keying the audience's mood without their necessarily being aware of it. From up in his booth, sensing the feeling in the room, Chong and his assistants dim the lights and the piece begins.

Ping Chong grew up in Manhattan's Chinatown. His parents had been in the Peking Opera in the thirties. In New York they ran a Chinese coffeeshop and in Chong's childhood they performed almost daily at the local moviehouse. He recalls what an adventure it was for him as a kid to travel uptown to Radio City, Rockefeller Plaza, to the world outside of Chinatown. His own experiences of cultural assimilation, of being in "two worlds" find expression in the figure of the Outsider in many of his works.

From early childhood he loved film and was impressed by the work of many anonymous Chinese filmmakers, as well as by that of Ozu, Mizoguchi, Ophuls, and Bresson, whom he studied in film school. Hitchcock, Chinese ghost tales, and comic books also had their effect. For whatever reason—perhaps it was his meeting with Meredith Monk in 1970, his money situation, or his family's tradition of theatre—Ping Chong turned to performance and not film as a career. A film consciousness pervades his live work, however, and he continues to use film as part of his total spectacle. And it is perhaps his background as a filmmaker which honed his ability to use light and shadow in his work to great effect.

One of Chong's early works is called "Fear and Loathing in

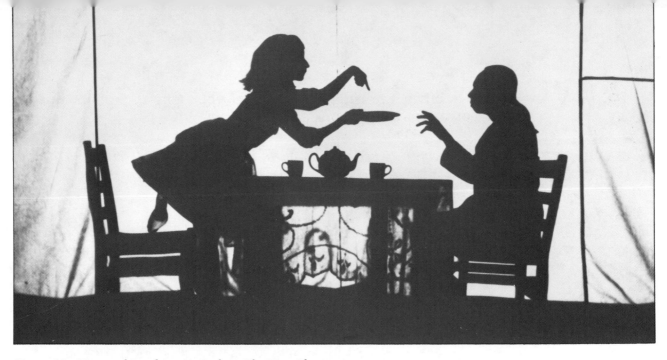

Figure 25. "Fear and Loathing in Gotham" by Ping Chong.

Gotham." It is based loosely on Fritz Lang's film "M" made in the l930's. In "M" a psychopathic child murderer has caused a panic in a German town. The anguish of the murderer, who is driven to kill, is conveyed through images given a catastrophic feel by subtle uses of shadow, alternating lights and darks. We see the child playing in front of a reward poster for the murderer. Suddenly a shadow appears across the poster and we hear a voice asking, "Do you want candy?" We know the voice is the murderer's and the child is his next victim. In Chong's version the killer is a lonely Chinese immigrant who listens to English language records, desperately mimicking the sounds he hears. He is not able to fit in to the culture around him. The murder scenes in "Fear and Loathing" all take place behind a scrim in silhouette. A nervous detective smokes and waits nearby. The Little Girl serves her would-be murderer tea in a silhouette of frighteningly clear detail.

"Darkness has always worked hand in hand with secrecy and revelation. It frames, accentuates, action. Performers moving out of the night or out of hiding places in caves into illuminated spaces command a degree of attention difficult to achieve in any other setting," writes John Pfeiffer of the cave ceremonies.[4] The theatre of images is a theatre of secret hearing and inner sights revealed to us in the language *of* the theatre. The Hopi Indians knew exactly the effect of appearing first to their audiences over the rise of a hill with the dawning sun behind them. People who have seen the Hopi Kachina dancers approach say it is an awesome sight. The Kachina dancers accentuate their entrance with the startling use of natural light. Like his German Expressionist mentor in "M," Chong uses darkness and shadow

to convey the atmosphere of the Other. Chong explains this use of strong contrasts:

The question the piece poses is what happens when you assimilate and the self becomes the other—giving up your cultural identity, that schizophrenia of being and not being.[5]

The Germans have a word *unheimlich* which, translated literally means, "not homey," and in actual use means "uncanny." It refers to things or experiences that bring about a discomforting fear, such as when something familiar evokes a deeply repressed image of the past, or when something familiar behaves strangely, like a cup of tea moving on its own across the table. In Freud's essay "The Uncanny" he defines this quality as "that class of the terrifying which leads back to something long known to us, once very familiar."[6] According to psychoanalysis, the feeling of the "uncanny"—split between the impression of something familiar and something else, perhaps from deep in the past, might lead to the sense of being split from oneself, seeing oneself as the Other, the Doppelgänger.

Lang, Murnau, and other German Expressionist filmmakers used lighting effects to convey the atmosphere of places where the familiar becomes dangerous and threatening. And they focused on inanimate objects in a way that gave the objects a significant role in the flow of events. Chong brings this filmic sense of lighting and the attention to objects to his pieces. They illuminate his preoccupation with the theme of the Outsider, or our separation from what he calls our primal selves.

The artist working with live images locates them first by listening to him- or herself and communicates/stages the images in a way that speaks to the viewer's unconscious. The word *spectator* has as its root the image of a watcher in a tower. It also has the same etymological root as the Latin word *speculum*, which means mirror. When I watch a work of visual theater I am that watcher in the tower and I see aspects of my psyche reflected as the images in the mirror of the performance.

You would not know what a Ping Chong piece looked or felt like if you were shown a script. Text is but one among the elements which Chong orchestrates. Others are light, image, movement, sound, time. His are the kind of plays Artaud describes as "made directly in terms of the stage." What in the French theatre is called the *mise en scène*, what we call staging, Artaud says is really itself the essence of the language of the stage.

Chong refers to this language as the "plasticity" of the theatre, and feels that commercial theatre since the nineteenth century has slighted this quality by becoming increasingly literary. In contrast he cites Chinese opera, where for instance, you have someone say,

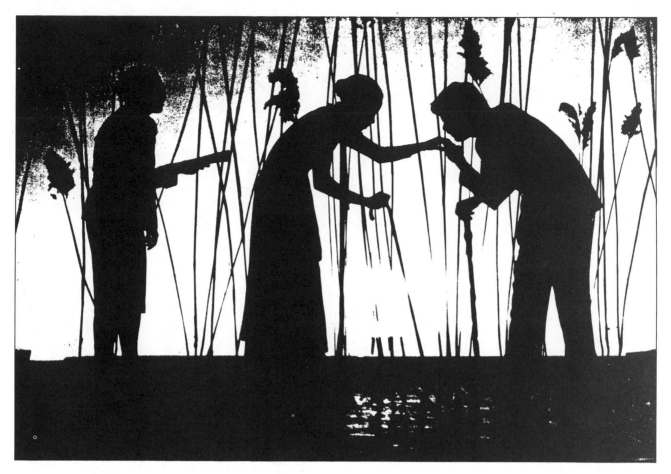

Figure 26. "Humboldt's Current" by Ping Chong.

"Now I'm going to leave." And then they have a whip that represents a horse and they start walking around a stage to music; and they walk a couple of circles and then a couple of years have passed and now they've returned. That kind of time is theatre time, and theatre in the last hundred years has gotten totally concrete. To put a real stage set on the stage that has a real setting fixes the event and doesn't allow it to have theatre time, time which is more abstract.

Chong's works, made in terms of the stage, are composed of images. It is a language of the theatre, which speaks directly to our souls.

Chong often selects very dark images which he feels speak to what he calls the "dark" side, "the part of ourselves that as civilized people we don't acknowledge, but which, if the lights went out for a moment in New York City, we might soon revert back to." He is fascinated by the rituals of animal life, by what constitutes primitive instincts, and by our own culture's rift with nature. The fact that we almost all eat meat but can no

longer face killing it ourselves, he feels, is emblematic of this rift. Chong feels it is essential that people today accept their whole selves, which means that "you have to face both the evil and the part you accept; or accepting the whole self means accepting all of yourself, the primal self and the civilized self."

In a work-in-progress "Nosferatu" (a title taken from another early German Expressionist film), Chong envisions mankind as a race of failed vampires with cancer as their final plague. The final image is planned to be a photographic slide of a Neanderthal woman and her child. They are grotesque, but they are also familiar. While the audience views the slide they hear a taped greeting to "sentient beings in space." It is simultaneously a reaching out towards other selves out there in the universe and a going back to primal time. The Neanderthal woman, Chong says, "represents what we don't think we are. We don't think we are animals. We think we're beyond that."

Though the piece is not yet made, Chong has already seen much of it in his mind's eye, an ability called eidetic imaging.[7] I asked if he knew what the vampires in the piece would look like:

One image I had was totally iconographic. It's a totally still image that won't last very long on the screen and you just see a vampire with very long claws and you don't see the place because it's in shadow. I'm going to totally stylize the lighting so the hands are lit, the shirt is caked in mud or something—his body's covered with mud and it looks like he's been buried alive or something . . . and he'll have his mouth open with sharp teeth inside and he'll be drooling, totally oozing, and on his lap, like a Pietà, will be a victim.

In the film section of "Nosferatu" we're looking into a barn. The barn is empty at the beginning. Then we notice objects that would never be in an ordinary barn.

There may be large growths that just sit there and breathe. It's a setting that's totally of another world, very visceral. It's more like I'm trying to put on stage the feeling of inside an organ in your body . . . All these unsettling images are just to knock the lid off people's rationalism, this feeling of we're in control. We know how to do this and we know how to do that, everything's under control. It doesn't take much for it to fall apart.

It is said that the inventor Nikola Tesla envisioned his theory of alternating currents after walking with a friend and reciting a few stanzas of Goethe. Tesla described the images which appeared in his mind as "clear and as solid as metal and stone." The theatre of the Foreseen works with images in this way. It is a

theatre of visualization and dream and attention to the inner eye. Part of the task of creation is to "see" the images yourself, the other task is to stage them so that others may see them. The visionary German filmmaker Werner Herzog has stated,

> If we do not find adequate images and an adequate language for our civilization with which to express them, we will die out like the dinosaurs. It's as simple as that.[8]

Sometimes it takes what James Hillman calls "the pathologized image," the obscene, or bloodied or grotesque image, on the stage or in our dreams to make us take notice that our psyche is being moved. In the final live section of Chong's "A.M./A.M. (The Articulated Man)" while a parade of soldiers march, position themselves, pass plastic bags with bodies in them, march out, march in again, a pregnant demon girl tottles out on the stage. She observes the soldiers. Her arms are tied behind her to a pole with a flashing light on the top. We notice she's pregnant. After the army finally exits, the lighting suddenly changes. The demon girl is in silhouette. She reaches under her dress and pulls out a long shiny knife and holds it, poises it above her full belly, then strikes, digs down and digs again. There is an audible shudder throughout the audience. What could be more frightful than to see a woman wound with her own hands the life inside of her. Now the lighting shifts again to an eerie blue, the music changes. Now the same woman is unraveling from what we thought was her pregnant belly yards and yards of black material as she steps backwards. The image is transformed just at the moment we are receiving its impact. It is too disturbing an image to forget, even if we want to. Hillman would say this image is "striking the soul to its imaginal depths so that it can gain some intelligence of itself."[9]

In the fantastic image theatre of the emigré Hungarian troupe Squat, now in residence in the Chelsea section of Manhattan, real street life and theatrical effect intermingle. The juxtaposition of these two realities implies the intention of the creators to confront, and to help us to confront, what is hidden, to help us to see from our inner eye. In "Pig/Child/Fire!" the audience sits inside the storefront theatre, facing the window beyond which is bustling 23rd Street. The window frames the already surreal events of a typical New York evening. Suddenly, a bearded man walks by the window, his arm on fire. I will never forget my shock, my bewilderment as to whether I should "do" anything or not, my horror at seeing the kind of brutality one may encounter daily on the street now framed in the time of the theatre. There is deep irony to this image which is literally burned very deeply onto my mind's eye. Fire embraces both destruction and regeneration. In the caves of our ancestors the

flame was a force of great beauty. Yet in his brief appearance before us, the Hungarian actor jolts us into contemplation of the cruelty of our century, where just forty years ago millions of innocents were systematically burned in the ovens of fascism. The arm on fire in Squat's work, and the demon woman menacing her unborn/unknown in "A.M./A.M." are both images which are hard to stomach, and difficult to forget. But if we are ever to absorb and learn from the lessons of the past, first we must contemplate their meanings in all their rawness.

The artist has access to the language of his or her unconscious by learning to "see" the images which appear in the theatre of the mind. The images may appear in the moments before sleep (hypnogogic images) and in sleeping dream, in the twilight of just waking, in daydream, reverie, memory. These are moments of receptivity, similar to what Bob Ernst referred to as "getting to neutral." One of Ping Chong's rehearsal warm-ups is a little ritual to help the performer "forget" the worries of that day: be a vessel in an old house that has been there forever, he suggests. Get up slowly and lie back down again. Keep the eyes closed. Get up slowly and lie back down again. Feel the back resonate against the floor. Be a vessel in an old house that has been there forever.

In classical and Renaissance times, interior images were treated with great care, treated, in fact, like precious vessels in an old house that had been there forever. The human memory was conceived of as an internal house or theatre, rather than an alphabetical filing system or like digital circuitry. One learned the layout of the house or theatre and then grouped ideas one wished to remember in specific places. A mental "walk" around the premises would reveal what you had left there, what you cared to remember. James Hillman has noted, "Whereas an encyclopedic filing system is a method by which concepts are written, available one page at a time, a theatre is a place where images are envisioned, available all at once."[10] Giulio Camillo, the great sixteenth century scholar, put the entire imagined universe into a small wooden room, his Renaissance memory theatre. Thirty feet of imagined space was the suggested distance between images in Albertus Magnus' memory system.

When we look at a miniature painting or a doll house, the knowledge of the whole precedes knowledge of the parts. When we can see into a room all at once, we see the whole. When I look at the maquette of Anne Frank's house in Amsterdam, I am moved more than when walking room by room through the actual house. Viewing the entire house from above, I am able to let my memory roam through these rooms, searching out the lives of those real people once secreted away, in hiding from the terrors of the world.

Figure 27. Notebook drawing by performer Melanie Hedlund.

All of the live images in Ping Chong's theatre/film piece "A.M./A.M." take place in a gleaming white room. It is a room where images are treated with great care. The room is first revealed after the scrim on which the opening film is shown is lowered. It seems as if the entire front wall of the theatre vanishes, a breathtaking moment, a window into a soul. The room holds images and our vision can take in the entire room, an enclosure within the enclosure of the theatre. In the unconscious of the spectator, of the creator, and of the performers who are fleshing out the images a resonance results.

The original inspiration for "A.M./A.M." came from a poem by the Argentine poet Borges called "The Golem." The Borges poem (as well as a classic German expressionist film) in turn was inspired by a Jewish Frankenstein myth which originated in sixteenth century Prague. The famous Rabbi Loew was said to have invented a man of clay (the golem) to help save the ghetto from destruction. Eventually the clay man runs amuck and the rabbi is forced to deactivate his creation by removing the magic tablet placed under the golem's tongue. To create a life—perhaps to make our world return to paradise—this temptation is an archetypal theme.

"A.M./A.M." is in three main sections. Imagine a visual sandwich with film on the outside and live action on the inside. The opening film is a view of what might be paradise, yet what is especially ironic about the film is that the view of paradise is actually the world as we know it. The film is set in Central Park and shot in negative black and white. It shows people being people: an old couple strolling arm in arm, children on a pony ride, young lovers. The inhabitants of this world move slowly, languorously. The world seems very soft around them. The way the wind blows the leaves on a tree make it glow with the intensity of Moses' bush. These images coupled with a haunting vocal score by Meredith Monk induces in me a profound nostalgia for the world as it *is*.

In his epic book *The Fate of the Earth*, Johnathan Schell imagines what the end of the world would be like in order to prevent its ending. If we can imagine the end, our appreciation of the present becomes highly charged. I feel this way when I watch this film. I felt it as an audience member and I felt it as a performer backstage on the other side of the screen. The images of people and animals in the park give way to a static image of a garden and a voice which recites Christ's message in the Garden of Gethsemane, where he was betrayed. The voice is that of the protagonist, the robot Ambi.

The live action consists of five short demon fables. Each fable is in some way a contest of the forces of Good and Evil. In the first a young boy is teased by demons at his birthday party,

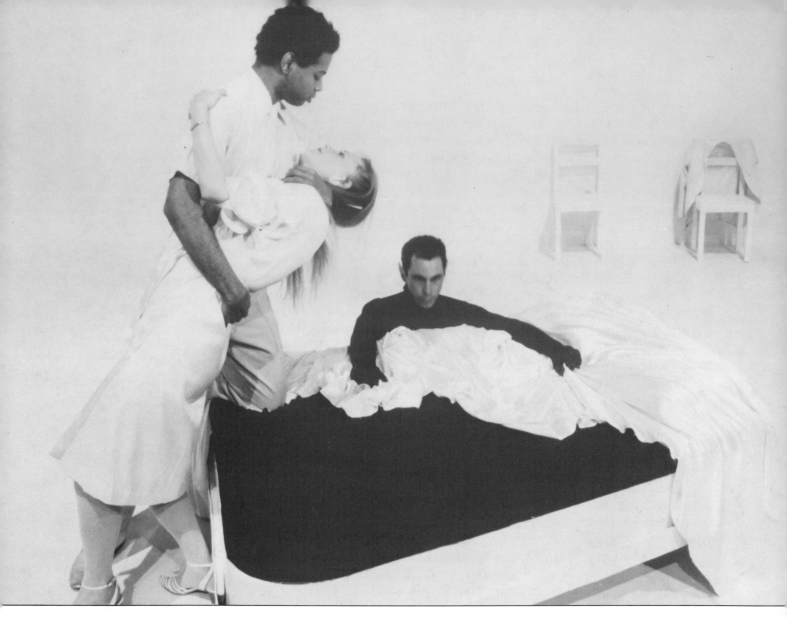

Figure 28. "A.M./A.M. (The Articulated Man)" by Ping Chong. Pictured in the second fable are Ishmael Houston-Jones and Louise Smith as the couple; Rob List as the demon.

then comforted and listened to by his father. In the second we see a beautiful blond woman about to lie down on her white satin bed after her indifferent lover has left her room. She unclasps her earring. For the moment her small gesture is all that is happening in the room. With a filmmaker's eye Chong zooms our attention to her hand—a close-up. From underneath her bed we see a demon emerge before she sees him. He vaults onto the bed on all fours, lithe as a cat and lethal as a poisonous spider. She sucks his teat as we hear the sound of water running.

In the third, while an old woman struggles for her life with an (by her) unseen assailant, a movement chorus of masked shadow figures slither from wall to floor. During the old woman's death struggle they flurry from one side of the room to the other, always keeping their backs to the audience and caus-

Figure 29. A drawing by performer Louise Smith showing her perspective of the demon emerging from under her bed in the second fable of Ping Chong's "A.M./A.M. (The Articulated Man)."

ing a din with their feet. The Shadows cannot see what is happening, they feel it. At the demon's shriek of victory, they cease moving.

The fourth fable begins with a severed hand lying isolated in a pool of light on the ground. Townspeople ogle it in curiosity and dismay. A sanitary worker, her mouth protected from contamination, strides purposefully on stage and sweeps it up in her dustpan. The effect is *unheimlich.* The fifth fable, in which the demon girl wounds herself, I have already described.

In the final film of "A.M./A.M." the Golem character is being taught in a laboratory about the "ways of the world." Since Ambi, the robot, is portrayed by an actor (Rob List) not a machine, we see in his responses our own questioning of our indoctrination into the workings of the world. He is shown how to eat correctly, he is shown the value of money. But taken out of their ordinary contexts, all the basics seem arbitrary. The innocent blank man reminds me of Werner Herzog's Kaspar Hauser. He is physically an adult, but as unformed as an infant.

The narrator of the film informs us that Ambi (A.M. # 364) escaped from the laboratory, killing a technician in his flight towards freedom. The film continues from the point of view of Ambi, the robot who has taken refuge in the room of a Howard

Johnson's motor lodge. Ambi tells us, "Through the windows of the television set all the ways of the world are revealed to me. I can see about the ocean, about the sky, about sporting, about war and love liking . . ." We see him sprawled on his bed, awaiting his inevitable "termination." One wonders what the Golem of Prague felt like with the rabbi on his trail. Ambi watches an old movie on television. There's an image of a grotesquely stereotyped mariachi band playing wildly.

At times, Chong has referred to his theatre of images as *bricolage* as used in Lévi-Strauss' famous essay "The Science of the Concrete." Lévi-Strauss writes of the "bricoleur" who makes do with "whatever is at hand," by way of materials.[11] To Chong the term *bricolage* means creating "a new world created out of the material from an old world, resulting in luminosity." Chong uses "whatever is at hand" (like the old movie that happened to be on television when he shot his film), in conjunction with what he has created (the idea and characterization of this artificial man) to construct a message about our own complexity. The "new man" contemplates a relic of the "old world"; the juxtaposition creates new meaning.

A resonant image has many layers of meaning. It can be paradoxically simple yet complex, obvious yet obscure, rational in form yet mystical in meaning. A resonant image may be particular and universal at the same time. Chong's work can't always be made understandable on a conscious level, because the work speaks to us in the language of the unconscious. He has referred to the society depicted in "A.M./A.M." as "post-verbal."

Our culture lives by the word. Through our ability to write, to word-process, we have gained tremendously in our capacity to store information. But in our own inner beings, we may have lost some of our ability to perceive with a harmonic orchestration of all our senses as our ancestors perhaps did in the ceremonies of the cave. The sensory mechanics of reading plus the value accorded to the eye at the expense of all other senses reduces our perception of images to one sense or other. To fully exercise our memory we need to be able to "relive" our experiences with all our senses; and that includes the heart.

Chong's work speaks to what has been lost to consciousness but still tries to affect us on the unconscious level. He creates ceremonies composed of images that unsettle us with their darkness, their beauty, their aura of paradox. And though he meditates on the dark aspects of our being, there are also images of hope, or suggestions of it, in Chong's work. At the end of "A.M./A.M." we are told that perhaps Ambi escaped again, into the great metropolis. Perhaps the outsider continues to live, continues to question, as a spiritual being. The playwright Ionesco wrote in his *Memoirs:*

There was a time long ago, when the world seemed to man
to be so charged with meanings that he didn't have time to
ask himself questions, the manifestation was so spectacu-
lar. The whole world was like a theatre in which the ele-
ments . . . played an incomprehensible role that man tried
to understand, tried to explain to himself.[12]

Artists like Ping Chong now help us to understand that theatre
which the whole world is like.

Memory Strata: Meredith Monk's "Quarry"

*My muscles were talking in tongues, my cells thinking, my skin remember-
ing about something it knew a long time ago before I, my self, had a location
to be born from and into.*
IRENE MCKINNEY, *The Girl with the Stone in her Lap*

We enter the large performance space and choose our seats on
either side of the performance area. We hear a soft lullaby on the
radio which is in the center of the room on a small table. Near it
on the floor is spread a patchwork quilt. A child sleeps under it.
The lights darken. A voice: "I don't feel well. I don't feel well. I
don't feel well. It's my eyes it's my eyes it's my eyes. It's my skin
it's my skin it's my skin. It's my ears it's my ears it's my ears." A
mother voice responds, "What's the matter?" Answer: "It's my
hands it's my hands it's my hands." As the lights rise gradually,
the mother voice is revealed to belong to a dark-haired woman
in thirties attire. She asks the child whose distresses we heard:

> Dear, dear . . . dear—Do you remember when we all went
> to the shore? There was a storm outside and you went up
> to the attic to play? Then we went outside to see what had
> washed up? I was reminded of this because I heard from
> your uncle today. He sends his love to you. You could send
> him a drawing, or a postcard . . .
> The child's complaints dissolve into a series of pants,
> breath sounds . . .[13]

World War II is a nightmare Americans of my generation did not
live through; but its legacy we have felt. As reporter Jane Kramer
wrote, "The anguish of memory is that it dies with the people
who remember."[14] That it dies may be true in a literal sense, but
as a culture we are served by artists like Meredith Monk and
others who activate memory by meeting history head-on with

their own anguish, and who create their own memory and ours through an act of imagining what happened before. By researching documents of the time and by reaching into her own unconscious for dreams and images, she creates a gestalt of that dark time in the past which is beginning to feel ominously close again. Indeed, Monk has said she made "Quarry" because she felt the forces she evokes were starting to build in the world again.

The word *quarry* itself, like the images of Monk's live epic has multiple meanings. Quarry can be the prey, the hunted, like the characters we see victimized in the play. A quarry is also a place where stone is excavated, where one digs down through the strata to the bedrock. The bed is the foundation, the support, the arena for dream and imagination and nightmare.

Figure 30. Meredith Monk as the Child in "Quarry."

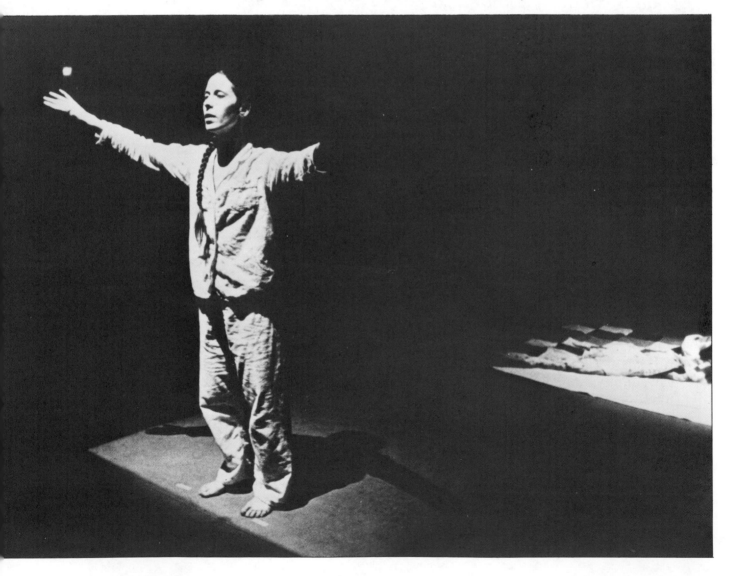

How well I remember the bed of my major childhood nightmare. I was on the edge of sleep alone in a hotel room in New York on a family vacation. My parents had gone to theatre and left me, nine years old, for a few hours with my baby brother. Somehow all at once it just came to me that some time the darkness now surrounding me alone in this room would be forever, and there would be just me, just nothing. Whatever that first consciousness and terror of darkness was I can still feel. I can recall the whole disoriented sensation of that room and my intense desire for my parents to return. The child's parents in "Quarry" are either absent or distant. Her mother (played by Lanny Harrison) is preoccupied with her career as a radio singer. The father is away at war. The child is alone, overly sensitive to sounds because of her illness. The sounds we hear in "Quarry," as important as the images we witness unfolding, are filtered triply— through the medium of the sick child, the medium of the radio, the medium of the creator's choices. The child's only friend, her trusted maid (played by Coco Pekelis) changes the stations on the radio for her. We hear an aural pastiche of the world's troubled sounds, we're comforted by a lullaby, assaulted by the stridency of a martial rally.

Monk points out here that the impressions that come from receiving information aurally is different from information we gather visually. The radio was one of Hitler's main media of control. When the *Volksempfanger*, Nazi Germany's official radio set, went into mass production, Hitler gave orders to have them all marked "VE 301" to commemorate the date of his seizure of power. "Just as every German home was controlled and manipulated by the false reports given out over the Volksempfanger, the same radio required only minor alterations before one could listen to the enemy—at the risk of the death penalty."[15]

The world which begins to unfold around the bed of the child (played by Monk herself) in "Quarry" is a nightmare world, a memory theatre in which a world Monk never herself experienced is presented in fully realized, deeply-felt, multi-layered images. In each of the four corners of the playing space are characters who inhabit the far corners of the geography of madness. Actions occur simultaneously in each of the corners and these incidents each affect the whole picture we are watching, hearing, feeling. The child tossing and turning in her bed is a metaphor for the dis-ease of the era and a mental screen on which this dis-ease is projected.

Meredith Monk was born in Lima, Peru, and grew up in Connecticut. Her mother Audrey was a radio singer, her grandfather a cantor in Czarist Russia, and Monk was singing before she could speak. To correct a coordination problem her mother sent her to study Dalcroze eurthymics. At Sarah Lawrence College she pursued music, dance, and theatre. "Quarry" makes use of solo as well as choral music that Monk composed, a film, de-

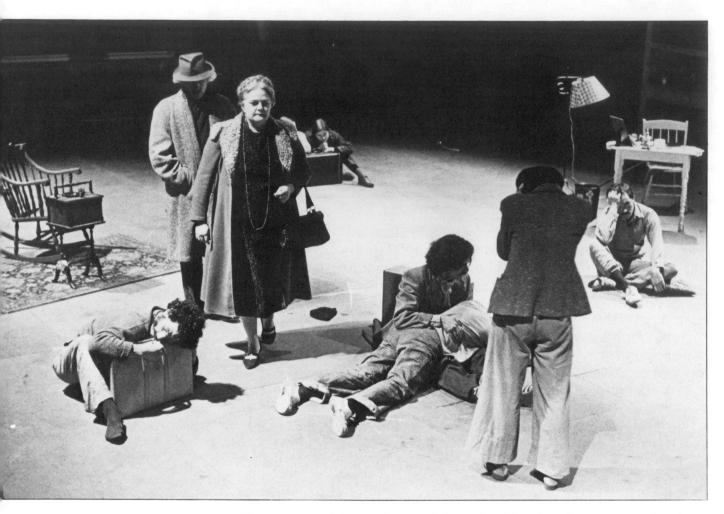

Figure 31. From "Quarry" by Meredith Monk. Pablo Vela and Lee Nagrin as the White-Haired Couple.

tailed gesture, and group movement. It was conceived of in three sections, each "washed away" by a large chorus that moves fluidly across the whole space, linked together in a vocal canon.

In the four corners we see: in one corner four working girls in what might be London, dining on tinned food and sharing rations, lining up on a gestural assembly line; in another corner a grey-haired couple, seemingly highly cultured and maybe the grandparents of the child. The grey-haired man is preoccupied with his partner's lack of response to his writing on Cervantes. He does not see what is coming. In the third corner a biblical couple sits crosslegged on a straw mat. The bearded man calligraphs a scroll and the handsome dark-skinned woman winnows her basket of grain with precise movements of her slim wrists. The mother is the fourth station. She practices her dance routines, primps in her mirror, admires the photograph of her absent husband.

These characters all assume other roles, transform within

the piece from victim to victimizer, showing the fluidity of fortunes. We see the mother as a radio singer silhouetted in blue up in a soundbooth above the action. Her movements are harsh, overstated. The gleam of sequins from her costume is garish. It is the singer as Nightmare. A man photographs the biblical couple, an act which causes them to roll up their mats and lurch away into the unknown. They stop, turn around, then lurch off again, long robes billowing behind. Later they reappear as ghetto dwellers, awaiting deportation. The mother, the working girls, the grandfather, even the biblical couple all appear in a Parade of Dictators. Darkness exists in all of us, these images seem to be saying. Only the child and the maid remain constant.

In times of war children learn to operate alone without the usual protection society customarily offers—a home, parents, food. All the basics are upset. Just the other day it was announced in the papers that an as-yet undiscovered Grimm's fairytale had been found and would be published. Though I have not yet read it I have heard the story is about a mother taking her child to the forest to abandon her because there is a war going on and the child will be safer there. In "Quarry" nothing is safe, nothing and everything is familiar. The exhortation of the dictator (a figure in the play) to his followers is spewed out in a tonal language of no words and yet exact, terrifying meaning.

Monk does not set out to create a realistic portrait of World War II. Instead she explores nightmare metaphorically and archetypically. The dictator in "Quarry" (played by Ping Chong) does not resemble Hitler (he is an oriental man in a suit and tie) and yet his presence on the set immediately presages evil. She does not show us newsreels of concentration camps, but has herself confronted this material and from that confrontation has found the image that comments in essence on that horror.

In making "Quarry" Monk was

. . . starting from reality. And that was what I was most scared about in this piece. I wrote a note to myself, "I always work from imagination, and I don't know how to imagine from this kind of material." So that was a challenge. I read The Rise and Fall of the Third Reich from cover to cover and looked at a lot of photographs in the war museum in the Marais area of Paris and talked to a man who'd come back from Buchenwald, Henri Michel. It was a discipline, to force myself to overcome my squeamishness. I feel I have a certain kind of mental courage. If I was going to do that kind of work, I had to confront those photographs straight on. And I was really in a great deal of sorrow, it was very emotional, what can I say. It's a level of sorrow that's beyond any one person . . . there's almost no words for it. It's not that different from seeing pictures of Vietnam except that I'm Jewish and I know my family would probably have been taken away.[16]

After the dictator, lit from below by a fluorescent light, delivers his straight-to-the-gut harangue, the lights go dark and a black-and-white film is projected on the wall behind him. First we see rocks which we don't know are boulders until we see people climb out from between the cracks in them. At first they seem like insects they are so tiny. The film plays havoc with our sense of scale. The tiny people clamber over and under the rocks. Then the scene cuts to a view down onto blackest water at what must be the bottom of the quarry. There appear to be sticks floating on the surface of the water. But as the camera pulls in close we see they are logs and that people are floating among them on their backs. Their eyes are closed, their faces serene. It is an image into which Monk has compressed many meanings.

While we watch the film we begin to be aware that the live space is filling up with people. They crawl out in the half light and take their places. When the film ends lights come up and all hell breaks loose. Hey! Hey! Hey! Grey-suited, lederhosen-wearing youths are enthusiastically pumping their way through rigorous martial arts movements in repeating patterns. A snaking web of singers weaves through them, a folk dance turned nightmare. The rallyers continue to shout until their voices sound exhausted.

The working girls, now dressed in trench coats and fedora hats appear among the crowd pulling a wagon laden with suitcases. They hand each person or cluster of people a valise. Bit by bit the strident sounds cease, the atmosphere in the room changes as the characters transform and the image is replaced. The rallyers assume tableaux of people waiting, people in a big room filled with despair. The child lies tossing and turning in the center of all the violent sound and movement. Monk comments:

"It's not really built on Nuremberg because I actually never saw it. But just as a phenomenon of people doing this very gutteral sound with this very harsh, athletic movement. A lot of things are going on simultaneously and it is very frightening and at the same time very seductive. So I was trying to see what that phenomenon was, to examine it. And I realized how easy it is to create it—although I feel the Germans were brilliant in theater. But it's not very hard to create that phenomenon. Just a little rhythm and visual excitement. The child is swept away by this thing. I felt sometimes like an ocean was going over me."[17]

Every element in "Quarry" and its relationship to the other elements has been calculated. The ring of three bicycle bells as riders drift through the space evoking the end of a day on a Berlin street in 1939 perhaps—the peacefulness that can coexist with chaos. After the rally, as we gaze out on the room of dazed re-

fugees sitting next to what is left of their possessions, the quietness is assaulting. One of the suitcases has been dropped next to the old couple who are now wearing their coats. Before they exit, the wife unclasps her watch, loosens her necklace, takes off her earrings. They drop to the floor with an unnerving clatter.

At times in "Quarry" it seems there is too much to see. Where shall we look? Monk is aware of these conflicts and has carefully calibrated the kinds and timing of images, sounds, their transitions. "Quarry" is a spectacle about spectacle, with Monk dictating the intricacies of the composition. While our minds are still full of the images that have appeared with such forcefulness and been washed away by the chorus of white-clad singer/dancers, the final section of "Quarry" takes place in dim light. It is made for our ears. The entire cast fills the periphery of the room and begins an audible march in a giant circle. As the sound of their clumping shoes anchor the rhythm, they sing a circular requiem over which Monk's soprano rises and falls from her position as the hub of the moving wheel. This requiem is similar to the song she sings at the end of "Turtle Dreams Cabaret." "Turtle Dreams Cabaret" is about the dangers of the future, whereas "Quarry" comments on the past. Her voice here is a warning, a mourning; it rises and falls with feeling—anger, sorrow, incomprehension—at what has happened and at what we may still prevent from happening.

If it is indeed the anguish of memory that it dies with those who remember, then that anguish is at least honored by Monk's efforts to create images that go beyond historical specificity to show through a child's eyes, ears, voice, mind, the feeling of history's shadow.

Access (Remembering the Water around the Knees)

As an artist working with live images, one is constantly on the lookout for new paths of access to the images of the caves, and deeply respectful of the ones one has already discovered. The paths are crosscut, like the neurons of the brain or the vessels that supply our blood.

Visualization, "traveling into the mind through images," is not a practice nurtured by the traditional schooling we receive in our culture, nor is it a skill that is highly regarded. Perhaps it is because people have lost sight of the value of memory, of the act of seeing, of the messages of dreams. The great writer, Aldous Huxley, found his initial route of access through the ingestion of mescaline. His was an abrupt entry into "seeing more than what meets the eye":

Confronted by a chair which looked like the Last Judgment—or, to be more accurate, by a Last Judgment which, after a long time and with considerable difficulty, I recognized as a chair—I found myself all at once on the brink of panic. This, I suddenly felt, was going too far. Too far, even though the going was into intenser beauty, deeper significance.[18]

Learning to be receptive means recognizing one's ability to see both the inner and the outer worlds. The Bushmen of southern Africa refer to their receptivity as "tapping in," a way of being quiet so as to hear "that which is thinking through us." Laurens van der Post has a wonderful description of a Bushman describing this ability to him. The tribesman likens it to seeing van der Post using the telegraph:

> "Wire?" I exclaimed.
> "Yes. A wire, Master. I have seen my own master go many times to the D.C. at Gemsbok Pan and get him to send a wire to the buyers telling them when he is going to trek out to them with his cattle. We Bushman have a wire here," he tapped his chest, "that brings us news."[19]

When Meredith Monk created her opera "Vessel," she used the role of Joan of Arc as a metaphor for the artist who listens to her own voices. Such listening is a challenging thing to do in our culture. Monk wrote of Joan as

the receiver of secret information. The belief in the receiving and then the acting on it. The archetypal sybil. If you are lucky, it comes to you. If you force it, you become empty.[20]

If we learn to "tap in" then we can hear the thinking through, we can remember the dream, we might see the vision. Many artists learn to cultivate those moments just upon waking or just before sleep when images drift by with special intensity. Sometimes they rouse themselves to catch a phrase or to draw a sketch as the dream fades and new light comes in.

The trusting of our own voices, our intuition, is a prerequisite for making performances, perhaps for making any art. Choreographer Wendy Perron writes:

> A general reason for making dances is the knowledge, or intuition, of how important intuition is. Dances are built on intuition: "Oh I think this goes here. Oh, how about doing this after that." There is no rational way to explain these choices . . . I want very much to trust my own intui-

tions and follow them and not let rational thought get in their way. Making dances is an ideal exercise for this.[21]

Besides hearing the inner voices, another route of access to the cave of the unconscious is simply learning to see anew or to really *see* what is around us all the time. Training one's mind to perceive images of external reality is also a way to cultivate the reception of inner images. The epiphanies, the unfamiliar and the wondrous, coexist with the familiarity of what we see everyday. We can experience this if we just pay attention.

I look out the window of my studio and see across the street a blind man and a child walking down the sidewalk. The blindman has a cane and, tapping his way along, seems to think he is the leader or protector of the child, who is sighted. The child seems to think *he* is leading the man. It is a poignant and ambiguous image. I look out the window of my flat in the Mission District of San Francisco. A woman is kneeling on the sidewalk in front of a statue built into a niche of the Mission wall. She has set out flowers, she is intent, she wears white shoes. A woman kneeling on the sidewalk facing the wall is not a familiar sight for me. Unfamiliar images, when we are open to them, attract out attention and suggest theatrical "translations" that catch their specific quality. And the totally familiar—the ring of the telephone, red brakelights illuminating two lovers in a fogged up Chevy from behind—take on new wonder when we pay attention to them or when the artist frames them within the context of a performance. We may have to subject ourselves to experiencing the *unheimlicht*, the "uncanny," but we make endless discoveries doing it.

It may not be the image across the street that catches our attention; it may be something from yesterday's newspaper. Ping Chong recalls one story in the *New York Times* that touched off parts of his visual theatre piece "Nuit Blanche." The report recounts how Pol Pot's soldiers in Cambodia killed two and wounded eighty-five of their own soldiers after they began to fire tracer bullets into the nighttime sky. They were aiming for a dragonlike creature that lives in the moon. Bricoleur that he is, Chong finds sparks in leftovers, preexisting materials from the culture around him.

As I pointed out earlier, memory is embedded in our very act of seeing and movement seems to be a particularly potent force in unlocking memory's vivid detail. Trisha Brown has an exercise where she asks students to remember the layout of their grandmother's house and then create a movement path within that house of memory. Doing the exercise I found my movement infused with new interest, new meaning, as I sidled around the large bed where my grandparents slept, crawled on my belly

under the dining room table where my grandfather played interminable late-night casino games. Brown has commented:

Sometimes my dancing is metaphoric, using memory as a resource. Yet what may have been traumatic in, say 1941 makes hardly a ripple today when it is put through the mind and out the body. Still, memory gives a phrase a reality for me and modulates its quality and texture. . . . However, the image, the memory, must occur in performance at precisely the same moment as the action derived from it. Without thinking, there are just physical feats . . .[22]

Memory is an activation of the mind's eye. In the Memory Theatres of classical times, we stroll through rooms of the imagination, coming upon the objects of value we had deliberately placed there. Our memories are sometimes as vivid as the images of our dreams, sometimes more so. I can still feel the fog of night walks in Edinburgh, see my grandfather carried out the door on a stretcher, breathe the dust of a road in the Cretan hills, and remember the sighting of whales from cliffs in Cornwall and Oregon. Sometimes, as French novelist Marguerite Yourcenar writes,

> These fragments of real fact have the magical intensity of vision glimpsed in my dreams; and on the other hand, certain visions from my dreams have all the weight of lived events . . . Only my reason prevents me from mixing up the two orders of phenomena, but this same reason counsels me to perhaps reconcile them, to put them all together on a plane which is certainly one of unique reality.[23]

Performance offers one of those planes of "unique reality" where memory and dreams, past and present, the everyday and the once-in-a-lifetime are reconciled and woven together upon a single loom of time.

When the god Asclepius appeared to pilgrims at Epidaurus in a dream the cure had begun. When Asclepius' staff with a serpent coiled upon it appeared in my dream transfigured into a wounded woman, my bones began to mend.

There has been an awakened interest in the use of imagery in healing, and it is not surprising that dancers and performers are involved at the forefront of that research. Often the research is conducted within their own bodies. Irene Dowd is a dancer and movement therapist who uses visualization of imagery of the body's inner realms to develop openness of a kind that can help to *avoid* injury or to promote the healing of an injury that has occurred. Here is an example of imagery she uses in working on the upper extremities:

I start to think of a light source being generated at the center of my chest. This ball of light sends out its beams to my shoulder joints . . . I imagine my joints as gateways which I can open to the light. As the beam of light from my chest passes through the now open gateway at my shoulder joints, it enlarges the space within the joint in the process of shining through it.[24]

It's not surprising either, that many performers of visual theatre and image performance/dance have explored the imaging of their own anatomy. Dancers and creators of performance are once again like citizens of primal cultures, cultivating the ability to *see with the whole body. Our whole body remembers. Our whole self dreams.*

Not all dreams are healing dreams or contain signs of a cure. We can learn to distinguish between the big dreams and the little dreams, the significant visions and the banal ones. Working with the material of the dreamworld in performance, one accepts the challenge to be responsible to the depth of the dream and its images.

Other cultures than ours, particularly the ones that thrived in our country before ours, had techniques and rituals for harvesting the information of dreams, and they had a vocabulary for talking about them. For instance, Sarah Greys, a Swampy Cree elder who has lived in northern Manitoba for over ninety years, has stated in an interview:

When I was younger I did not feel comfortable listening to people's dreams. I could not find the right way to hold myself, standing, or with my hands on my face. I grew worry about this. Because of this I went to the marshes, and it was then I believe I went into . . . into my heron. I was my heron then, probably for some years, and I have no human things I remember from that time. But I can tell you that when I came out of that, when I walked from my heron into my own walking again, I felt much better about listening to dreams. I stood my own walking again. I could remember the water around my legs, which was good for dream-listening. From then on I was known as a person you could talk dreams with.[25]

Though my own ancestral culture has within its literature a wealth of recorded dreams and visions (Daniel's, Ezekiel's, Joseph's interpretation of Pharoah's dream), it was not until I began to study performance that I became a "person you could talk dreams with." It was in Meredith Monk's classes at Naropa Institute that I began to keep a dream journal with regularity, and where I learned physical dream-remembering techniques. In one, for example, you find a gesture or a posture from a dream and then intensify it until the tension brings the dream back to

Oct 5th ish

[Dream]

teaching in an old beautiful
miniature theatre —
upstairs behind the proscenium
+ there it was filled with
ocean or the ocean backed
the theatre + me + the kids
cut out black frames from
paper + looked thru the
frames ▭ at the sea +
at people playing in the dis-
tance —
we went downstairs +
I said "when the doors
upstairs open, the water
will come rushing in" —
but something didn't work +
the water didn't come in

on either sides, down the
stairs"

Figure 32. Journal entry, Lanny Harrison.

the body. How does a dream character occupy space? What does dream dialogue, spoken out loud, sound like? How does it make you feel?

Another dream-sharing technique is the Dream Circle. The dreamer sits in the middle of a circle of the assembled. In his or her hands are rattles or noise makers of some kind. She begins to recite her dream, eyes closed, clacking the rattles whenever she wishes to emphasize a word, an image. The others walk around the dreamer in a circle. They attempt to feel the dreamer's vision in their own bodies. They receive the dream from the dreamer, take it on themselves. Among Native Americans, from whom we borrow this ritual, it was used for its curative value (to dissipate the power a vision may have held on the dreamer). For performers it is an important technique for entering the world of dream and vision. For if one is to actualize an image from a dream, integrate dream imagery into a performance, and if the performance is to be realized in collaboration with others, then they too must feel the weight and texture of the dream. The dreamer repeats the dream over and over and the repetition of the words and images helps the participants absorb the meaning of them, empathize with them. In the rehearsal space, a ritual is created which takes the dream out of the totally personal, away from the purely intellectual, and allows it to permeate the body.

When Susan Banyas and I began to collaborate on a performance dealing with two women's friendship and its significance in a troubled world ("Trails to Treasures (it could be you)"), I dreamed we were dancing in the full moon in a beet field in Roumania. We leapt from beet hollow to beet hollow in the red rich dirt. Finally we were interrupted by men carrying heavy stones. In the dream, I asked Susan why we were dancing in the beet field. She replied it was because she was "half-Roumanian, and half midwife."

The beet is a root crop. Its etymology connects it to the word for *bed*, that which is under the ground, the foundation, the place for memory. We are, through performance, reaching down to the bedrock of memory through the root systems of dream, whose juices course through nerve, muscle, and skin.

It is in the studio that we try to bring the dreamwork to the light of day where we live. Susan and I created beet dances, we spoke and danced as the beets, as the heavy stones. We became midwives to the birth of the essence of the dream which we would use in the staged work. Sometimes it may be the opening night of performance when the information gleaned from the presence of witnesses (the audience) brings the full realization of the dream image into one's body/mind. It is a very powerful feeling, to form this bridge between night and day. It may be in the quality of the movement, the intensity and hue of the lighting, the manner of the character's speech, the relationship of these elements to each other, the positioning of objects and people with a peculiarity that has it own logic as the dream does—any or all of this may allow the dream image to radiate its essence. Each dreamer dreams with a chemistry, as Yourcenar says, "that is his alone." But by sharing my dreams with my collaborators and hearing theirs, we create a pool of dream images from which we may all draw in common. Hopefully the result is insight into the world we all share and whose problems we collectively face. To create performance of the inner eye, of the Foreseen, the performer brings back from the dreamworld visions of variously colored intensity, helps his or her co-creators to feel the weight of these visions within their own beings. Then together they enter that vision to communicate it to the audience. The performers are "available" to the audience, and their performance is the mirror in which the audience may read its own meaning in the image.

I've heard my Russian grandmother tell her tale of how she left the Ukraine to journey to America, by cart and horse through Poland, so many times that I correct her if she leaves out any details. When I began to make "Last Earthwords for Awhile," I dreamed I saw my grandmother with a suitcase and a bouquet of beets traveling through a terrible new world. The next day, I took

a battered suitcase filled with straw to the studio and began to spin, counterbalancing my weight with that of the heavy suitcase. The latches gave way and the straw cascaded out as I slipped, tumbled and rolled on and with the suitcase. I began to run in place amidst the straw and felt its sharpness barb my legs. Finally, exhausted, I made myself a bed of straw and curled up on it to rest. I felt like any refugee anywhere—fleeing, hoarding, hiding. Sarah Greys, the Swampy Cree elder, found she became good at "dream listening" after her dream of being the heron, because she could always remember the feeling of the water around her legs. Whenever I perform "Last Earthwords" I can image the initial dream, not only because my grandmother told me those tales so many times, but also because I can remember the feel of the straw around my knees.

four

THE UNEXPECTED

Providere, *to see beforehand;* improviso, *to not see before.*

RISK. L, riscus, *Sp.* risco: *a steep abrupt rock; Ital.* risico: *hazard;* risicare: *to navigate among cliffs. One ventures into danger, into vulnerability, and possibly, also into riches, good fortune, self-knowledge (Arabic,* rizq*).*

Improvisation is an art of the present. In music, improvisation has long been acknowledged as a valuable form—for decades in our culture and for millennia in most parts of the world. As jazz musician John Coltrane's phrases seem to *be* as well as to come from, the man, so the writing of Gertrude Stein shows that the most important thing to know is that there is no separation between thinking and feeling and writing. It is all done at the same time. In painting I think of Jackson Pollack and his abstract expressionist colleagues who posited a simultaneity between thought and the gesture of applying paint to canvas. The poet Charles Olson proclaimed:

"One perception must immediately and directly lead to a further perception . . . Get on with it, keep moving, keep in, speed, the nerves, their speed, the perceptions, theirs, the acts, the split second acts, the whole business, keep it moving as fast as you can, citizen."[1]

In all of these media, improvisation is a process by which the evolving nature of the world around and within the artist is revealed by their actions. In dance and in theatre and in the area of overlap between the two called performance, improvisation is a form of immediacy, a discipline of spontaneity and awareness.

One invests each movement, each moment with the utter attention of the mind. The content of the work is in the content of the present.

The "theatre of images" which we looked at in the last chapter may be generated by a process which includes improvisation. In this chapter we look at improvisation as a process which is a performance art form in itself. If you saw some of the work by artists who are virtuosi of improvisation, you might not realize that what they are doing is "made up on the spot." Their assurance comes with practice, their spontaneity comes from daily discipline.

What does improvisation as a form feel like for the performer? What might we, as audience members, learn from watching it? What are some of the elements common to the many different directions of improvisatory work of artists like Barbara Dilley, Dana Reitz, Ruth Zaporah, Nancy Stark Smith, Deborah Slater, and others? What is the lineage of improvisation as an art form in our recent cultural history? These are some of the questions this chapter will address, beginning with the last one first.

My first heady experiences of improvisation are linked to the sense of openness and possibility I associate with the late sixties and early seventies. In improvisation classes taught by the Alwin Nikolais troupe, the elements of time, space, and shape were isolated and explored as the elements of dance composition. Through these first sessions of improvisation I became aware that it was possible to communicate with others in a whole new nonverbal language. This discovery was intoxicating.

Alwin Nikolais had been a student of the great American dancer Hanya Holm, who had herself studied with Mary Wigman in Germany. Wigman, a modern dance pioneer, was one of many disciples of Rudolph Laban (Irmgard Bartenieff, whom I mentioned in Chapter One, was another) who put his movement principles into practice. Wigman transmitted to her own students an intense kinesthetic awareness. In one film I have seen of her teaching, she spends the entire session working with the movement of the hands. "Tenderly vibrate your fingers in the air," she tells her students. Exploring movement's internal initiation was the goal of exercises like these, as contrasted with those imposed from the outside like the codified system of movements a ballet dancer learns. The base of Alwin Nikolais' dance technique was the understanding of motion pioneered by Laban and Wigman, which came to him via his study with Hanya Holm and his study of Gestalt psychology, which also originated in Germany.

Al Wunder, a student of Nikolais, brought this work to the Bay Area of California in the early seventies, where I first en-

countered it. The Bay Area was ripe for aesthetic and spiritual/
emotional experimentation. It had a climate geared towards per-
sonal and social change. The "human potential movement" was
growing there, and improvisation was part of its ethos: "experi-
ence your self."[2]

America in the late sixties and early seventies was in a
period of intense questioning, especially for the young. Social
and aesthetic forms, political process, life styles were all chal-
lenged, tried, recombined. For many who were experimenting,
dance improvisation provided a model for a new way of behav-
ing, "the fluid life" as critic Elizabeth Kendall called it.[3]

In the Bay Area a number of performers who were abandon-
ing the more structured forms of choreography and scripted
theatre and turning to improvisation loosely grouped them-
selves under the collective rubric MOTION. This group included
at one time or another Ruth Zaporah, Jani Novak, Al Wunder,
Terry Sendgraff, Nina Wise, Joya Cory, Ken Jenkins, Suzanne
Hellmuth, and Deborah Slater, among others. Zaporah arrived
in San Francisco disillusioned with what she saw as the limita-
tions of modern dance at that time. "You didn't see people, you
just saw bodies."[4] So people and their feelings became the focus
of improvisatory performances at that moment with a ven-
geance. Zaporah laughs when she recalls the chaos and self-in-
dulgence of many of her early improvisatory performances. She
herself was fascinated with what improvisation offered as an
experiential form in classes, but she was frequently frustrated
by "all the waiting around for something to happen" in per-
formances. It is perhaps this early legacy left by improvisational
performances over a decade ago that make it a form still viewed
with some suspicion by the current-day dance world. The exces-
ses of early experimentation were necessary, but they were
draining for audiences.

On the East Coast, The Grand Union, a collective of per-
formers who had worked with Merce Cunningham and Yvonne
Rainer, were the first improvisational performance group. The
performers arrived for the performance without previous agree-
ment of theme, format, acceptable behavior. What they already
shared was a common movement background and years of per-
forming together in various contexts. Grand Union has been de-
scribed as a soap opera, as *danse verité* where everything shows,
"the tiredness shows, and the confusion." But the honesty with
which they pulled through difficult moments and the unex-
pected moments of verbal and movement brilliance seemed to
have had potent value for many audience members. Dance critic
Deborah Jowitt speaks of "coping, in creating an art so vividly a
semblance of the pattern made by our own daily indecisions and
little triumphs."[5] At Grand Union performances anything was
possible, and sometimes something, sometimes nothing, hap-

pened. The group was fiercely anarchistic (Barbara Dilley, a member, referred to it fondly afterwards as "an anarchy of consenting adults.") To take control was taboo. If anything, to show that the group could pull through, that the group could make decisions was what was essential to the revolutionary improvisatory model. As young people were challenging the life styles and mores of their elders, so Grand Union challenged most theatrical conventions. Real life, ordinary behavior, was considered possible on stage. Audiences who came regularly to Grand Union performances began to see in the personae of the performers characters from a real-life soap opera.

Grand Union finally reached its demise. The pressures of performing "on the spot" were excessive, and there were personality conflicts. In 1973, Yvonne Rainer, a founder but no longer a member of the group, accused it of giving way to "crowd pleasing." Entertainment at that time was not the goal; personal and group revelation was. There were still "moments," but there was also, according to many, a lot of waiting around, and little passion and commitment by the end.

Gradually, the participants of these improvisational performances on both East and West Coasts went off to define their own paths more specifically. Trisha Brown, Douglas Dunn, David Gordon and Valda Setterfield, Nancy Lewis—all Grand Union alumni—incorporated the permissions of the sixties into their choreography, and went beyond. Steve Paxton and Barbara Dilley (both of Grand Union) as well as Ruth Zaporah, went on to investigate improvisation as a more disciplined form. Paxton created an "art sport" called "contact improvisation," which he has superintended for over a decade. Barbara Dilley found a home for her investigations at Naropa Institute, which teaches both mind and body disciplines from a Buddhist point of view. Here Dilley has headed the dance department since the mid-seventies, and it has been her laboratory for her investigations into dance and meditation. On the West Coast Ruth Zaporah continues her performing and teaching of improvisational theatre, or what she calls "the art of skillful being."

The "turning inwards" that came in the aftermath, and as a result of the fierce experimentation of the sixties culminated in the refinement of improvisation as a performance form and as performance training. Quietude was necessary in order to "listen" to the body again, in order to hear and act from the unconscious. How to be available to the flow of the moment and how to structure, instantaneously, its passage through oneself—these are the questions inquirers like Steve Paxton, Barbara Dilley, Ruth Zaporah (and the next generation—Dana Reitz, Nancy Stark Smith and others) have pursued into the next decades. The focus is on the performer as a medium to the unconscious, not on scrupulously arranged lights, staging, and cos-

tumes. Although the outcome looks much different from the kind of performance I described in "The Foreseen," the source is quite similar. Yet performance of the Unexpected is delivered on the spot, in the actual miracle of reception and at the moment of access. There is control, but control of a different nature than in the theatre of images.

Most of the performers whose work is mentioned in this chapter made a move from more highly structured or pre-set forms of performance. Steve Paxton and Barbara Dilley had danced with Merce Cunningham; Dana Reitz was trained in modern dance and music and performed with Twyla Tharp; Ruth Zaporah was trained formally in modern dance. The work of these very different performers takes on a great variety of appearances, from the elegance of Barbara Dilley's meditative forms to the witty jabber and quick transformations of character of Ruth Zaporah's theatre performances, from the athleticism of a contact improvisation between Nancy Stark Smith and Steve Paxton to the sight of Pooh Kaye gnawing on wood or burying herself in mud. However, in embracing the Unexpected, there are constants: form, practice, risk, play. It is to these constants that I address myself in this chapter.

Some Structures for Spontaneity

Barbara Dilley Dancing

An improvisation can have a complicated structure or no structure at all, though I've found that "no structure at all" is probably a myth. Among performers, the barest of understandings can be a structure.

Just as children on a playground draw off a section of the asphalt with chalk, within which each movement has special meaning, so improvising performers may mark out their areas. Barbara Dilley lays out a square of bright red yarn on the dance floor. By framing what will occur spontaneously within that square, Dilley creates a charged space within which her focus is galvanized.

One summer Barbara Dilley had a dream about a songbird that would only sing when it was put in its cage. The image suggests how an artistic structure might be freeing, how setting boundaries and limiting options makes possibilities for creating. "Without discipline, people only wallow in improvisation," Dilley has commented.[6] It is with this sense of specified boundaries that Dilley has explored improvised performance, in solo and with other dancers. The boundary may be as slight as the bright red yard on the floor or as restrictive as movement limited to just swinging the arms. The forms are so simple they become tricky.

While the more austere and somewhat serene forms Barbara Dilley works with now may seem a far cry from the anarchy of the Grand Union, the thread of making one's decisions clearly, in public, with dignity and an awareness of all that is happening around you links the two. Dilley, as well as other performers who have chosen to perform improvisationally, like Nancy Stark Smith, Ruth Zaporah, and Dana Reitz, possess formidable movement technique. Classical ballet, *t'ai chi*, gymnastics, Cunningham all form a basis for it. But it is not the extent of the formal movement technique that impresses one watching these performers in action; rather it is the attention and air of simplicity given equally to all moments of moving. The byproduct of *shamatha*, the Buddhist mindfulness-awareness practice which Dilley adheres to, is clarity of thought and therefore, also, clarity of movement.

One of the forms Dilley uses and teaches at Naropa is called "corridors," which is usually done in trio. The three performers move along parallel lanes of space. By using peripheral vision, seeing from the corners of the eyes, the movers pick up distant as well as near gestures. What one catches may be a blur. What is left to the performer is how he or she processes that information. With practice we can see 360 degrees of space, not merely the narrow band encompassed by the ordinary range of our eyesight.

Movement in "corridors" is often restricted to a few options, like walking, running, turning and arm swinging—very basic movements. It is useful to restrict movement, especially when working with unfamiliar people. One must build a mutual movement vocabulary from the ground up. Learning to move in an honest way with other people, not out of ego or a desire to attract attention, takes commitment. How we process the visual and aural information is so personal it says who we are. By restricting the kinds of moves the performer may make, the power of any move, even the smallest gesture, is intensified. Communication can be profound among the practitioners, the slightest turn of the head or the slowest sinking to the floor. A swing of someone's arm may impel one dancer suddenly to turn or another to stay still. How three people know without talking that they've finished is another interesting issue in "corridors." Beginning and ending are on one continuum. Unless one is really paying attention to all that is going on in the space, essential communication is lost. "Corridors" as a practice makes tangible the bonds of energy among performers.

Another improvisation form Barbara Dilley works with is an offshoot of the child's game "follow-the-leader." A leader gains followers simply by saying, "Follow me." Followers choose where they will follow in the space, if they will follow simultaneously or as an echo. They may even change the movement or perform a variation. But the decision must be im-

mediate. As one performer has said, "Improvisation is a risky business. No time for second thoughts or rearrangements. You do it or it dies."[7] In follow-the-leader the range of movement may include extremely small gestures: wigglings, quivers, stamps. There may be long periods of stillness. There is no pressure to remember steps or timing, just to be present in the moment of each decision, to sense the time of the whole composition as it is happening. There is also the possibility to not follow, to stay with the movement one is already doing. Barbara Dilley's statement is revealing of the nature of these movement forms:

. . . form being simply that three people doing the same thing at the same time becomes form. It's viewed that way and it creates an energy that both extends on one hand and relaxes on another. A dancer relaxes when imitation and repetition are going on. You don't have to be thinking, "what am I going to do next. What am I going to respond to next," so you relax and in that process of relaxing through repetition you start to feel the larger thing happening. Your decisions can then be based on the whole.[8]

These forms are structures for learning to pay attention, to focus, be it on one's own breath or the movement of one's partner's arm from across a room.

Dilley's students at Naropa are taught to cultivate in formal movement the spontaneity of improvisation and in improvisation the dignity and clarity of formal composition. It is this very dignity and clarity that made me incredulous when I first saw Dilley's "Cassiopeia's Chair," incredulous that it was being improvised. It is this dignity and assurance that makes audiences incredulous that Dana Reitz or Ruth Zaporah are improvising, that the performance they are watching can never be repeated exactly.

In "Cassiopeia's Chair," a neat grid of white tape is laid out on the floor, this defines the site of our attention. When Dilley dances, the strong white lines of the grid arbitrarily counterpoint the sensuality of her rounded body turning, adjusting. Intimate with the relationship of her thought to her body's gestures, Dilley knows how to use stillness and silence as manifestations of her own process.

Before the dancing, we sit in darkness as in a planetarium show, listening to a tape of Dilley in conversation with poet Sidney Goldfarb about the origins of the myth of Cassiopeia, the queen thrown up in the skies by Poseidon to learn humility. Half of the year she is upside down. The speaker's knowledge is obviously limited, to say the least, but they go on talking anyway. Amused at their own bemusement, they refuse to be embarrassed at finding out how much they have to learn.

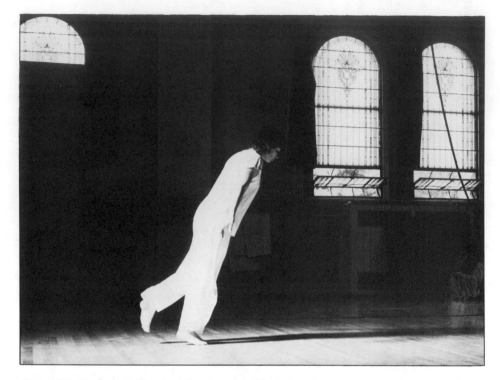

Figure 33. Barbara Dilley in "Cassiopeia's Chair."

The physical Dilley replaces the audible in the space, dressed simply in white pants and blouse. No chair, no Ethiopian queen, only the "constellations of the body." Yet for me the image of a proud and beautiful woman is clear. Face aglow, eyes slightly down, she begins, simply, to dance. Her attitude seems constant, introspective, workmanlike. The straight lines of ballet positions melt into the soft round asymmetry of the *t'ai chi chuan*, the hip flow and wag of social dancing. She dances spontaneously, there is no effort to "think" what comes next.

After dancing three or four minutes Dilley eases gradually into stillness, standing in an open position. The stopping is so subtle that the movement seems to continue. Two readers not quite in synch read from Gertrude Stein's essay, "Composition as Explanation." Dilley physically verifies the curiously redundant but emphatic lines, "Everything is the same except composition and as the composition is different and always going to be different everything is not the same." Dilley uses the silence of the readers in which to move. The speakers use her stillness to speak. Silence and words, stillness and movement can exist as metaphors of the same event.

By placing the audience on all sides, Dilley puts herself in an uncomfortable position. She can be seen from everywhere, like Cassiopeia in the sky. Eyes and lights focused on her, she simply does what she does. No astonishing feats.

Figure 34. Brushstroke drawing by Dana Reitz.

She finishes dancing, breaks into a run around the edges of the grid; slows, begins to walk. Her voice breaks the formality of her silent presence with the commandment: "You must remember this . . ." *We're hooked, all ears for the next line:* "A kiss is just a kiss . . ." *Oh it's just the words of that old song . . .* Then: "The fundamental things apply as time goes by." Lights out. But that *is* the truth of her dancing, the fundamental things: time, body, space. Dilley is *in* each moment, what we are watching is the flow of her thought which for now is that movement, just that. As Gertrude Stein says, "A continuous present, and using everything, and beginning again."

Dana Reitz' "Duet for Two Sides"

Dana Reitz' dances are, like Dilley's, forms for aesthetic and spiritual inquiry as well as visible manifestations of a thought process. Both Dilley and Reitz belong to what Deborah Jowitt has called, "a select band of American choreographers (Isadora Duncan was perhaps the first) who will not make a move they can't believe in."[9]

In Reitz' dances, the individual's movement is analogous to the brushstroke of traditional Japanese calligraphy—the gesture reveals the inner moment. One is committed to that stroke:

That moment can't be repeated, but it's a trained moment, it's prepared for, and comes out of everything that's happened before. It can be like you're not even there. It goes right through you.[10]

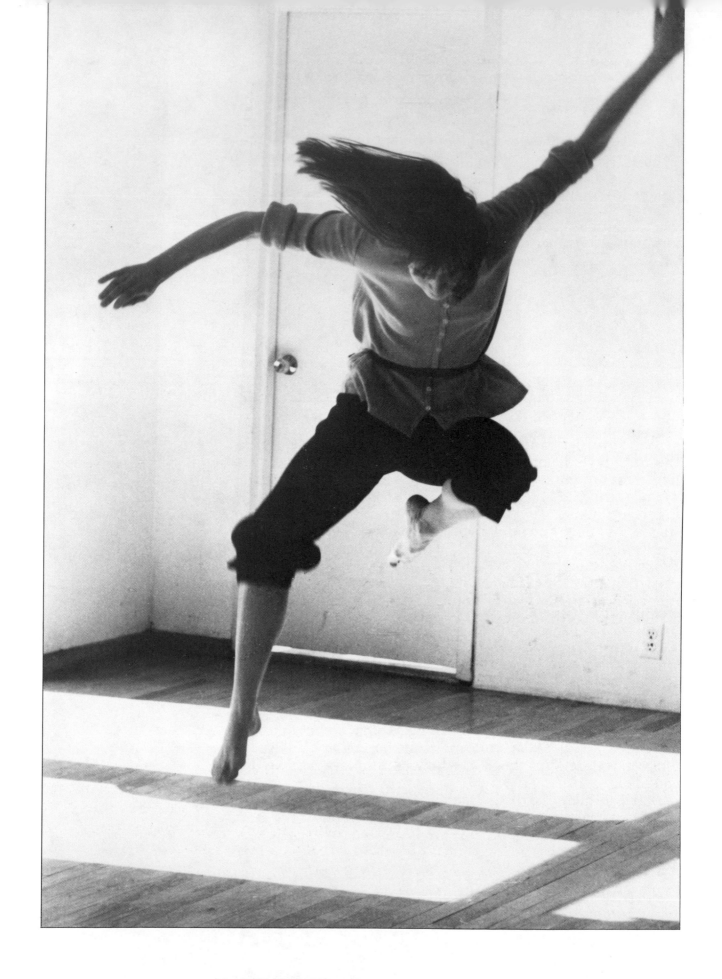

In actually drawing the energy patterns of her dancing, Reitz began to discover analogies between the straight line and the curved line and her own performing. Eventually she came to identify two, often warring, elements in her own psyche and in her own performing: the well-trained, precise, structuring side and the part of herself that resisted structuring, was feistier, had a "desperate need for freedom." She began to explore the differences in brushstroke committed by her right hand, left brain dominated, as contrasted with her left hand, controlled by the more intuitive right brain.

Out of this dilemma Reitz created a piece called "Journey: Duet for Two Sides," which she performed at The Kitchen in New York City. She set two platforms side by side, with a chasm between them. One platform was for improvised dancing initiated by the left side of her body, the right-brain controlled, intuitive, freer side. The other platform was for dancing from the right side of her body. Reitz danced a dialogue of her selves. She made the passage between unconscious and conscious as clear and abrupt as a leap between the two platforms, switching attitude in mid-air. What she found was:

I needed both sides fully. I needed them interacting and helping each other rather than condemning each other. The structural side kept condemning the other, but it wasn't really the structural side that was condemning, it was the critical voices which were condemning this kind of freedom.[11]

The conclusions Reitz drew from performing this piece were crucial to her work and to her life as a whole. And the openness with which Reitz lays bare her process of resolving metaphorical dilemmas invites the audience in; we are participants in the ritual. What Reitz investigated in "Journey: Duet for Two Sides" is an issue any performer embracing the Unexpected, performing improvisation as a performance form, must resolve for themselves. How do you learn to honor the need for structure and the desire to be free? To be able to step confidently into the Unknown in front of an audience, you really have to trust yourself, all parts of yourself. Reitz commented to me,

You don't develop both sides to be the same. You develop both sides to become strongly what they are, influencing each other and helping each other out. If you really listened to both sides you'd figure out problems. You'd have your gut, your intelligence, your full range. Both sides of the body, both sides of the brain. You'd have the whole system in operation, dealing with the outside world rather than fighting yourself or having this critical voice within yourself.

Figure 35. Dana Reitz in "Duet: Journey for Two Sides."

Perhaps this issue is one which *any* person, especially any artist, must resolve for themselves. As an improvising performer, one makes an art form of the questions.

Contact Improvisation, Gravity as Structure

Contact improvisation is a form of improvisation where the basic interest, focus, and structure are cultivated by its practitioners through jam sessions, public performances, and a quarterly journal. The brainchild of Steve Paxton, a dance adventurer who has influenced generations of performers, the development of contact improvisation has been aided by a legion of Paxton's talented fellow explorers (Nancy Stark Smith, Lisa Nelson, Nita Little, Alan Ptashek, and others). They have identified a dance form in which the flow of life-force is made visible by tuning in to the laws of physics—momentum, gravity, inertia. Contact is a play between the body and the physical forces that govern its motion. In contact, the reward of effort is momentum's free ride, as exhilarating as the twirling and rolling down hills we did as children, when we discovered ways in which, with the slightest effort, we could set our bodies moving.

Contact is a duet form in which partners share the demands and gifts of weight and momentum. The partners rebound off each other, they give and take weight. Unlike traditional dancing, where balance is defined by an upward stretch along the body's sturdy central column, in contact any body part that can bear weight might be a fulcrum. Contact dancers move upside down, bear weight on hands and heads, become accustomed to spatial disorientation. Contact looks somewhat like noncompetitive wrestling, somewhat like lovemaking, somewhat like the jitterbug. It is aerial and daring and rolling.

The structure for the improvised duet is basically to sense the information about one's own movement and one's partner's movement through touch and a constant awareness of gravity. For a contacter, the structure is always there, as constant as the weight of one's body, the rhythm of one's breath, the point of contact between two humans in motion. Adhering to this structure demands, as do all improvisational structures, that you pay attention, stay focused.

Practice/Focus/Communication

Practice. Practice. Practice.
HARRY HOUDINI

As part of a dance critic's conference years ago, I was asked by critic Marcia Siegel to keep a journal that was "unlike any jour-

Contact #4

Feel the place in your brain where
I'm talking to you. release it
into the earth
feel each vertebra. hold it in yr. hand
release it

→ this is as low as you can be.
change position. use floor as
massage

→ rolling w/ partner don't try to do
anything

→ head to head. trade heads
feel the other persons skeleton.

Ⓧ walking around
in change head
align do not
touch anyone.
pass through
center of room

Ⓧ at any time
go to floor +
roll then resume
walking

Ⓧ head carries
you to floor and
back. to standing

Ⓧ can't use ends of
room.

practice walking around yr house w/eyes
unfocused - seeing everything - rapid space

Figure 36. Author's journal
notes from contact
improvisation class taught
by Nancy Stark Smith.

nal I had kept before." For some reason I decided that each night I would paint a large page of a drawing pad with black ink, rip a hole out of the middle, and insert one word, one drawing, one anecdote. It was a strange discipline, but for the month I practiced it daily it became in inevitable statement of the particular moment how I painted the page, how I ripped the hole, what I put in it. Likewise, I think of improvisation as a "movement journal." You set a structure or you watch a structure emerge and through it you gain insight into your body/mind. Each joint of the body tells its own story. One learns to know one's energy level and respect it, using improvisation as a barometer of body weather.

Right now my physical practice is swimming. I swim everyday, paying attention to the circularity of energy from gut to shoulder, from thighs out to toes, and from chest out to fingertips. The rhythm of the stroking and breathing channels awareness into my body; my thoughts come and go. At other times, my daily practice has been a ballet *barre,* arms and legs moving in lines and circles around a vertical posture. Such traditional exercises set the momentum for paying attention to breath, alignment, physical geometry.

We define our daily practice according to our need to strengthen and limber the body or focus and concentrate the mind. The necessity for a daily practice, however one ultimately defined it, became clear to me when I first studied with Barbara Dilley at the Naropa Institute. Dilley has practiced Buddhist sitting meditation and has investigated its relationship to the art of improvisational performance for many years. There was a set ritual to each morning's class, which each member began and ended in their own time when ready. We breathed, sat, stretched and walked until walking spilled over into running. Within those particular activities each individual worked with their own weaknesses and strengths of the day. The teaching came from the commitment to carry through the ritual.

In the mindfulness and awareness discipline which Dilley practices, one relates one's mind, one's thinking, with the outbreath. She calls it "mingling your mind with space." The outbreath is the point of focus. One chooses to pay attention to the outbreath as a way

to tame the mind so that your speed and your effort and your struggle to comprehend and dissect any order and figure out and manage your world and your life is given room to just be, without any goal to figure it out . . . You are disciplining the speed of your thoughts, cutting through your habitual pattern of speed or of mind process, actually dropping it, and with your attention, following your outbreath—which is a very simple tool.[12]

In sitting meditation you pay attention to the outbreath. In performing improvisation, you pay attention to everything that is happening inside and outside of yourself. The outbreath may be the touchstone that focuses your awareness. Performer Ruth Zaporah goes so far as to say,

All theatre-making is about is paying attention. It's all it's about. At least that seems to be clearer and clearer to me. And it doesn't matter so much what you're paying attention to. Everything's cooking at once . . . the body's always cooking, the thoughts are always cooking, and it's all always going on. And so we can make a choice what are the things we want to pay attention to and the more skill we get, the more we can pay attention to, the more we can experience.

It's a practice because you go into the theatre space and you say, OK this is a two-hour period or a one-hour period or a fifteen-minute period. This is what I'm doing. I'm practicing paying attention. Gradually, because I've been doing it so long it's more and more integrated into my daily life. But as soon as I get carried away, or passionate, or emotional—then I really lose ground.

Whether it's paying attention to one's breath, or to one's relationship with gravity, the premise for performers is that to keep in contact with themselves enables them to stay in contact with the audience. As a teacher of performance, Zaporah places her students in situations which demand their attention. She is asking them to attain what she calls their "natural way of being," which is attentive. We're always struggling to attain this natural way of being, she feels, in which our inner reality and outer context are both taken into account, are "in synch."

In contact improvisation there is a built-in test system that instantly alerts one to the fact that one is not paying attention to one's alignment with the forces of gravity and momentum. In order to join your weight and your momentum with another person's, abdication of ego is essential. Concentrate instead on your will, or your virtuosity, and you or your partner may fall on your face. As Nancy Stark Smith comments:

Lose attention, lose contact. You feel these lapses of mind physically as your support wavers and the orbit of your movements veers off the common path. Your mutual balance is suddenly split . . . Just as the weight of your head falling forward as you nod out at the wheel jolts you awake, so too this moment of departure will bring you back.[13]

Inner awareness that improvisation demands must exist in equipoise with awareness of all that is happening outside of the performer. In contact training this is emphasized by encouraging students to keep their eyes open even while they are concentrating on inner sensations like balance and the feel of a muscle releasing. The dancer learns to integrate the proprioceptive information with the information coming in through the eyes. Contact improvisors soften their focus, concentrating more on peripheral rather than specific focus.

Practicing paying attention allows the performer to develop an extraordinary overview of the composition as it is being created. Choreographer Dana Reitz has commented how in performance

everyone's an observer including yourself. You're the activator but you're also the observer to all this, reacting and hearing what's happening all at once. You're a conduit. You've got all this stuff going through you and you don't stop it and you don't hold it.

This concept, of being a conduit or a vessel for "something else coming through" is one many performers have voiced to me. It is like the "tapping in" of the Bushmen that I mentioned in the previous chapter, and it is really at the core of all the performance I discuss in this book. In performance of the Unexpected, if "nothing comes through," that is the risk you have taken, and the risk the audience has taken with you. Sometimes nothing comes through. Not every performance is going to be a thriller. Ruth Zaporah has commented that

I'm willing to say, or sometimes my goal is to be willing to say that I don't know who I am. That to me is performance. That to me is living. *I mean, what's living all about? It's certainly not to stand still and say,* this is who I am.

There are many performance-goers, I trust, who might find this attitude unacceptable. They don't want questions, they want answers. But I don't feel irritated as long as I (as audience) don't feel neglected, shut out, by the performer's lack of outer awareness. When the audience can witness the dialogue—performers with themselves or with their partners or with the audience—then improvisation can be exhilarating to watch. Then I learn from the performer's process, their research. True, I've been to improvisation concerts where I would gladly have slipped out the door if nobody would have noticed (very difficult in small intimate performance lofts). I have also experienced improvisation where I felt the audience and the performers united with the same breath, the same eyes. When improvisors neglect to communi-

cate with each other, they neglect the audience also. And communication to me is the goal.

Relating: Solo, Duet, Ensemble

We are always in relationship: with the ground on which we stand, the air we breathe, the people we talk to, and in this case, the people with whom we dance. Improvisational performance makes tangible these dynamics of relationships.

Within one contact dance, partners' roles may continually change from carrier to carried, from thrower to catcher. Critic Marcia Siegel described a duet between dancers David Woodbery and Daniel Lepkoff:

> They would drag or pull each other, sometimes quite roughly, make motions of attack and defense, then suddenly they'd be embracing. Not only were the polarities and the quickness of the reversals surprising, but the dancers' resilience and adaptability, their readiness to fend off or grasp, to fall softly or bear the other's weight, was beautiful to watch.[14]

It is like a conversation, only with higher stakes. If you space out while you're talking to someone, there's silence. If you space out while you're performing contact you or your partner miss and lurch. If you daydream while you're performing solo, very likely your audience will get bored and restless.

When I was leading movement workshops at a state mental hospital with my friend and performing partner John Marron, I saw potent proof of the effectiveness of movement/contact as a communication tool. We set up a structure: each participant was to choose a partner with whom to have a movement conversation. John chose a silent old man for his partner. This man seemed like nobody had paid attention to him for years. But John led him to the center of the circle and he placed his forehead against his. They stood there for maybe five minutes with the rest of us clustered around. Finally that grim, silent old man broke into the slightest sweetest smile. And everyone cheered. They were "talking" through the contact of their bodies.
"There's a choice," Ruth Zaporah commented:

For me the choice is based on communication, that you're not autistic, you aren't lost in your private world but you are genuinely looking at your relationship, first of all to yourself, and second of all to the world that you're in and the people who are in that world.

With a friend try this: sit back to back, crosslegged on the floor. Feel your spines against one another. Just sit there and breathe. Through the points of contact you can "read" a great deal of information from your partner. Try gently exchanging weight with your partner, one spine arching back over the other rounded forward. Now, standing up, one of you behind the other, establish a point of contact between yourselves at abdominal level. Move slowly, be aware of the point of contact between you. After a few moments it may feel as if the point of contact rather than one of you is determining where the two of you will go. If you use force, try to dictate where you and your partner move, most likely the point of contact will be lost. Simply find it again.

In contact, you are empathetic with your partner and responsible for your own self, weight, direction. Instead of grabbing your partner to "save" him or her from falling, you might offer the surface of your back to ease their descent. If I suddenly throw my weight onto my partner's back, I do not know how he or she will react. Making physical what often is intangible in daily relationships is a useful clarification: what is my responsibility, what is yours, what are my decision-making powers and what are yours?

I have mentioned many different performers in this chapter, and, as I said earlier, their improvisatory work takes on many different forms. But the practice of any of them leads to a clarity of intention and an expanded awareness of self and other. "And what does this work have to do with the people of El Salvador?" remarked Ruth Zaporah in an interview.

I don't know the answers. I think that maybe this work is part of a social underground in which we practice how to have clear intentions, how to open up, get along. The work is about ensemble. *Ensemble says, "We are one." All the countries on the planet are one. We're connected. It's not that we don't have things to overcome in order to get along, but that we recognize first of all that we are one.*[15]

Risk

I think that facing and overcoming fear has a lot to do with the kind of tests I've shown in performances.
POOH KAYE

Risky business, performance, and even riskier, improvisation. People thrive on all kinds of challenges. For performers, risk can be, literally, the edge that they need.

For example, at a time in my life when personal relationships were an alarming tangle, when I was an alarming emo-

tional tangle, I found movement improvisation could cut the Gordian knot. My friend and I began going to a studio late at night and moving together in the dark. I felt a great need to throw my body around, into the air, onto the floor. In the dim, without many visual clues, we trusted and found sanctuary in each other's bodies, at high speed.

Physical support was emotional support. My friend was more often the anchor—keeping my weight from flying off altogether. Trust is risk's partner. What the work brought about was the physical resolution of frenzy.

One night in the studio, I did a spectacular upside-down jump and my friend caught me just before my head hit the ground. I was so elated with this particular move, I decided to try it again. But I had neglected to signal my partner. He recalls seeing me suddenly, quite without notice, jump onto my head. Fully expecting him to catch me, I never stiffened up before I struck the ground; so, whereas I might have been seriously injured, I was only mildly bruised. The less you know you're going to fall, the more you know about falling.

Not that performances are always made to counter dire emotional straits in the performer. Far be it from that. But I will admit to times in my life when performance literally provided the necessary ledge to balance on. In a theatre/dance work called "Down at the Traps," I created a character for myself called "the traveler." This character, I decided, would make a surprising and improbable entrance from the second-story window at the rear of the gallery space, access to which was only possible by carefully navigating a ledge from the second-story office next door. It was Christmas, the window ledge was icy, two floors up from

the street, and there wasn't anything to hold onto. My heart sank every time just before I went out onto the ledge; but once out there waiting for my cue I felt calm, certain, and immensely alert. People on the sidewalk below never seemed concerned as to why there was a woman on the ledge in mid-winter at night carrying a suitcase and wearing an overcoat. I can certainly identify with a statement Ruth Zaporah made:

I don't spend too much time thinking about what I do, because if I did I would probably scare myself out of it. When I first started I was petrified, but I couldn't think of anything else to do. I had done choreography. I had acted in plays. They just weren't risky enough. I'm always looking for something harder.

Now Olga, the cat next door, hangs out on window ledges three stories up all the time. It doesn't seem to concern her. It's really a question of what constitutes an edge. I don't feel the desire anymore to make pieces where I'm standing on a window ledge in wintertime. It might be just a question of temperament. Not every performer has the inclination to improvise or perform at all in front of an audience. Some prefer the climate of anonymity which technology provides, like the great musician Glenn Gould who gave up a brilliant career as a concert pianist. He explained that the artist needed the time and freedom

to prepare his conception of a work to the best of his ability, to perfect a statement without having to worry about trivia like nerves and finger slips. It has the capability of replacing those awful and degrading and humanly damaging uncertainties which the concert brings with it . . . At live concerts I feel demeaned, like a vaudevillian.[16]

If I'd been in the audience the night I entered through the window and if I knew what a risk the performer was taking, I might even have felt angry. I know I feel angry if I think someone is taking risks with the audience's safety. If I knew performers were going to take risks with their own lives, I would probably not come and watch. Perhaps trust is something the audience gives the performer gradually. People come over and over to see Ruth Zaporah start from scratch, sitting on a chair facing the audience with no script.

Deborah Slater is a performance artist who creates very physical images. In a recent work, "Pieces of the Frame," Slater could be found dangling from a fifteen-foot ladder. Deborah, an arresting performer of great physical presence, often devises parts for herself that demand that she pay attention because of the risk. She sets herself a task the accomplishment of which is

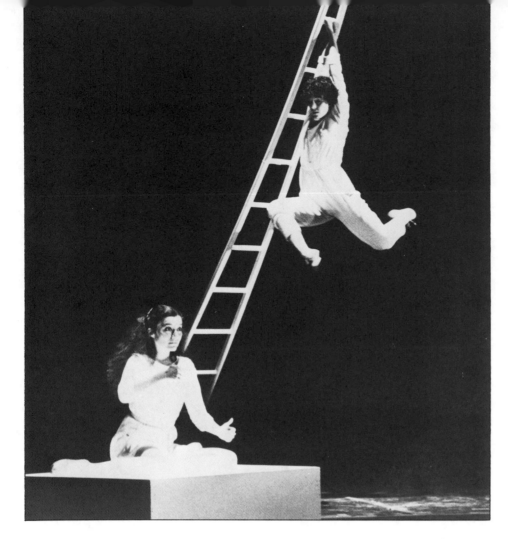

Figure 38. Deborah Slater (on ladder) and Betsy Ford in Slater's "Pieces of the Frame"

left open to the moment and which she must call upon great skill to accomplish.

I have this fifteen-foot ladder that terrifies most people to get on. And I love it. It is so exciting to me to master this ladder which is capable of throwing me across the room if I don't watch what I'm doing. The only thing that I can say about this that I understand completely about me is that I have to make the performing task for myself so difficult on stage that I cannot do anything but that task. Otherwise I get distracted and I either mug or the performance is superficial somehow. I have to make myself work at what I'm doing. It cannot get easy. I just can't do a performance that gets easy because I haven't figured out how . . . Question: So risk is very important to your work? Unfortunately, unfortunately. I mean I like it, and I like watching risky things—I like things that are risks on any level because I think that's where the excitement is for me. That's what makes something compelling. Whether it's the risk of truth or the risk of whatever it is.[17]

Watching Slater at her Sisyphean task involves the audience kinesthetically. The risk she takes in her movement images take

me back to memories of childhood when I thought nothing of jumping backwards off a diving board.

Slater is prepared for the physical risks she takes, as are practitioners of contact improvisation. Steve Paxton explains that

> A mark of the dancer used to improvisation is his quickness of response. This quickness is faster than habitual movement/thought and is based on acceptance of the imminent forces, letting the body respond to the reality it senses and trusting it to deal with the situation intuitively. Trust is an organic form of communication.[18]

One had best be able to trust one's reflexes when 150 pounds of weight are suddenly thrust upon one's shoulders. Contactors do move with complete freedom of choice and also at high speeds. They are skilled, though, in a vocabulary of falls (some from the martial-arts form *aikido*) which are important to prevent injuries. As the poet Frances Phillips writes, "The secret of flying/ Is love of the fall." Contactors are on an even keel about the ups and downs of their form; the descent is as much a moment of awareness as the sudden spring upwards. Falling, Nancy Stark Smith points out,

has always been experienced as a mistake, as a loss of balance rather than an active balancing. This fear turns the fall into a dark and endless shaft with two ends, the before and the after, colliding at great impact. As practice accustoms us to being upside down and moving through space in new relationships to gravity, we are no longer on foreign soil, but at home in space, in our bodies, when we are falling. Time begins to spread out, light falls in, and what was sudden and uncontrollable is now easily recognized and directed—directed in the sense that you are IN the vehicle, at the wheel, with more and more choices available to you.[19]

Smith also describes the ability that develops to distinguish between a foolish risk and a viable challenge. Whether dangling off a fifteen-foot ladder or another person's shoulder, you know your physical capabilities and you have confidence in your instincts.

Play

Work consists of whatever a body is obliged to do . . . Play consists of whatever a body is not obliged to do.
TOM SAWYER

Perhaps Tom has done as well as the many psychologists and academicians who for some time have been trying to define just

what play is. What has become increasingly clear is that play is one of the main ways by which the young learn. In both animal play and human play, the young learn social rules and adapt to them with minimal risks. In cultures where this is formally recognized, the boundaries between child's play and adult responsibility are not rigid. Erik Erikson has described how a Cheyenne Indian family would, with great gravity, make a ceremonial feast to honor a little boy's first snowbird. At an infant's birth he was presented with toy bow and arrows and as he grew older, serviceable bows and arrows were made especially for him, tailored to his size. When he finally killed a buffalo, it was not a new adult role but one for which childhood had been gradually preparing him.[20]

Play serves survival. Puppies pounce and growl in mock combat, utilizing postures and strategies they will later use with more force and vehemence. The young animal progresses smoothly into autonomy without ever making a distinction between play hunting and real hunting. Among humans, typically, play is channeled into competitive games, or swimming laps, or running round a track "against time." The fantasy play and imitative play of childhood are no longer "proper" behavior for an adult. And when educators complain that children "only want to play," they are considering play to be a primitive, animal-like activity that is not necessarily compatible with learning.

It's not surprising that improvisational movement artists like Pooh Kaye are inspired by the child's sense of discovery:

Kids are learning how to move in order to be people in the world, but at the same time they're exploring with complete innocence a whole spectrum of possibilities, all in the name of play and exploration. I liked that conjunction of play and exploration. I still do. It just seemed right to me to draw on that childhood period where movement is at its most ridiculous and functional.[21]

In Pooh Kaye's "Homelife of a Wildgirl," we see Kaye alone on stage with an enclosure made of bricks. In watching this small, fearless-seeming woman stacking, then knocking down, her brick house we sense the whole basic human impulse towards structuring and destroying. Kaye has stated that her work has strong ties to the games she composed for herself as a lonely child. Now, with virtuosic and highly personal movement, she continues to devise games for herself to explore and for those in the audience to marvel over.

Many aspects of the creative process bear a relationship to play. In particular, as a tool in composition or as a performance medium, improvisation parallels the sense of discovery of the growing child. Improvisation also tempers that sense with the

structuring facility of the adult. To improvise, the performer learns to disregard the line our culture draws between child play and adult work. Improvisation, like the play of the young child and the young animal, is still a practice of basic survival skills, a celebration of life: imagination, adaptability, concentration are all intrinsic to both processes. Improvisation *is* play. We are not used to seeing adults play in a noncompetitive manner in our culture. When I watch improvisation I am not rooting for the performer to win. I am a fellow traveller, on a journey hopefully, towards revelation.

Claude Lévi-Strauss has described "ritual" as like "a favored instance of a game, the only one which results in a particular type of equilibrium between the two sides."[22] The challenge of a game and the spirit of competition may be present, but neither side wins. Both sides gain from the interaction.

In our ongoing movement improvisation we call "Sticks" the performers are myself, my partner Susan Banyas, and three five-foot wooden dowels. We have discovered certain games we play with the sticks and each other—some of them have names—and we figure out instantaneously which game it is we are playing according to where the previous game leaves us. New games are invented all the time. The response of the sticks to momentum and gravity are just as responsible for the outcome as we are. Sometimes the physical events will lend themselves to forming a visual image; a stick may become a spyglass and we're suddenly on a ship at sea. "Sticks" is play, and it is an ongoing ritual for Susan and myself, making tangible our skills in discovering, trusting, communicating. We often start a rehearsal for our theatrical work by playing at sticks for awhile. It throws us into the creative process and out of the analytical mind-set. Through this simple structure, complex imaginary and emotional situations arise and we respond.

There are no previously successful strategies. Each situation is new and calls for the action appropriate to that moment. This is very useful training. It is especially helpful in times like ours when the ability to make appropriate choices is crucial. As critic Walter Benjamin wrote in his essay, "One Way Street," "These are days when no one should rely unduly on his 'competence.' Strength lies in improvisation. All the decisive blows are struck left-handed."[23]

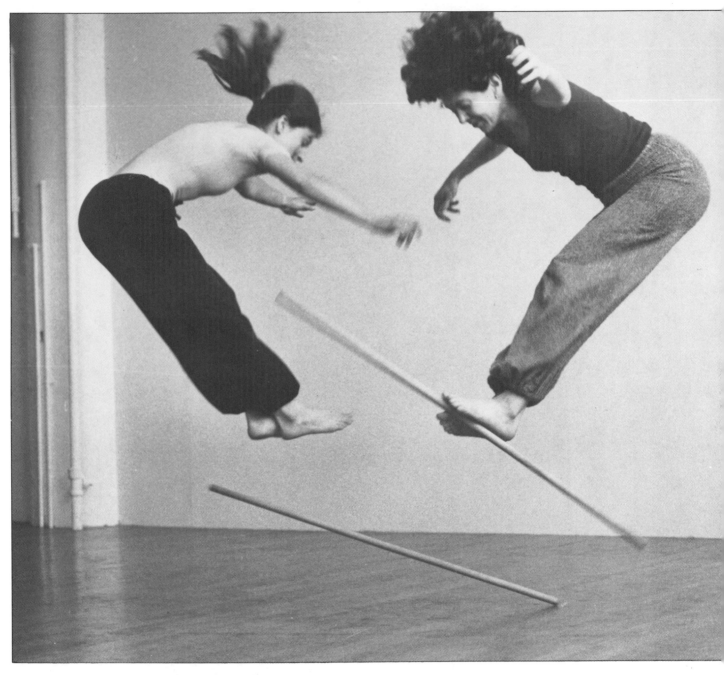

Figure 39. Susan Banyas and author in "Sticks."

five

THE STORYTELLER

. . . All this points to the nature of every real story. It contains, openly or covertly, something useful. The usefulness may, in one case, consist of a moral; in another some practical advice; in a third, in a proverb or maxim. In every case the storyteller is a man who has counsel for his readers. But if today, "having counsel" is beginning to have an old-fashioned ring, this is because the communicability of experience is decreasing . . . Counsel woven into the fabric of real life is wisdom. The art of storytelling is reaching its end because the epic side of truth, wisdom, is dying out.
WALTER BENJAMIN, "The Storyteller"

In 1936, on the eve of World War II, Walter Benjamin wrote "The Storyteller,"[1] the essay from which the above is excerpted, as a paean and a lament for what he saw as a vanishing breed. Benjamin wrote his essay before the enormous information explosion of the last forty years—before linear accelerators, computers, television, telephone-answering machines, digital watches, word processors. All these devices, while they can be aids to the human intelligence which created them, distance us to some degree from the experiences perceived and communicated directly through our senses. They distance us from heart-to-heart communication with each other. If we communicated more with our senses and our hearts, would we be as we are; in a fair way to destroy the world utterly and meaninglessly with our own tools? How could/can storytelling survive the distancing from experience passed on mouth to mouth, the source from which all storytellers have drawn? On the other hand, how can our humanity survive without stories? What other cultures, like the stone-age Bushmen, have always understood—that without a story of your

own you have not got a nation or a culture or a civilization or even a life of your own—has become clearer to many.

Responding to what feels like a great hunger for stories among many people, it is perhaps useful to look at the contemporary performance-maker's storyteller persona. For, although it may not always be at first recognizable as storytelling, in today's new, experimental, so-called postmodern performance, one can see more and more what Benjamin called "the great, simple, outlines which define the storyteller." The fragmented narrative that is a hallmark of avant-garde literature and theatre in our time—words, phrases, texts separated from conventional uses; sounds closer to the cries of animals or babes than to everyday speech—may seem to be an attempt to obscure communication with the audience. What is challenging to one's accepted mode of receiving information can be threatening, infuriating, alarming. In reality, however, this fragmentation bespeaks in many cases an attempt to reveal storytelling as the root of performance. The function of the storyteller in this sense is to make his or her experience the experience of those who listen or watch.

Around the same time as Walter Benjamin wrote his provocative essay, Antonin Artaud, the French poet, mystic, visionary, lunatic, wrote his essay "The Theatre and Its Double." Artaud too, felt that the communicability of experience was threatened. He laid part of the blame on the emphasis placed on the medium of language itself. The conventional language of the theatre, according to Artaud, was failing. He made an impassioned plea for a return to a language of the theatre that was not based on the written word, but was instead based on the body and the psyche of the performer. He objected to the separation of the functions of author and director. He objected to the subservience of gesture, image, music, and dance to the written text. The basis of emotions, physicality, knowledge were to be found in the bodies of the actors, he felt, not the script of the playwright. As he assaulted the ability of words and rational discourse to carry the full potential of the theatrical exchange, Artaud looked to cultures where he felt basic sensual human communication was undamaged by advances in technology, militarism, transportation. He looked to and for cultures where people still had a respectful relationship to the natural world, with their instincts and intuition, and with each other.

In the Cambodian Theatre, which he saw in Marseilles in 1922, and in the Balinese Theatre, which he saw in Paris in 1931, Artaud found models of a "total art form" (Wagner called it, in German, *Gesamtkunstwerk*), a nonliterary theatre which embraced all the arts equally. On a more modest scale, this "total art" can be found in the village rituals of all primal oral cultures where storytelling is still a chanted, danced, told, drawn, ges-

tured form for communicating experience, history, the values of the tribe. If Walter Benjamin said that the communicability of experience was dying out, Artaud said that in the Western theatre it was already dead, and that new forms based on movement and sensual image as a means towards "truer" communication must be found.

Though they used different means, and came to different ends, both Artaud and Benjamin saw a decline in the effectiveness of human communication, and as a result, a decline in the transfer of real knowledge. Both Artaud and Benjamin were moralists. Artaud saw the actor/creator/director as an alchemist who could provoke spiritual transformation in the audience. Benjamin wrote that every real story "contains, openly or covertly, something useful." Both located storytelling as a primary experience—a direct exchange between the performer/teller and the watcher/listener. "Counsel woven into the fabric of real life is wisdom," wrote Benjamin. "No image satisfies me unless it is at the same time, knowledge," wrote Artaud.[2] I agree with both of them. The point of storytelling, of performing, is to communicate something of value, something one has learned.

Isadora Duncan attempted to restore to dance the potential for spiritual transformation and expression. Artaud made a similar plea for theatre. Performers today live in an era of theatre that is post-Artaud, and of dance that is post-Duncan. Yet they are neither as hostile to language, nor to the traditions of dance and theatre techniques as were their groundbreaking predecessors. Neither are they as subservient to the written text or to classical convention as in the time before these groundbreakers. Performers today, to make a wide generalization, are determining performance values through their own experience, and particularly in and through their bodies. They are finding ways to voice them which feel true to their fundamental origins in human experience. As they turn to those primal modes which our own culture does not seem to hold in high esteem—dreams, visions, power songs, ecstatic dances—it is no wonder a kinship is felt by many with the traditions of those primal cultures that never devalued them.

As contemporary performers place themselves in a lineage of storytellers who in oral cultures have acquired knowledge through vision, dance, and transformation, they also seek integral forms in which to communicate what they have learned. Their performances may look different from the traditional dance and theatre of our Western culture because they are built on ways of "seeing reality" different from those our culture prescribes. The storyteller/performer takes his or her body into the realm of the story.

In the rest of this chapter we will look at the contemporary search for origins, for the ground of theatrical experience; at how

the communicative potential of language and gesture are being explored. We will look at some of the kinds of stories that are being told and the forms that are being found by which to express them. Finally we will consider one of the most basic functions of the storyteller—to remind us of our mortality.

Origins

> Down through the workings of his own throat to that place where breath comes from, where breath has its beginnings, where drama has to come from, where, the coincidence is, all act springs.
> CHARLES OLSON, "Projective Verse"

We are reminded of the involuntary relationship of breath and emotion, of utterance and movement if we are suddenly startled, if we rise suddenly from a chair, when we are dismayed, when we are ecstatic. We can see this coordination of response in the behavior of animals: if the wolf mother, nursing in her den, is intruded upon, she raises her hackles, lowers her tail, issues a low warning growl from her throat. Posture, breath, vocalization, movement are integrally fused. Except for those moments which catch us off guard, most humans have lost this capacity for integrated response, even though the nerves and muscles of our breathing, speaking, locomotor systems are exquisitely interactive. Vocalization is a natural thing, a primary sign of life. When the infant cries at birth everyone present breathes a sigh of relief.

In oral cultures, sound is an event. Words are thought to have great power. Sound itself implies the presence of power. A hunter might see and smell a lion without excitement; but when he hears the lion roar he will become fully alert.[3]

Performance artist Terry Fox cites as inspiration for his work how "the Sioux Indians, before they sing, they give a yell. And it's a one-breath yell that they give, and it's as loud as they can yell it. And in that yell is contained the whole structure of the song they're about to sing . . . The song is an elaboration of the yell."[4] In looking for the bases of the elemental theatre, for the root of the desire to exchange experience we must, like the singer who yells, return to the breath.

The old Dogon wise man Ogotemmeli was asked where the Word came from. Ogotemmeli, like most great storytellers, did not like to give direct answers. He replied:

> The Nummo, who is water and heat, enters the body in the water one drinks, and communicates his heat to the bile and the liver. The life force which is the bearer of the

Word, which *is* the Word, leaves the mouth in the form of breath, or water vapour, which is water and which is Word.[5]

The Hebrew word *dabar* means both spoken word and an event or action. According to philosopher Rudolf Steiner, there was a time when "the word Pflug (plough) gave man the same inner experience as the activity of ploughing."[6]

Sounding/speech is an action, a gesture. Placing language in the realm of the physical, and placing movement and gesture in the realm of language, allows us to integrate all the powers available to communicate. Making use of all modes of communication is taken for granted among storytellers of oral cultures. Oral poetry is kinetic ritual. Knowledge is danced and sung. To know is to be moved by song, to be alert and quick. A man of knowledge, it has been said, dances his wisdom.[7]

Yet in the high art forms of Western culture, the dancer is taught to be silent. The actor has become overly reliant on words. Movement is the province of the former; spoken dialogue, memorized from a text, the province of the latter.

I sensed there was a potential integration of disciplines when I began my dance training, but did not know how or where to look for it. In learning the nonverbal art of dance one learned to communicate with the whole body, yet the voice was strangely lacking. The approach of literary drama, as taught in colleges in the early seventies, seemed also to lack something essential for me. What a revelation it was then, in Meredith Monk's classes at the Naropa Institute, to exhale a hearty HAH!

Our voices belong first to our bodies, only secondly to our native language. Initially, our language is not translation of experience; sounding and moving, including speaking, *are* our experience. We voice our feelings before we have words to frame them in. Can it be that as we acquire language we lose some of our innate abilities to voice our deepest feelings? If so, we can regain them. In the pre-memory state of infancy, before we learn to speak, time is seamless. There are no verbs and nouns, but there are recognizable sensations—pain and cold, heat and fear, hunger: "Wordlessness means that everything is continuous. The later dream of an ideal language, a language which says all simultaneously, perhaps begins with the memory of this state without memories," wrote John Berger.[8]

It is to this state I am brought during Meredith Monk's epic solo from "Education of the Girlchild." Monk begins as an old woman sitting motionless before us for half an hour on a plain wooden chair. She rises and begins a journey down a long road of white cloth, towards her childhood self. Her wordless narrative is like every song you have ever heard and yet like none. It is her

Figure 40. Page of text from "Vessel" by Bob Ernst.

Figure 41. Meredith Monk in "Education of the Girlchild." Left to right: Meredith Monk, Daniel Ira Sverdlik.

own song of power, song of sorrow, song of life's history. The texture of a life, of a history is embodied in it. Monk calls it "the voice of the eighty-year-old human, the voice of the eight-year-old human; Celtic, Mayan, Incan, Hebrew, Atlantean, Arabic, Slavic, Tibetan roots; the voice of the oracle, the voice of memory."[9] Monk takes sounds down to their elemental origins. The sounds are so primal that the part of ourselves we haven't accepted cringes sometimes at their force. Yet she also creates melodies so familiar that we feel we heard them in our cradle, or that we will hear them in our coffin, at our wedding, out at sea.

It is deep in the belly where we gather our sound, allow it to resonate, then send it forth. The performer investigating the voice becomes intimate with the entrance and exit of breath, learns how to leave it alone, direct it, expand it. One learns to fill all parts of the body with sound, energizing the total organism— the surface, the skin; the connections, the joints; the interior, the inner organs and spaces between them. Monk's revelation that the voice can be as flexible as the spine has resounding implications for the Western performing arts. The voice is a direct line to the emotions: in wordlessness, ironically, is the beginning of the path to reclaim the power of the word.

The search to find one's own voice can take one back to childhood, when babbling is the infant's sensuous enjoyment of the movement of breath over lips and tongue. Children understand magic formulas. Children, before learning to read, constitute an oral culture, and like other members of oral cultures they understand the power of words as events. They understand how words can be used to hurt or heal. They understand the taunt. They understand the verbal caress. In creating our performance "brother/sister," John Marron and I dug through childhood memory by improvising—babbling, scrambling, scrawling, sparring—until we had uncovered a potent language of childhood. Doing this required what is considered, by normal standards, foolish behavior. Here it is helpful to recall that the word "silly" has at its roots the Old English word *saelig* which means both holy and foolish. It may be necessary to allow oneself to be foolish in order to return to the meaning inherent in the body's utterance. The intent is not to defy communication, rather it is to regain an understanding of verbalization as a physical event.

Spalding Gray is an actor who was a founding member of the Performance Group, an experimental theatre company in New York in the sixties and seventies. In the last decade, Gray has become well-known for work which is based on his own experiences, without the filter of a playwright's script. The journey from more conventional theatre to performance work was one that Gray has described as, "slowly, *slowly* getting an idea of my own voice. Like Pinocchio."[10]

For Gray, a most important part of this journey to find his

Figure 42. Trisha Brown in "Accumulation," 1978.

own voice came, paradoxically, from finding what could happen within a silent moment. Until he began doing dance improvisation with choreographer Kenneth King, and improvising at Robert Wilson's loft, Gray had always been involved in highly verbal theatre.

In the sixties in New York, the performance scene was a provocative overlap of art forms. Dancers were beginning to use speech, actors were exploring movement improvisation, painters and sculptors were using the element of time in their compositions.

Gray's traditional training had accustomed him to psychological encounters on the stage where all feelings were identified and named. Going beyond this, he began to work with improvisation. Here he experienced

. . . a flow of feeling that I could not name because the flow, which was directly connected to the physical flow of body movement, happened so quickly and in a continuum that it was more difficult to pin down and name. There was only direct unmediated expression . . . for the first time I experienced being held together with a group of performers by something other than words . . . At last I had room for internal reflection. I could think as I moved. I began to have a dialogue with myself. My thoughts were freer because they were not tied down to a psychological story line of a particular text. At first I was just moving and experiencing direct feeling . . . but as I did this more and more, and got familiar with it, there was more room for reflection.[11]

While some actors, like Spalding Gray, have discovered the communicative potential of abstract movement, post-modern

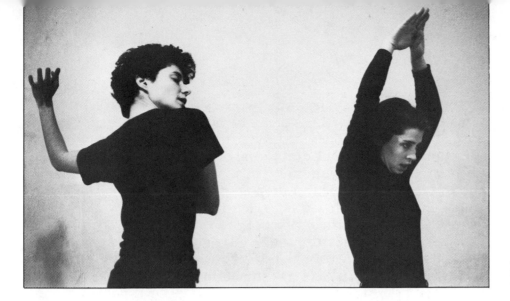

Figure 43. Wendy Perron and M.J. Becker in Perron's "Bad Day."

choreographers who, since Merce Cunningham, have been mainly concerned with abstract movement, have begun reinstating narrative into their dance structures.

I shall discuss three works of this sort. All three focus interest on the relatedness and disjunction of speech and movement. When simultaneously offered two distinct stories, one delivered to our eyes by gesture, the other to our ears by speech, which do we choose to follow? This puzzle, as presented by these three works, has continued to reverberate in my imagination for years since seeing them.

In "Accumulation," Trisha Brown stands quietly in front of us, an engaging and personable presence. She begins her gestural story by twisting her wrists, thumbs outstretched. It is not a movement you are likely to have seen someone do before, so instantly you take notice. She repeats the gesture, adds a new one, a twist of the hip, and returns to her own neutral stance. She begins with the first movement, then the second, adds a third, returns to the first. The movements accumulate. The idiosyncratic first movement becomes a recognizable landmark as the sequence lengthens. then again, after some time, it loses its familiarity, as does a word repeated over and over. Still, the predictability of the sequence makes each addition a revelation. While this is going on, Brown verbally tells us a story having to do with performing this very dance at another time and place. The gestures begin to take on new significance in the context of the spoken story. They seem to illustrate the story, and at the same time the phrasing of the gestures seems to affect the way she tells the story. The two stories are separate but inseparable. We can't help but integrate the gestural and verbal narratives for ourselves, even as we marvel at Brown's virtuosity in adhering to the formal structure.

In Wendy Perron's "Bad Day," two speaker/dancers (Perron and M.J. Becker) stand side by side facing us. Simultaneously each begins to tell the same stories of war atrocities while illustrating their stories in abstract gesture and what looks like

American Sign Language. The two sets of gestures are different, whereas the texts are the same. Perron keeps her gestures close to her body. Becker uses a large volume of space, occasionally diving onto the floor. The emotional emphasis and phrasing each gives to the stories is unique. The disparity of gestures and of their verbal styles give the already chilling anecdotes an additional eeriness. While we struggle to decide which performer's gestures to believe, the impact of the verbal stories dominates. The disjunction of gesture and word becomes intrinsic to the effect of the stories. Although not all of us have experienced war directly, we may still feel its impact on our lives. The stories Becker and Perron narrate are secondhand, so to speak. Yet Perron has constructed a form that honors her remove from the experience as well as delivers the impact of emotion inherent in the content.

The form of Nancy Stark Smith's "Correspondance" leaves room for the unexpected. The form is this: Smith conducts a nonverbal conversation by dancing an improvised contact duet with her partner. At the same time, she carries on a verbal conversation with someone else, who is not dancing. The identity of either partner may change. When I saw the work, the dancers were Smith and Nita Little, and poet Peter Orlovsky was the conversant. The piece investigates the correlation between the communicative powers of language and the languagelike features of dance. Dance, the piece bears out, requires a fuller physical involvement in the communication act than does speaking.

Just as the dance was not predetermined as to shape or dynamics, so Smith's conversation with Orlovsky was not predetermined as to content or duration. Orlovsky had just returned from the hospital where he had visited a friend in critical condition. Smith and Little began their dance; it was breathtaking to watch these two women lift, spin, ride each other's waves of momentum. Orlovsky began to tell Smith about his friend. He described the friend's pitiful condition. Though surprised and dismayed at the nature of the conversation, Smith pursued it gallantly, asking questions and voicing concerns. The nature of the verbal information was so disturbing, however, that the dance between the two women began to degenerate. Though they had begun in impressive attunement, the two dancers began to falter and miss. At one point Smith completely miscalculated her partner's descent and the two tumbled to the floor. Orlovsky persisted in unburdening himself of the terrible scene he had just witnessed in the hospital. The dance ground to a halt.

For me, the dissolution was the success of this emotionally daring performance. The interplay of the verbal story and the dance displayed itself accurately. Witnessing the effect of the conversation on the movement of the dancers, we share the urgency and heartfelt emotion of the telling.

Artists like Trisha Brown, Wendy Perron, and Nancy Stark Smith play on the selectiveness of our perceptions to show us how interconnected they ultimately are.

Big Stories, Little Stories

Listen, one heart speaks to another.
REBECCA STEINMAN (my grandmother)

After we have located our physical voices, felt them issue forth from the breath with which we warm our bellies, what kinds of stories are we going to tell? We have found the source in our bodies where the stories are remembered—lodged in our nerves, muscles, and joints. A wide range of kinds and sizes of stories are being explored by experimental performers today. The range goes from creation myths to family portraits.

Myths are some of the big stories that have come down to us through time because from generation to generation there has been a consensus of their value. In oral cultures where myth and story are the repository of knowledge, myth is everpresent on the surface of everyday life. The near and distant past are as obvious as the water one drinks, the hills one walks across, the way the stars come out at night. As the old standard says, "the fundamental things apply, as time goes by."

Even though we may have ventured far from belief in our culture's old myths—the myths of the Greeks, the stories of the Bible—there remain permanent, archetypal themes and motifs which are as essential to our life and thought as are vertebrae and lungs to our bodies.

We tend to think in patterns resembling the old stories, because we have the old stories, if we're lucky, at the back of our brains as containers to hold our present experiences. The folk tales and fairy tales and myths we listen to with great fascination as children, as they are told to us over and over, help to "story" our psyches. Even if we have not heard them directly, these stories are present in our culture because they are the myths and stories our culture are based on. To acknowledge myth in our everyday lives, to seek to know by telling a story, is creatively to reconstruct the past and to be wide awake in the present.

In times past and in other cultures, communities had rituals in which they gathered together to affirm collectively the meaning of events in their lives, and to mark the moment of life's transitions. These rituals, usually involving dance and rhythmic song, reminded the participants of the bases of their society's structure and power and its relationship to the natural world.

In the West, there is no longer one Big Story which we all believe in, which tells us how the world was made, how everything

got to be the way it is, how we should behave in order to maintain the balance in which we coexist with the rest of the cosmos. The old rituals are no longer widely practiced, and it is no wonder some seek to create new ones.

Not long ago I saw an exhibit at the Jewish Museum in New York entitled "A Precious Legacy." The exhibit consisted of ceremonial and everyday objects from the former Jewish community of Prague. The Nazis had confiscated and catalogued these objects as part of an attempt to create an "anthropological museum" of a vanished race. The objects were rediscovered after the war and are now traveling from museum to museum, testament to a lost way of life and to the role of ritual in a cohesive society.

In one of the rooms of the exhibit were the objects relating to death. There were the giant ceremonial goblets of the burial societies, which volunteered to take care of the dead and the dying. There were a series of paintings which depicted their tasks: visiting the ill, prayers at the deathbed, taking custody of the corpse, sewing the shroud, washing and preparing the body (considered the greatest deed one can do for another because there are no thanks), making the coffin, digging the grave, and so on. Each village had its burial society. The rituals surrounding dying were known to all in the community.

I feel many of us sense the loss of rituals and stories which help us to face the crucial transition points in our own lives and in the life of the entire fragile planet. In creating stories for our times, performers find an affinity with peoples of oral cultures and adherents of "old wisdom," who are still connected in their communities through common beliefs and traditions. Like these, the performers believe in the whole body as an organ of knowledge; they believe in the capacity for and necessity of personal transformation; they believe in the value of ritual and storytelling to create meaning in our lives; and they believe in sharing this search, with the wish that others, too, may find something of value in it. Performers' stories, their fragmented narratives, may not manifestly resemble the storytelling of old, yet it stems from the same humanness.

An Iroquois storyteller remarked to contemporary storyteller Laura Simms that

the reason why we don't tell those stories the way they were told a long time ago is that we don't believe any more that a man could become a bird or a bird could become a man, so we have to tell them differently.[12]

In his book *Cheyenne Memories*, John Stands-in-Timber recalls that the old Cheyenne storytellers began their sacred narratives

by smoothing the ground and going through a brief ritual of marking the dirt and touching their bodies. This indicated that the Creator made humans and the earth and that the Creator was witness to what was to be told.[13]

At the beginning of "The Pine Cone Field," the fourteenth section of Kei Takei's ongoing theatre/dance epic "Light," a dancer enters and sets down on the ground a bundle of folded cloth. By peeling flaps out from the center of the bundle, she stretches the delicate fabric to the limit of the space so that it covers the ground. The performer smooths out the wrinkles. Another performer enters with another cloth bundle. He repeats the ritual of unfolding the square and smoothing the ground. By the time this ritual has been carried out four or five times, the entire stage area is transformed by the cloth. The space has been readied for the rest of the drama to unfold.

As a child in her native Japan, Kei Takei immersed herself in Japanese folklore. As an adolescent she went through a traditional apprenticeship with a master dance artist. To watch her constantly evolving "Light" is to get a sense of those old tales and traditions as embedded within Takei's own rich inconographical and gestural vocabulary. As her dancing tribespeople gather loads of stones or stealthily pilfer from one another's baskets of firewood, or travel what might be miles against an invisible wind, I am reminded of the woodcuts of Hokusai, figures on a primeval landscape persevering through numerous adversities for reasons we can only begin to fathom. If there is one overriding moral to Takei's post-Hiroshima allegory, it is that they persevere and this is surely something powerful.

In the twelfth section of "Light," "The Stone Field" the lights come up on Takei, a slight and wiry woman crouched in the middle of a ring of stones. She clacks two stones together as accompaniment to a Japanese folk song she sings in an eggshell-thin soprano. The ten members of the performance company, The Moving Earth, engage in a lively, rhythmic dance of stamping feet, thrust-out joints, clacking their stones in a ring around Takei, as if she were the queen bee. They dive onto their knees to gather or push their smooth, rounded stones into a pattern like a honeycomb, a code of behavior they seem to understand. Inseparable from their weighted moves is the sound of sharp exhalations, punctuating the rhythmic shock of rock against rock. The men lunge towards one another in a challenge dance, exhaling rhythmically. They move, sound, breathe in one integrated action. This is not a land of easy living—people gather food and fight and die and the group struggles on. Their behavior and movements at times resembles that of animals. They can quickly drop to their haunches and scamper off; they can take

weight on their forearms. And they are subject to the domination of unseen, but felt, physical forces. Wild winds whip around them, yet they stagger on.

Yet all is not combat, suffering, endurance in Takei's "Light." In "The Daikon Field," Takei dances a solo of exultation, of unity with the growing plants and her joy in their cultivation. When I saw the work recently Takei was five-months pregnant and her bent-legged, arms-raised jumping amidst the clutter of silken daikons (Japanese turnips) on the stage was an especially poignant celebration of fertility.

Long after Takei's danced stories have ended, I still can hear the rhythm of the stones clacking, the exultant "ha!" she uttered as she caught the daikon tossed to her in midair. The sounds bring to mind the characters who uttered them, worked to them, battled to them, the determined beings of a society before time. Sifting through her own experiences, her imagination, her cultural tradition, Takei assembles a primal drama of astonishing complexity and power.

In Meredith Monk's "Plateau Series" one is witness also to a timeless, primordial scene. Three women in what feels like a wide expanse of prairie go about their daily tasks: washing, praying, struggling, playing, dying. Each woman is a unique type: a tall, thin, gracious elder (Tone Blevins); a compact, feisty Amazon in baggy culottes (Ellen Fisher); a soft, round gentle one (Mary Shultz). A repertoire of specific gestures, postures, movements is shared by all of them, yet these take on individual meaning according to each woman's character. The women are like separate panels in a triptych; their distinct themes are united and together they tell one tale, form one society.

Monk's story takes the form of a visual fugue. The tall thin dignified woman bows, balances on one leg and makes a twisting motion with one hand that suggests she is pulling in the skein of her life, her own fate. She seats herself and wraps her long arms around a clay urn. When she shakes it, beans or grain kernels rattle musically against the earthenware. The Amazonish woman is a woodcutter. The swing of her sharp ax is sure, determined. The third woman is washing clothes, washing her body. The sound of cloth falling into her buckets and over her breasts is soothing. These very concrete sounds—the rattle of beans or grain, the thwack of the axe in wood, the swipe of a wet rag over a woman's torso—help to establish a distinctive sense of time and place which is not separate from the time and place of dream.

In both "Plateau" and "Light" figures move in timelessness almost like creatures at the beginnings of the world in many a primitive myth. The women in "Plateau" and the tribespeople in "Light" work at their appointed tasks. They become posses-

PLATEAU SERIES

solo #2	duet #1	group #3
walk in	xxsing in place 1st	song- darkness- porch
song in place- porch	sing quarry in t.	ellen wood
shout- in place	light on	kasia water
walk to spot	train-light on rocks	tone movement-singers enter
movement- scanning	general light come on	running down mountain
song and movement jade lullaby	mm. find spot (bird) sun eyes	lullaby- mya mya with movement
take off shoes	hang out clothes	train-blackout
walk to spot	sit down-sing lullaby	kasia washing
turning-wa-lie -oh	horses hooves	ellen at night
arms foled walk forward	l. as animal	gail-double
animal dance -	mm. into tent	blackout-birdsong
pouring rocks	clatter of pots	running down mountain
song in place-breath insect	bring out water	tone shakes rocks
descending--movement	wash	old women into warrior
bird and cartwheel	backwards movement into point-drone	preparation for sleep sleeping
wash with birdsong	coutch	train- dream dance
point	running	insect song- movement cartwheels
running down mountain	breath song	tone drops rocks
old woman--song	l. double	singers walk-wa-lie-oh
warrior	sick woman	kasia- sick woman - laying on of hands
running in circle	l. gets bed	dirge-spinning
scanning snakes	snow	blackout
sleep-train	red lights- dream and news or music	pointing circles- running- dancing
get up-skia -	blackout- train	dirge-breath
drone finger and circles	general lights	square dance
sit down	mm. bird and 4 corners	the visitor
wipe mouth	l. spirit sweep	crickets
drink ?	hello-goddbye onions, piano, news	three little houses goodnite
skia -	mm. to rocks-dirt play rocks- trance	
	l. dance	
	mm. and l. face audi.	
	mm. sings in dark	

Figure 44. "Plateau Series" by Meredith Monk, solo/ duet/group score.

sed by unseen forces and spirits. They rest in reverie. Movements emerge from still tableaux, which last long enough to let the static image make its impression on us. The tale ends but it could just as well start over again.

The Stories of Our Lives (The Givens)

As a child I remember the sensation of having an "inner narrator," someone who was telling my story as it unfolded. Now I recognize that watcher as the part of myself who is the storyteller, driven to look back over periods of time and discern the shape of that story and how that story is also a part of my culture's story, my ancestor's stories.

The desire to see one's life as story becomes more common as we grow older. In the last several decades there has been a resurgence of interest in gathering oral histories of our elders, providing an occasion and a listener for the memories of a life to be narrated in some unified form. The word *narrate* is related to the Latin *gnoscere*, to know. To create a narrative is a way of seeking knowledge, understanding.

My grandmother was my primary storyteller. I had never thought to record her big story, so deeply is it embedded in my memory, until she was seriously ill two years ago. I came for what I thought might be a last visit and brought my tape recorder with me. I walked into her room and sat on the edge of her bed. I set the tape recorder between us and turned it on. Neither of us looked at it or acknowledged it. Without prompting, she told again her own big story, an archetypal tale of betrayal, revenge, flight to the New World, death of the firstborn. "This," she said finally, "is the story of my life." At precisely that moment the tape recorder clicked off and I got goose bumps on my arm.

Fact merged with fiction, vivid detail mixed with folklore is my grandmother's way of seeing the world. Telling her story over and over has been a way for her to set her life in order. Sometimes she delights me with a new little story, one I've never heard before—like the hilarious one she told me recently about the woman buying a chicken for Sabbath supper and discovering a needle in its innards. Is such a chicken kosher? The advice the woman seeks, and finds, illuminates something essential about a community that lived by a shared belief that the law allows for compassion, for bending the rules a little bit.

There are all kinds and sizes of stories. I can tell you how I cut my hand tending a windowbox of seedlings yesterday. The glass was sharp. Or I could tell you why the moon wasn't visible in the sky last night. The stories may or may not be true, but they make their point.

There is a very human impulse to talk about one another, as well as a very human impulse to recount what has happened to us. In the introduction to his wonderful collection of stories about life in rural France, *Pig Earth*, John Berger writes of the importance of gossip to a village's awareness of itself as a society. Past and present mingle in day-to-day narrations. A story about what happened in 1834 or one about what happened in the barn that morning may take on equal importance at a particular moment. Berger writes

> Most of what happens during a day is recounted by somebody before the day ends. The stories are factual, based on observation or on a first-hand account. This combination of the sharpest observation, of the daily recounting of the day's events and encounters, and of the lifelong mutual familiarities is what constitute so-called village gossip.[14]

In her performance/film work "Tall Wheat," Susan Banyas evokes the ambience of the small-town Ohio life of her childhood. Playing all the different characters herself, Banyas transforms at one point into the village gossip who wanders through a field of white tombstones. Each tombstone holds a soul, is the site and the occasion for stories of the loves and deaths of those interred. The village gossip narrates her tale in both word and movement. She recounts how

> Maud was married to Will and just before she died, she told Grace, I don't mind dying. I just wish I knew what was on the other side. After she died Will couldn't get over it. He went travelling. He sent Edith Irene a red sweater from Switzerland. Well he came back and he married this young woman named Jean. She had these ruddy cheeks. Well, he couldn't be a proper husband, and he had a nervous breakdown, and Jean had him committed. He was diagnosed as a schizophrenic. Edith Irene found a letter he'd written once. Get me out of this hell hole. They keep me locked up here all the time. Well they never did and he died in the state hospital.[15]

"What makes people the way they are?" Banyas is ultimately asking. Part of what makes us who we are are the storehouse of memories that guide us.

Speculations about the mythical beginnings of culture may be the impetus for works like "Plateau" or "Light" in which a parable about our cultural origins is enacted. As well, the smallest events of daily life, one authentic detail out of a life's many stories can also be a starting place.

Helen Dannenberg is a choreographer/performer now living in San Francisco who grew up in a close-knit Jewish neighborhood in Brooklyn. In her home the Jewish traditions were observed. As an adult Dannenberg moved out to California where, she noted, "everybody was madly celebrating Christmas and Easter." The assumption that these were the celebrations common to *everyone* was a foreign one to Dannenberg. It was in her kitchen, as she prepared *latkes*, the traditional Chanukah potato pancakes, their smell filling the room, that she began to conceive of her dance/theatre work "Album."

I felt that people don't know what other people's memories are, they don't know how they grew up, they don't know what happened in their lives and that my way of growing up had certain things that are just given . . . And any person would have a whole set of givens, everybody has a set of givens.[16]

In "Album" family stories (recorded on tape) from Dannenberg's past are put together with choreography for Dannenberg and

Figure 45. From Helen Dannenberg's "Album." Performer: Marsha Paulson.

three other women dancers. Sometimes the physical language of the dance and the verbal story may coincide. A story about the special plates required for one holiday meal is simultaneous with a hilarious and precisely rhythmical plate-tossing dance among the women. The stories range from how Dannenberg skipped her last month of Hebrew school without ever telling her parents to the revelation, which sets her childhood in a historical framework, that her father had two sisters, not one—"Aunt Dvora who died in the Warsaw ghetto."

"There is no part of my personal record," writes James Hillman, "that is not at the same time the record of a community, a

society, a nation, an age."[17] As we tell our small stories and connect them with large ones, we create meaning out of our life.

Scheherazade (Making a Narrative Without a Plot)

Incredibly slowly, our view begins to slide . . .
"Private Parts," an opera by Robert Ashley

Virginia Woolf referred to the "semi-transparent envelope surrounding reality," the "fragile skin" which encases what might go on in our minds in the flicker of a moment, the journey of a day, the lifetime of an hour. As artists have moved away from the linear perspective in painting and the linear plot structure advocated by Aristotle in literature and theatre, readers and audiences have been invited to "step outside" their normal reality. The storyteller (for our purposes the storyteller who creates performances) stops time for the audience. He or she invites the watcher to enter the time of the story, to dwell on its inner storehouse of images along with their own.

Our unconscious mind processes thought quickly, like fire moving over a field of dry brush. Ideas dart. The way your father looked at the breakfast table in 1956 flickers past the image of your small son eating his morning cereal. You walk across the room carrying the teakettle to the waiting teapot, and on that journey you've re-thought your marriage, planned your shopping list, remembered your friend's new blue shoes.

"I am bored by narrative," Woolf wrote in her diary in 1929, near the same time Benjamin was noting the decline of storytelling.[18] The narrative Woolf was bored by was what she called the "appalling narrative business of the realist: getting on from lunch to dinner." Instead, she looked to give the moment whole, whatever it may include. "Say that the moment is a combination of thought, sensation; the voice of the sea."

Our moments are a dense layering of sensations, ideas and information. Today we are confronted with this fact in a more drastic way than Virginia Woolf contemplated. The phone may ring with news that a relative is dead halfway around the world. You can be there for the funeral in a day. Our synapses are primed for quick transitions; yet, there is a depth of experiencing missing in all this that comes from standing still, from taking time out to inhabit a story, meditate on an image, listen to the tale implied in a wordless dirge.

"When I tell these stories, do you picture it? Or do you just write it down?" a Zuni storyteller asked anthropologist Dennis Tedlock.[19] To tell a story and to receive a story, you have to be

inside the story, to find your place in it. The storyteller leaves it to his audience to interpret events for themselves. Mysterious and marvelous things are revealed, but their meaning is not overly explained. The connections are for the audience to make for themselves. In Meredith Monk's "Turtle Dreams Cabaret," we find ourselves situated in a cabaret, actually, as well as within the play. We sit sipping drinks, our gay social interactions in ironic counterpart to the images Monk puts before us. Performers onstage dressed in post-nuclear chic (cones with flashing lights seem to grow out of their heads and shoulders) cha-cha and waltz to a vocal medley of cataclysmic sirens and wails. A woman sheathed in black save for her hands and face enters. She joins her fingertips in front of her as if encircling a crystal ball. Her fingers dance, the ball seems to disappear, then to reappear. She is illuminated by an eerie light reflecting from the underside of her flat disc-like hat. A rhythmic engine sound accompanies her, rising in intensity to a thunderous clatter. It could be our civilization's death rattle. Via a film we see a turtle, symbol of wisdom and endurance, plodding over a map of Sakhalin Island, where a Korean Airlines jet was recently shot down by the Soviets, who claimed that the plane was spying. As the turtle marches stolidly onward, the ominousness of that event is brought forward in my mind. Monk has placed me in her narrative—as a reveler at a cabaret at a time that could be ten seconds before the Big Bang. But this is my own interpretation, informed by my own thoughts, feelings, concerns.

Juxtaposition and simultaneity are more the methods of this lively art of inner and outer reality than are transition and linear development. Narrative need not follow chronological sequence. Sequence of any kind can be narrative. Inner logic (dreams, symbols, concepts) also narrates, and this inner logic is well-suited to live performance. Martha Graham, a consummate storyteller, understood this. She used these techniques to "stop time" in order to let us enter the inner lives of her archetypal heroines shown in moments of crisis. In "Seraphic Dialogue," for example, Graham tells the story of Joan of Arc at the moment of her ascent to sainthood. As Joan meditates on her past, three other women in succession perform solos as aspects of Joan's self: Joan the maid, Joan the warrior, Joan the saint.

This new and yet ancient literacy is a recognition of the saturation of a single moment, a reconstruction of the complex "inner speech" we are uttering within ourselves while we peel potatoes, walk the dog, create a dance. Although we may be unused to recognizing this mode of awareness, our memories and our attention can be trained to conceive "unitively in simultaneous occurrence, as well as historically in chronological unfolding."[20]

Figure 46. Storyboard of the hostage scene from "At the Falls" by Rob List.

Performer/director Matthew Maguire, in a manifesto on performance, wrote:

I fragment, suspend and recombine the many stories coming into my eyes. Each one is a straight, linear story—but I don't experience reality that way. They're all flooding me at once, interweaving, overlapping, intercutting, overriding, interbinding, overtoning. I take the pieces, I chop them up, I keep them all floating at once, and then I reintegrate them so they fit at the same time. Then I go into a vast rushing free fall.[21]

Collage, Maguire affirms, is the form best suited to this reintegration of inner/outer reality as living performance. "Composite theatre" is the term Meredith Monk has used for her theatre/dance/music amalgamation. The word composite shares a root with the word compost. In composite theatre one takes the elements, the sounds, the images, the gestures revolving around a given theme and place them in fertile contact with one another, where they break down to create a new luminosity, the heat provided by the performance. The final juxtaposition of the elements, the sequence ultimately chosen to place them in, is not random. "In large theatre pieces," Meredith Monk has commented, "the challenge is to balance the movement, music, visual imagery, sound, objects, and light, so that everything works together with a certain inevitability."

Ping Chong, as noted earlier, sometimes uses the word *bricolage* to refer to his theatrical compositions. His method is to create something new out of memories, objects, oddments leftover from human endeavors. He speaks through the medium of these chance objects and events in a way that awakens us to our inner flow of awareness. When Chong juxtaposes the sound of a weather report with the image of a boy asleep at a table before his birthday party, he is setting off an explosion of comprehension in the viewers' minds.

Montage is the word used by the Russian film director Sergei Eisenstein to imply how "any two pieces of film stuck together inevitably combine to create a new concept, a new quality born of a juxtaposition."[22] Certainly the innovations of cinema in our times have fundamentally affected the traditional Western perception of time, space, and reality. The possibilities of the cinematic form are perfectly suited to convey the restlessness and speed of the human mind in action. It is not surprising, then, that its principles have affected the working process of experimental performance artists. Performers now use the filmic concepts of montage—cutting and rearranging the fragments of sensation and experience into a new live composition.

"Traces of the storyteller cling to the story the way the

YARN

Oct. 30

met Mary Ashley after Steve's performance. told ~~you~~ her about seeing "Eat Your Totems..." in Portland and watching a woman untangle her yarn. She told me about a woman whose being in the body task after gaining enlightenment too far ahead of herself, was always having to untangle yarn.

Figure 47. Journal page, Melanie Hedlund.

handprints of the potter cling to the clay vessel," wrote Walter Benjamin in his lament for the disappearance of this craft of experience. Traces of the storyteller cling to the story the way the quality of a woman's stitch is still revealed in a centuries-old quilt. The size of the stitch, the choice of the patch, and the pattern—all these variables are present in the final product. Choosing a pattern, like the quilter does, gives form to the chaos of incoming sensations, the bombardment of stories we undergo in our lives. Choosing the pattern—perhaps traditional, perhaps not—assists the viewer in assembling pieces of experience into meaning. As performers, we take apart, recombine, snip off, and stitch together those many layers of our experiences. The making of the performance is one way to resolve the experience with

CRAZY SCRIPT - 30 MARCH

① SOUND ONLY- OFFSTAGE
HAMMERING /SHARPENING Tools (files)
Jew's HARP adds ; perhaps mandolin

② LIGHTS UP TO DIM
SET - BACKSTAGE LEFT : couch - Oriental rug
PIANO w/ flowers and shawl
table w/ gramophone
hanging window / ladder underneath

character pacing back & forth w/ scroll containing
medical diagram of HUMAN HEART
shadows on scrim behind. Lights cigarette
from case on piano - sounds increase in tempo giving sense of
darkness, passion, mystery, waiting, time passing. Climbs ladder, hangs diagram from it.
THIS IS DON FABRIZIO. Servant enters with mail & brandy
on a silver tray. D. FABRIZIO IS AGITATED. He moves to
gramophone, waits, hears nothing, puts ear into horn, still nothing.
Frustrated, turns away. As he walks away, static begins, then
louder, then voice of CARUSO.

PAN OF FACES
OF MEN & BOYS
interest w/ trees

③ SERVANT rings for musician. He enters with suitcase, sets on piano
opens up for sheet music. Begins. Telephone rings. Servant "Pronto"
hands it to pianist. Don F. is involved in the heart diagram.
Pianist is shouting, hanging up phone and reciting passionately in
Italian. Atmosphere is quirky, chaotic but underplayed.

④ Don F. has missed his cue from his musician. Servant has to
nudge him out of his study of diagram, quickly removes his
waistcoat so DON F. can move downstage and begin the
aria, "ZAZA" with the pianist.

military
jacket
dark pants

⑤ PASSIONATE rendition during which pianist takes time out to have a drink,
Servant cuts a strand of hair while DON F. is on his heels in pleading
part of aria. At end, DON F. is exhausted. Takes out a cigarette which
Servant lights, wipes his forehead.

FILM SOUND
FIOFO DELLO
SCARRAFONE
(black beetle face)
CALABRIA · men
STORNELLO A BOTE
(accordion)
MEN'S SHOTS

Figure 48. Page of script from "From the Dreamworld of Men," a film/performance work by Steve Clorfeine.

which life may overwhelm us. Practicing the disciplines of physical and verbal improvisation, or developing awareness of our dreams puts us directly in touch with the vivid kinesthetic flow of thought and memory. The performance is the way we ultimately weave it together and these disciplines can make that weaving an illumination.

Our text is experience itself, which may or may not involve words and writing. This sense of *text* goes back to the origins of the word itself. Etymologically, a text is a woven fabric. To *rhapsodize* once meant literally, "to stitch songs together"—the way an oral poet would sing the many songs everyone knew so well, of the hero's journey through incalculable dangers, back to the safety of home.

Scheherazade never quite finished her story, even though she went on spinning the tale until the light of dawn appeared. The king, hooked, asked to hear its end the next night. And the next. Prolonging her stories was a wise strategy on Scheherazade's part. As long as she had the king's attention, she also had her life.

A plot is a way of keeping a listener or a viewer engaged. The structuring of plots familiar to Western culture is based on what Aristotle found in the Greek drama, which was one of the very early art forms structured by writing. The dramas of Aeschylus, Sophocles and Euripides were first written, then memorized and acted out. The tight climactic plot suitable to drama, Aristotle proclaimed, could be likened to the tying and then the untying of a knot. This kind of plot is still useful to novelists, but it is not the kind of plot most of us find ready-made in our lives.

The novelist Thomas Hardy grumbled to Virginia Woolf in his parlor one day, "They've changed everything now," he said. "We used to think there was a beginning and a middle and an end. We believed in the Aristotelian theory. Now one of those stories came to end with a woman going out of a room."[23]

A narrative, according to one dictionary, is "an orderly, continuous account of an event or a series of events." Narrative has been reinstated in various guises in contemporary performance and dance, but it is not always orderly. Some performers use "sort-of" stories or they hint at stories or they embed fragments of stories in primarily abstract work.

If they are not going to use the device of a linear plot, what kinds of frames do creators of performance devise for their works that will stitch them together and hold the audience's attention? The problem of finding a framework on which to structure the experiences one wants to share has a different solution for each work. The compositional form is an extension of the content.

I was in Jerusalem when I received a letter that my childhood rabbi had committed suicide. I was on a street corner in Portland, Oregon, when I read about the massacres at Jonestown.

My bewilderment about both events engendered the desire to find meaning in what struck me as meaningless acts. It was in the spring, Passover time, that I pondered the form this new work, "Lents Passage," would take.

The Passover seder is a ritual meal at which Jews gather to tell the story of the exodus from Egypt and the journey through the wilderness into the Promised Land. Here is the story of the origins of the Law, the ethics of the tribe and the story of perseverance over evil. There is a set order to the telling of the tale. Physical gestures help make the story more memorable. Participants dip a finger in the wine goblet and flick a drop of the red liquid on the table as each of the ten plagues on Egypt is recounted. They dip parsley into salt water to remember the bitter tears shed in the days of slavery. They spread a fruit paste on unleavened bread to commemorate the mortar used by the slaves to make bricks for Pharoah and to recall the fact that the slaves fled so quickly they had no time to let their bread rise. This meaningful ritual provided a theatrical structure for my own inquiry in "Lents Passage." The ritual meal is the narrative mortar of the piece. Recordings of my family reciting portions of the seder stories and parables "move" the piece along. The progression of the Passover meal is a device, like a plot, to give the watcher guideposts as images unfold: a Bedouin woman crying into a water vessel, a red handprint on a doorpost.

Coming up with the design for a performance is what Victor Turner calls, "the proper finale of an experience."[24] One has "gone through with" the making of a meaningful ritual for oneself and the viewer/participants. Susan Banyas noted,

This phase of the work is important because I have to ask myself, beyond just the collection of images, what is really being communicated? The formal elements, the compositional thread is necessary to support the organization of thought and experience for the performer as well as the viewer.[25]

"Trails to Treasures (it could be you)" was undertaken after I dreamed Susan and I were awarded the honor of being the first women to travel to the moon. Our research for this piece took us into moon mythology, into the story of the nymph Psyche, whose four tasks to reclaim Eros exemplify the spiritual development of the feminine. The different sections of the piece are marked by projected images of the moon, which progress from quarter crescent to full. The phases of the lunar cycle suggested to Susan and me the quality and sequence of the material that ought to occur.

It was by envisioning the way blood vessels circulate the blood within a human organism that Meredith Monk decided on the structure of her opera "Quarry," discussed in Chapter Three.

The labels in the image read: medicine woman, Spanish guard, Bay, prophet, woman in fur coat on hill, Couple, alarm, Bedouin Woman, Tourist, woman in hammock, Sphinx, onlookers, Lover afar

Figure 49. Map script of "Trails to Treasures (it could be you)" by Banyas/ Steinman.

The form of "Quarry" is not linear, it is a cycle of overlapping events with a sick child lying on her patchwork quilt as the imaginal heart of the historical circus. Characters appear, then vanish, then reappear metamorphosed as figures of another century.

I am working with time in the same way I am working with space, stretching it, compressing it, twisting it, manipulating it.[26]

Monk refers to a view of reality perceived with the whole body: mind, muscles, bones, nerves, eyes, ears, dreams.

"The Goddess," by Joanne Kelly is not a chronological "telling" of the events before and after she gave birth. It is, rather, a textural gestalt of that experience. Live action occurs between two large video screens. Filmed "chapters" from Kelly's domestic life alternate with the live, dancing Kelly. Her movements have a timeless quality to them; she is a journeyer, a pilgrim, she walks in place. The music accompaniment is serene, monotonous. In contrast, the video scenes are penetrating, alive with an infant's cry and other real-life sounds.

Alternation of images is a consistent tactic in "The Goddess." In a section called "Caring," Kelly's film cuts from herself carrying the new child to her husband carrying the child. In rapid succession, the mother becomes the father becomes the mother, unified in the act of caring. The figures move jaggedly through space as they alternate identity, sex. There is a close-up of the baby's pink smooth skin against the silk sleeve of her mother's arm. The arc-like form of the child in this protective hug is then repeated, only with the child's skin now seen against a man's hairy arm and rough woolen shirt. Kelly renders the physicality of the child, of childhood, with attention to focus and scale. These ordinary details are juxtaposed to live, metaphorical scenes. At the conclusion, Kelly, who has been dancing behind a white paper scrim walks forward, breaking the paper barrier. She crosses the boundary between audience and performer, and at the same time, that between her life before and after motherhood.

To render such a moment whole in all its facets is part of the performance-maker's task. How he or she chooses to do so and what he or she chooses as the frame on which to "support the organization of thought" for performer and viewer is a central challenge of the storyteller's craft.

Memento Mori

"There used to be no house, hardly a room, in which someone had not once died," wrote Walter Benjamin. The decline of the vividness and the omnipresence of death in the general con-

sciousness, Benjamin felt, was part of the decline in the value of experience, without which storytelling was losing its source.

Earlier, and in all cyclical views of time, death was seen as the ground which provided the friction on which the wheel of life turned. Out of death came new life. Out of the withering of last year's crops came enrichment of the soil and, eventually, this year's food. Time and the timeless were in symbiosis: we age and we die, and yet somehow everything remains the same.

A friend in Iran wrote me recently of coming upon an old woman in a remote mountain village who was, by all accounts, 130 years old. Still vigorous, she was collecting firewood when he met her. Yet, what she longed for, she told my friend, was death. "Why?" he asked her. She responded, "My husband was alive and now he is dead, and still I am alive. My children were alive and now they are dead, and still I am alive. My grandchildren were alive, and now they are dead, and still I am alive." She opened her mouth and pointed to new teeth breaking the gums. The cycle does continue.

In our own culture, death is usually out of our hands, and our elders are usually out of our sight. The way we shield ourselves from death exemplifies the way we shield ourselves from direct experience in general. The animals who die in order for us to be nourished are nowhere apparent in our supermarket consumerism. No longer is death, as Benjamin called it, "a public process in the life of the individual, and a most exemplary one." Death is rarely public, and death's publicity is more often through the disembodied medium of television, where the remains of victims of faraway and not-so-faraway massacres flit across our consciousness in between commercials.

The sixteenth century, an age of plagues, wars, and famines, was the period in which the dance of death motif (French: *danse macabre*; German: *Totentänz*) is thought to have originated. Originally, the theme was commonly rendered as a mural painted on the walls of a burial ground or in a church. The image depicted was of a procession of figures, both living and dead, animal and human. In the scenes cadavers or skeletons alternate with living forms. Often the skeletons are breaking in upon the activities of the living to carry them away to another realm. Death was depicted as omnipresent and universal. All were equal before it: the king at his feast, the merchant at his coins, the babe at breast, the adulterer in the act, the priest at his prayers. The "memento mori," the reminder of death, portrayed human mortality. In this kind of representation all who live appear in the company of skeletons, cadavers, skulls, or other symbols of death.

The lifespan of people in the sixteenth century was brief— about fifty years. Families usually buried more than one child. Executions were in public places. Funerals were frequent and

public. People died in their own homes. Graphic realization of death's ultimate victory, perhaps, helped people to come to terms with the ominous fate hanging over each and every life.

The sixteenth century was an age of faith. It was almost universally believed that the human soul was immortal, that each soul would be called upon to meet its maker at the Last Judgment. The dance of death reminded the viewers that they had best maintain a state of readiness, for they could be snatched away at any moment.

We all have our mortality in common. It is one of the storyteller's primary roles to help people confront this basic fact. And recognition of the mystery of death is one of the things that marks the spiritual separation of man from the beasts. Not only can we grieve, but we can create rituals in which we can grieve together. The skeletons unearthed from the cave burials of Neanderthal man are arranged in sleeping postures. Joseph Campbell wrote that "the analogy of death and sleep and the associated thought of a waking are clearly suggested in these finds."[27]

Storyteller Laura Simms told me:

What completely focused my life and gave me tremendous courage to do what I'm doing is helping my father to die. The conversations we had and the reality of his body fading in my hands and the magical events surrounding that moment, the synchronistic quality of the everyday world that was suddenly completely available—the birds that came—made me realize my stories were true. You're rarely as in touch with that depth of experience as you are at the moment of death.

A person's wisdom, his real life, assumes transmissible form at the moment of his death. The authority which the dying possess for the living around them is at the very source of story. "Death is the sanction of everything that the storyteller can tell. He has borrowed his authority from death," wrote Benjamin.

This year at the Passover seder, my ninety-one year-old grandmother kept interrupting the service with a vehemence I'd never seen before. "You think you know what this means?" she would ask, and then she would answer, "But you don't. I will tell you what it means." And then she would tell a story that was a story *her* grandparents had told her, which made clear the lesson of the ritual. She had never before made her interpretations known as forcefully, or as masterfully. Late that night after all the guests had gone she thought her time had come. Pale, a terrible pain in her side, she tottered into the kitchen and summoned my parents and myself into her room. She showed us where her burial dress was, gave us instructions for the funeral. We sat up

with her, held her, comforted her. That night, every story my grandmother had ever told was glowing.

In oral cultures elders are revered as the keepers of knowledge. It is their stories which contain the wisdom it is necessary to know for survival and for death. I see in performers today a desire to listen to those stories and to apply that wisdom, to confront the experience of death and all that it implies about our own lives and our own perilous times. The deaths which impel us to find meaning in life may be the deaths of those near to us. Or we may be so impelled by cultural death—such as the Holocaust—which attains the dimension of myth. Or it could be the spectre of nuclear death which haunts the entire culture and is as near to us as a missile silo in Iowa. Or it could be simply the sense of cultural loss in our civilization as a whole.

Death "stops time" for the living, as does the story. Both make available to us the depth of experience which exists outside our usual linear perception of time. When we are overwhelmed by the rush of a steam engine for the first time, that moment is forever accented. As we age, we see less and less with the intensity of first experience. Less and less time is accented, time seems to progress more rapidly. The transition moments—birth, death—slow time down and make us aware of the simultaneity of happenings at any given moment. The presence of death gives life a context and a rhythm.

In Meredith Monk's "Plateau Series," life in a mythical time past is punctuated by four appearances of a death figure, each time to claim its due. Each of the woman characters has a unique confrontation with death. Each at first resists, then, inevitably, succumbs. For the woodcutter, it is a wrestling match with her shadow, a panting percussive tussle pitting strength against strength, courage against courage. Death wins. Death whirls into the washerwoman's space, a figure enclosed in a black rectangle of cloth. The victim panting slowly, rhythmically, spirals to the ground. For the woman who tends the clay urn full of rattling beans or grain, death appears as an old woman with a black scarf tied piously under her chin. She knocks three times on the pillar near her quarry. At first the bean-rattler woman ignores her. Then she attempts to placate death by handing her the precious jug. Finally, she opens her arms toward death, who slides quickly onto her lap like a lost child in a loving mother's embrace.

Performance is an art of time, particularly suited to addressing our questions concerning time. It is an art of life, particularly suited to addressing life's ultimate turning point, death. The intimate relationship of time and death is a primary concern of the performer/storyteller. Their contemporary *Totentänze* remind us that death is a presence in our lives. They remind us both of

1. I still have my hands.

私には まだ 手(て)が ある。
あた手

2. I still have my mind.

私には まだ 頭(あたま)が ある。

3. I still have my money

私には まだ おかね が ある。

4. I still have my books

私には まだ 本(ほん)が ある。

5. I still have my telephone

私にはまだ 電話(でんわ)が ある.

6. I still have my memory

私には まだ 気憶(きおく)が ある

7. I still have my gold-ring
"beautiful" "I love it!"

私にはまだ 指輪(ゆびわ)が ある, "beautiful" I love it!

8. I still have my allergies

私にはまだ アレルギー が ある

9. ~~I still~~ I still have my Philosophy

私にはまだ 哲学(てつがく)が ある。

Figure 50. Text for "The Tale," a song in which the old crone in "Education of the Girlchild" inventories her life. With translation for Japan performance.

134 THE KNOWING BODY

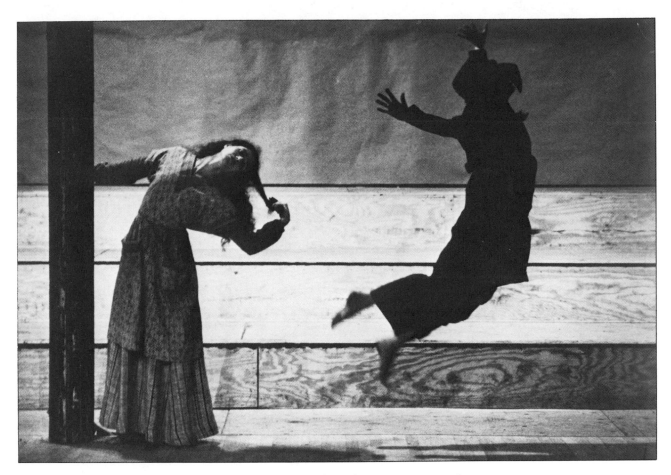

Figure 51. Death's arrival in "Plateau" by Meredith Monk. Performers: Monica Solem (left) and Gail Turner (right).

what death takes away and the fact that the sun rises every morning. We are different at the end of the performance. We can inhabit the personae of our ancestors and of their stories. We become old ones like them. In "Education of the Girlchild," when Meredith Monk unwinds the skein of her life, we see how she is the same through all the stages and not the same, how she contains all at once the elements of old woman, young woman, child, and yet becomes different in each of them. "Because there is Death," as storyteller Laura Simms put it, "everything in between is so interesting."

It is the task now more than ever for the storyteller to help his or her audience to confront personal death, cultural death, and the spectre of planetary death. It is the job of the storyteller to remind us to tremble and wonder at all that is so mysterious and wonderful about living and dying. In the remaining section of this chapter we will consider three very different approaches and resolutions of this role of the storyteller. We will see what drew these storyteller performers to confront the issue of death, and what they have learned to share with us.

Bird, Bread, Bed

Spalding Gray was traveling in Mexico when his mother committed suicide in the garage of the family home in East Greenwich, Rhode Island. No one knew where to reach him, so when Spalding returned home, his mother had been dead for over a month. "It took me a long time to sort it all out," he related. Over the next nine years, Gray interviewed his father, his grandmothers, and his mother's psychiatrist, tape-recording their recollections in an effort to mesh his memory of the person who was his mother with those recollections of his family and her doctor. The questions he asks them opens the wound of his mother's death. "Rumstick Road," part of Gray's autobiographical trilogy "Three Places in Rhode Island," is the theatrical resolution of his investigation and ultimately, a salve for that same wound.

Gray's memory of his mother is often at odds with the memory held by his family. He honors them both by weaving them into a seamless whole, an autobiography which is a collage of fact and fiction, documentary and fantasy, abstract movement and realistic acting. Under the watchful eye of his director/collaborator Liz LeCompte, Spalding and two actor/collaborators (Libby Howes and Ron Vawter), improvised movement in the studio while the unedited tapes of his family interviews were played. "The way they spoke began to tell me a lot about who I was and why I thought and related to the world the way I did," commented Gray.[28] His family's attitudes towards his mother's professed mysticism also told him a lot. In "Rumstick Road," Gray sets the spiritual visions of his mother in juxtaposition to the rational, pragmatic attitude of his father and grandmother. The two different ways of looking at the world comment on one another, the way our dreams comment on our waking life, and vice versa.

From the recordings, played intermittently throughout the performance, we learn the following: Margaret Elizabeth Horton Gray was a devout Christian Scientist. She confided to Spalding when he was thirteen years old that she had first been visited by Jesus Christ in the family living room. Her husband, years later, believed otherwise; "She had no vision of Christ, you know that very well and I know that very well." Margaret Elizabeth also once told her son of the time she went to see Arturo Toscanini conduct a symphony in Providence and how she "was sitting in her chair . . . and the next thing she knew she was floating up . . . to the ceiling . . . looking back at her body . . . sitting in the chair." Grandmother Gray, on tape, recalls no such confidences, and comments that she herself has "no patience with visions . . . at all . . . I thought it was all in her (Margaret Elizabeth's)

warped imagination." Though no one professes to know what pushed Margaret Elizabeth Horton Gray "over the edge," her demise haunts the entire family. Spalding's father's distress is palpable as he relates to his son that his wife was "a perfectly normal sort of gal . . . and she just . . . uh . . . went overboard on some score."

The "evidence" gathers in texture in the nonlinear format Gray and LeCompte have designed. Dreamlike images and abstract movement provide visual focus as the audience listens to the recorded interviews. For instance, while we hear a conversation recorded between Spalding and the psychiatrist who treated his mother (who didn't trust doctors) with electric shock, we see on stage a woman nesting down in a red tent illuminated from within. The image of the woman taking shelter is a poignant contrast to the doctor's clinical description of Mrs. Gray's depression. Later, while we listen to Spalding and his grandmother we see a danced drama. Spalding and the woman character, the fictional mother, chase each other through the rooms of the set. It is not clear who is chasing whom. Is it the son pursuing the memory of his mother, or is it the mother attempting to pull her son into the realm of the dead? The two players fling open doors which are mirrored on one side, reflecting the interior of a room they vanish into, which is flooded with intense white light.

In the final scene of "Rumstick Road," Spalding reads directly to the audience a letter from his father written one year and five months before his mother killed herself. The letter reads:

> Friday night when I came home I went into the bedroom and found glass all over the floor—then discovered that the storm window and one 8 x 10 pane next to mother's little shelf corner in the front had been smashed. I was about to call the police and looked around for the stone or other object, but found nothing—then discovered feathers and after looking further found a partridge, dead on my bedside table. It's hard to believe that a bird which weighed one and a quarter pounds could go through two windows, brush through the curtain, knock over the TV aerial, and without losing any altitude, zoom across the room, hitting the corner and dropping dead on the table without even disturbing the lampshade.

The partridge's unbidden crash through the glass of his father's bedroom window was, in hindsight, an omen of his mother's death for Spalding Gray. Animals are, in mythological literature and in most oral cultures, considered messengers from the other side. To Gray the bird was a vision summoning him to piece together the debris resulting from the shock waves of his mother's death.

Rockwell Gray, Sr., Spalding's father, was a pragmatic sort. He took two hours to clean up the mess the partridge made of his bedroom, and "dress the bird for the ice box." His son, instead, heeded the message of the bird's appearance. When she left her room in the middle of the night and headed for the family garage, Margaret Elizabeth Gray was leaving a message for her family and for us, the audience—but one that it was necessary to decipher. In his attempt to "restore a kind of meaning" to his life, Spalding Gray undertakes that deciphering. Walter Benjamin, who chose to swallow morphine rather than be delivered into the hands of the Nazis in his flight from Germany wrote that, "in death even the poorest wretch possesses authority for the living." Margaret Elizabeth Horton Gray's visions may have been denied veracity in her lifetime, but with her death they come to light in the spiritual will she deeded to her son, Spalding Gray, the storyteller.

<p style="text-align:center">★ ★ ★</p>

A film of rushing cars is projected onto Susan Banyas' white-garbed body in one section of her solo, "Tall Wheat." The film cuts to a journey through the countryside, a house comes into view. It is the house of Elizabeth Edwards, a Quaker woman whose home in Highland County, Ohio, was a stop on the underground railroad during the Civil War. This is the house of Banyas' great-great-grandmother, into whose nineteenth-century world we are entering.

Banyas pulls off her white robe, ties it around her waist like an apron. She reaches for a bowl of bread dough, which has been rising in a corner of the space since the beginning of the performance. She ties her hair back, her floured hands tinting her dark hair white. She becomes the old woman whose 1865 diary she now speaks, as her hands steadily knead the dough. The daily entries, spoken in a soft, yet clear and firm Ohio accent, describe a rural life in which a day might be spent baking for a wedding or sewing on a quilt. It is a time when a child might be "taken hard with spotted fever," like little Jesse was, whose "spirit left its clay without a struggle or a groan." The arrival of runaway slaves on the underground railway is coded in the repeating phrase, "No strangers here today."

It is the grace and humility of Elizabeth Edwards' life that Banyas evokes as a nurturing image of her ancestors. "She represents a kind of time," remarked Banyas, "when spiritual life and daily toil were integrated. The work she did was directly related to the life she was making." The kneading of the bread is a life-affirming act, and the origins of that bread in the wheat fields of the Midwest is the informing metaphor for Banyas' solo.

A sense of her ancestors as healing spirits was an outcome, not a starting point in Banyas' journey in making "Tall Wheat."

Like Spalding Gray, Banyas used family archival material to construct a cultural record as well as a personal sense of the past. She maps a family cosmology, tracing the sources of her own belief system by charting the course her family followed. She anchors this course in specific navigational points—stories told to her by her mother; home movies taken by her father; and the characters she chooses to embody (the Quaker woman, the town gossip, the magician, the urban woman, the old man).

It was her immersion in these images of the past that led Banyas to confront the fact of her own mortality. "These people were alive, and now they are dead" was the message that emanated from the old photographs. One night, after she had placed some of the old photo albums under her bed, she fell asleep and dreamed a voice came to her and said, "That's the way the dead come to you. They come through the old photographs. And the more photographs you have, the more they take you to the other side." She felt immensely frightened, and was tempted to give up making the piece, to put the photographs, diaries, and home movies out of sight and out of mind.

Finally, she took all the photographs into the studio and set them up in a circle around her. "What do you want from me?" she implored. She began to sense, in these images of her ancestors, their need for acknowledgement. And that acknowledgement entailed a recognition beyond fear of her own mortality. As the lines of the 23rd Psalm, which she had not heard or recited since childhood, came into her mind, she began to feel the warmth and welcome of these family spirits. "I felt their presence as a friendly presence, that they would welcome me into that journey when it was my time."

Each of the characters in "Tall Wheat" has their own death story, told in a different way. The town gossip dresses for her own burial as she tells us about all the folks buried in the local cemetery. In the final scene, all the characters in the play are evoked in one composite moment by Banyas, as she plays a waltz on a piano. Filmed images of her childhood are projected onto the white tombstones, causing odd visual displacements. The face of a grinning child appears on the front of one stone while the image of her shoulder and arm overflows the stone and is elongated onto the floor and onto another stone further away. The music and the images waltz together in the darkness and memory becomes not just about the past, but a living presence. Banyas has stated:

> I don't think "Tall Wheat" is just about my family, though certainly that is the starting place. I was in New York for the June 12th nuclear freeze rally. There I was with 500,000 other people walking past the United Nations.

There was a spirit of unity that day that I've never experienced with that many people at once—that no matter what our differences we all wanted to express a simple desire to have a future at a time when future cannot be taken for granted. A week later I was in Highland County, Ohio at an ice cream social. People were lined up outside on the church lawn for homemade chicken and pie and ice cream. It was a hot day, the midst of the wheat harvest. I watched people come over and greet mom, the little girl who had grown up in their town, and I thought how both large and small the world is. I thought how we can't take our past for granted anymore than our future, that as I get older and more aware of my mortality, that time has a way of beginning to appear circular.[29]

As we watch the images of Banyas as child stream over the tombstones, we become aware of the change that brings this child to womanhood, and will ultimately bring her, and us, to death. It is as inevitable, as natural, as the wheat that is threshed from the fields of Ohio, ground into the flour that Elizabeth Edwards kneaded into the bread which gave her family sustenance. By creating these images from the past and giving them life with her own presence, Banyas both reminds us of our own life's passages, and reclaims from nothingness what might otherwise have been forgotten.

Leeny Sack is a child of survivors. Her parents met in Dachau, her grandmother survived the camps of Maidanek and Auschwitz. Her identity from her earliest memory has been forged from these central facts of her family's history. Her performance solo "The Survivor and the Translator" is subtitled "A Solo Theatre Piece about Not Having Survived the Holocaust."

Sack, as other children of survivors, feels a particular duty to tell what happened to her family.[30] Yet, how do you tell what you have not experienced? How do you tell of experiences so dark that they surpass human understanding? We recall once again that "the anguish of memory is that it dies with the people who remember." Memory also lives because of those like Leeny Sack who elect to put themselves through the imaginal fires of that experience, so that we all might come to some understanding of what is seemingly unknowable. Sack brings light to fill the darkness.

Sack originally set out to create a solo performance about "women, madness, and God." Though the final work has a more specific focus, she fulfilled her initial intention as well. "The Survivor and the Translator" evokes an event of massive, almost impenetrable proportions with three props: a bed, a suitcase, a chair; and with one performer who speaks in three voices: those of the Survivor, the Translator, the Second Generation Performer.

Holocaust is from the late Latin formation from the Greek, *holos*, "whole," and *kaustos*, "burnt": an entire burnt sacrifice. In the burial societies of Eastern European Jewry, the various tasks for attending to the dead were divided among the community and ritualized. But the death one confronts in facing the Holocaust is the death of an entire flourishing culture. There are no rituals for mass graves, giant holes dug by the intended victims. The event transcends ordinary levels of understanding and reaction to reach mythic proportion. It cannot be set aside. It is history of mythic dimensions, yet it belongs to the recent, knowable past and for Sack it is personal history. "How can the story be told?" asked Sack,

when the mythic characters are Mother and Father, not as in Great Mother and Great Father but as in Mom and Dad, and their begat was me . . . when there is no perspective or analysis to place it in, when the name is holocaust and i am a child of survivors, when holocaust means the complete destruction by fire, and i am still smoking and burning from, their, not my experience, how can i tell this story.

How could she tell this story? In the retelling of the story there is the power of opening the old wounds. But there is also the power to pay homage to remembrance.

Sack enlisted the aid of a witness, Chloë Wing. Wing was the midwife to the process of creating the work. Sack would go to the studio every day. She brought some props, a pillow and a blanket, an old suitcase, and a pair of headphones. There was a folding cot in the studio. At each session, she lit two candles—one to protect herself, one to protect Chloë Wing. She had already decided that there would be a bed in the piece. Then, she realized she wanted to get into the bed. So she got into bed. She would go in and warm up and then she would lie in the bed. With this realization, "a huge exhalation happened."

In the bed, the experience began to be integrated: I decided I wanted to spend some time in bed. So I spent a month in bed. I would go to the studio, warm up, and then get in bed for three, four, five hours; maybe I would say something, maybe not. There used to be lots of silence in the piece, because that's how we worked on it. It was "what we were doing." It was my sensibility, the bed space. I spend a lot of time in bed anyway, just staring at the ceiling and thinking—I think most people do, women especially.[31]

In the finished work, the bed becomes the central prop. It is a bed of virginity, of childbirth. It is the bed from which the Survivor confides intimate details of her life. When Sack suddenly jumps

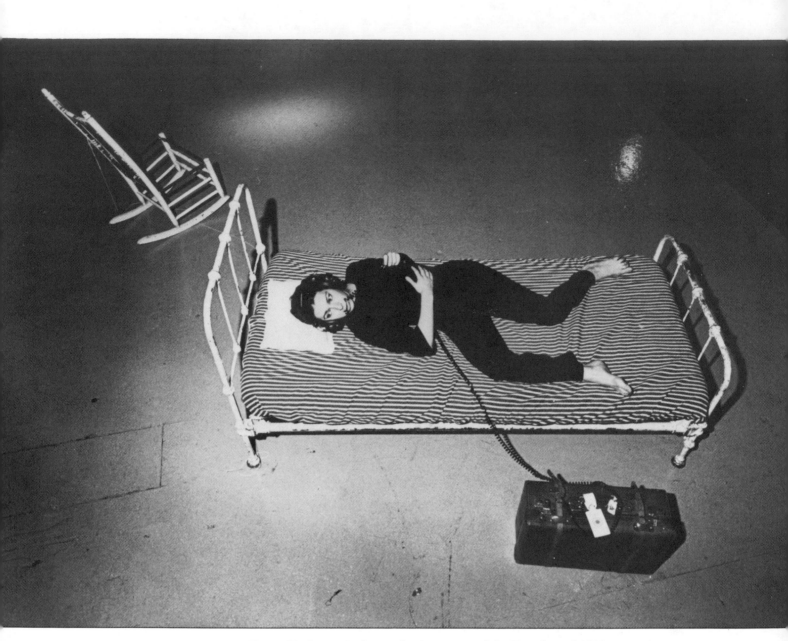

Figure 52. Leeny Sack in "The Survivor and the Translator," 1980.

up and begins running in place on the bed, the sound of the springs becomes the death rattle of the cattle cars rushing their human cargo towards doom.

She began to transcribe a tape she had recorded of her grandmother's tale, her struggle to relate about "the machines for burning people, what were they called? machines for burning people . . ." At first Sack intended to translate the story "correctly," then she realized that the twisted syntax, the broken sentences, the lapses of memory and sequence were just the kind of language she was striving for. "From the beginning my sense was that there wasn't a vocabulary for this experience, there

isn't a vocabulary for certain human experience . . ." and so the persona of the translator was born. The image of translating, the gesture of translation was the format of the piece.

It was then a problem became a solution. an artistic solution. how do I translate what I know? They told me in Polish or they told me in silence. I started scoring for three voices, the survivor, the translator, the second generation performer. It's always been clear to me that the performer is a bridge, a translator, a transmitter.

The "telling" of Sack's story is fragmented between three personae, speaking English and Polish. It is broken English because the experience itself is a disjunctive one. "I was thinking this a few weeks ago," Sack said to me, "I was thinking, they survived. They lived. I did not survive. Am I dead? Is that the sense of deadness I've been carrying?" Yet Sack's very presence on stage is integrally connected to her parents' act of survival.

. . . I wanted to be very clear that I, alive in the performance space was a child of survivors. That it was not a fiction, it was not even . . . it was as if, "this is not just a play. Hello, my name is Leeny Sack and my parents were in concentration camps. This happened. I am still alive. I am a survivor of this genocide." That was very important to me, it was like, "Pinch me, I'm real." And there was a certain kind of, "See! they didn't get me!"

Sack's grandmother's memory has lapses. She cannot remember all the details of the terrible events. Yet in these lapses of memory, Sack realizes, is a story. "In the space between not remembering and remembering," says Sack, "is the recognition." Sack's translation "reads true" because it admits to the difficulty of the task.

We are never separate from the past. I did not experience World War II, but had my father not survived active combat, I would not be here writing this book. I did not experience Hiroshima, but my present existence is threatened in that act of destruction. It can happen again. It has happened to our fellow human beings, it has happened to our planet. Facing the reality of evil that is the Holocaust, that is the genocide in Cambodia, that is the evil that could mean the potential destruction of the earth—facing these things blurs the boundaries between the everyday and the mythic. It is not surprising that the voices that artists find to express these experiences seem fragmented. They are necessarily fragmented, wrote critic/artist Vera Frankel, "because we are standing in the ruins of a fragmented culture . . . Post-Holocaust rehabilitation includes gathering, with some mistrust, the fragments of a broken language."[32]

In each of the three pieces I've just discussed, the artist is gathering fragments of the past, and integrating them into the present, as an act of faith for the future. The making of these performances is soul work. The loss of memory is related to the loss of soul. The ancestors still want to be remembered. "The Survivor and the Translator" opens with a passage celebrating Jewish women, and is followed by the lighting of one candle and a prayer which proclaims, "That which does not kill me makes me stronger." Leeny Sack commented on this:

This material is so black and, in a sense, so dangerous that one way I have found to balance it is with prayer, and that prayer has to do with allowing myself to just be a channel for the information.

The performer is a translator, a channel for forces that are larger than him- or herself. All three of these performance works are complicated, many-layered. I may attempt to translate a sense of them to you, but ultimately, they are created for another medium that both includes and goes beyond the language at my disposal to inform you of them.

We have moved far from the simplicity of the first chapter, which begins with understanding our own bodies as the first step towards understanding ourselves. It is with healing the basic rift between our minds and our bodies that we begin to create the wholeness and the awareness that are necessary to venture into the realms mined by these performance explorers.

Whether they explore a death in the family, the spectre of planetary destruction, or some other image of mortality, these storytellers all assume the same age-old role as the medieval painters who depicted the dance of death on the walls of cathedrals and churchyards. In their very live presence, with their movement and their breath, they affirm the life that is in exquisite balance with the process of death. The transformations they undergo are a metaphor for the constant process of change which brings food to our tables, our bodies to our graves, our babes from the womb. Experience which comes from "wisdom, the epic side of truth," is dying out, proclaimed Walter Benjamin. But there are reassuring signs today that wisdom is present, that experiences are being shared with skill and with passion, and that the story which begins in our bodies is the fundamental sign of life. We just have to listen.

Key to Illustrations

CHAPTER ONE

Figure 1: Snake dream drawing, Louise Steinman.

Figure 2: Bird studies, "lift one wing" and "tail in air" from Simone Forti's unpublished "Thoreau Drawings." In her gesture drawings, Forti "takes on" the essence of the animal's movement.

Figure 3: Margaret Fisher's insect movement in "Il Miglior Fabbro."
Photo: Alzek Misheff.

Figure 4: "Untitled drawing," ink on paper, 1981 by Pooh Kaye. Kaye has written of her drawings, "When I draw I often make sequences of activities about relationships. Some of the drawings I make with both the right and left hands simultaneously."

Figure 5: Dr. George Archibald and Tex, courtesy International Crane Society.
Photo: Kyoko Archibald.

Figure 6: Journal drawing by Sylvia Whitman.

Figure 7: Gesture drawings by Dana Reitz.

Figure 8: Movement hieroglyphs by Nancy Stark Smith. "Writing is a system of movements involving touch."—Clifford Burke

Figure 9: Journal drawing by Bob Ernst.

Figure 10: Trisha Brown's drawing for "Glacial Decoy," 1980.

CHAPTER TWO

Figure 11: Drawing of Little Frank, courtesy of Lisa Davidson.

Figure 12: Notebook sketch for work-in-progress by Charlotte Hildebrand.

Figure 13: Drawing by Meredith Monk for "Plateau."

Figure 14: Drawing of the Sorcerer of Trois Frères.
Courtesy Department of Library Services, American Museum of Natural History, Neg. No. 329853.

Figure 15: Working sketch by Corey Fischer of A Traveling Jewish Theatre. Preparation for carving a mask for the shaman woman in "A Dance of Exile."

Figure 16: Author in "Face Value," 1976.
Photo: Penny Johnson.

Figure 17: Ping Chong and Meredith Monk in their collaborative travelogue duet, "Paris."

Figure 18: Lanny Harrison as La Professora in "Nite and Day."
Photo: Christopher Rauschenberg.

Figure 19: Notebook drawing by Bob Ernst.

Figure 20: Photo of Ruth Zaporah in performance.
Credit: Robert Cavanna.

Figure 21: Whoopi Goldberg as Moms Mabley.
Photo: White Line Photos.

Figure 22: "Education of the Girlchild." Standing, from left: Blondell Cummings, Lanny Harrison, Meredith Monk. Seated, from left: Coco Pekelis, Lee Nagrin, Monica Moseley.

Figure 23: Drawing by Joan Jonas from her video performance work, "Organic Honey's Vertical Roll" (1973). Photo: Carole Mersereau.

CHAPTER THREE

Figure 24: Rob List's drawing for solo woman in corner from his performance work "At the Falls," premiered New York City, 1983.

Figure 25: "Fear and Loathing in Gotham" by Ping Chong.
Photo: Lois Greenfield.

Figure 26: "Humboldt's Current" by Ping Chong. Photo: Nathaniel Tileston.

Figure 27: Notebook drawing by performer Melanie Hedlund.

Figure 28: "A.M./A.M. (The Articulated Man)" by Ping Chong. Pictured in the second fable are Ishmael Houston-Jones and Louise Smith as the couple; Rob List as the demon. Photo: Tobey Sanford.

Figure 29: A drawing by performer Louise Smith showing her perspective of the demon emerging from under her bed in the second fable of Ping Chong's "A.M./A.M. (The Articulated Man)."

Figure 30: Meredith Monk as the Child in "Quarry."
Photo: Johan Elbers.

Figure 31: From "Quarry" by Meredith Monk. Pablo Vela and Lee Nagrin as the White-Haired Couple. Photo: Johan Elbers.

Figure 32: Journal entry, Lanny Harrison.

CHAPTER FOUR

Figure 33: Barbara Dilley in "Cassiopeia's Chair." Photo: Karen Caines.

Figure 34: Brushstroke drawing by Dana Reitz. Courtesy of the artist.

Figure 35: Dana Reitz in "Journey: Duet for Two Sides."
Photo: E. Lee White.

Figure 36: Author's journal notes from contact improvisation class taught by Nancy Stark Smith.

Figure 37: "Navigating the Edge." Photo: Christopher Rauschenberg.

Figure 38: Deborah Slater (on ladder) and Betsy Ford in Slater's "Pieces of the Game." Photo: Marty Sohl.

Figure 39: Susan Banyas and author in "Sticks." Photo: Annie Popkin.

CHAPTER FIVE

Figure 40: Page of text from "Vessel" by Bob Ernst.

Figure 41: Meredith Monk in "Education of the Girlchild." Left to right: Meredith Monk, Daniel Ira Sverdlik. Photo: Philip Hipwell.

Figure 42: Trisha Brown in "Accumulation." Photo: Courtesy Walker Art Center.

Figure 43: Wendy Perron and M.J. Becker in Perron's "Bad Day." Photo: Mary Patera.

Figure 44: "Plateau Series" by Meredith Monk, solo/duet/group score.

Figure 45: From Helen Dannenberg's "Album." Performer: Marsha Paulson. Photo: Penny Brogden.

Figure 46: Storyboard of the hostage scene from "At the Falls" by Rob List. Narrative can be sequence of any kind.

Figure 47: Journal page, Melanie Hedlund.

Figure 48: Page of script from "From the Dreamworld of Men," a film/performance work by Steve Clorfeine.

Figure 49: Map script of "Trails to Treasures (it could be you)" by Banyas/Steinman. Drawing by Susan Banyas.

Figure 50: Text for "The Tale," a song in which the old crone in "Education of the Girlchild" inventories her life. With translation for Japan performance.

Figure 51: Death's arrival in "Plateau" by Meredith Monk. Performers: Monica Solem (left) and Gail Turner (right). Photo: Lois Greenfield.

Figure 52: Leeny Sack in "The Survivor and the Translator," 1980. Photo: Stephen Siegel.

Notes

PREFACE

1. Rosette LaMonte, "Avante-Gardists Reveal Their Classicism," in *The New York Times*, August 2, 1984, 3.

CHAPTER ONE

1. Suzanne K. Langer, *Mind: An Essay on Human Feeling* (Baltimore: Johns Hopkins University Press, 1972), 3: 20-21.

2. Quoted in Irmgard Bartenieff with Dori Lewis, *Body Movement: Coping with the Environment* (New York: Gordon Breach Science Publishers, 1980), 51.

3. Claude Lévi-Strauss, *Myth and Meaning* (Toronto: University of Toronto Press, 1978), 6.

4. Walter Benjamin, *Illuminations*, ed. Hannah Arendt (New York: Schocken Books, 1969), 84.

5. Richard Grossinger, *Planet Medicine* (New York: Anchor Books, 1980), 355.

6. Marcel Griaule, *Conversations with Ogotemmeli: an Introduction to Dogon Religious Ideas* (London: Oxford University Press, 1975), 18.

7. Stephen Lonsdale, *Animals and the Origins of Dance* (New York: Thames and Hudson, 1982), 32.

8. Gregory Bateson, "The Pattern Which Connects" in *Co-Evolution Quarterly* (Summer 1978): 5-15.

9. Mircea Eliade, *Shamanism: Archaic Techniques of Ecstasy*, trans. Willard R. Trask (Princeton: Princeton University Press, 1964), 99.

10. Claude Lévi-Strauss, *The Savage Mind* (Chicago: University of Chicago Press, 1970), 37.

11. John Berger, "Why Look at Animals?" in *About Looking* (New York: Pantheon Books, 1980), 9.

12. *Ibid.*, 21.

13. Simone Forti, interview with author, spring 1977, Seattle.

14. John Berger, *About Looking*, 17.

15. Simone Forti, *Handbook in Motion* (Halifax: The Press of the Nova Scotia College of Art and Design, 1974), 13.

16. Isadora Duncan, "The Dance of the Future" in *Dance As a Theatre Art*, ed. Selma Jeanne Cohen (New York: Dodd, Mead & Co., 1974), 124, 126.

17. James Dillon, "Margaret Fisher Interview," *Salome* 27/28/29, August 1982, 7.

18. Franz Kafka, *The Metamorphosis*, trans. and ed., Stanley Corngold (New York: Bantam Books, 1980), 17.

19. Laurens van der Post and P.L. Travers, "Where Will All the Stories Go?" in *Parabola* #7 (Dreams and Seeing Issue), no. 2 (May 1982): 40.

20. John Berger, *About Looking*, 26.

21. Pamela Sommers, "Simone Forti's Jackdaw Songs," *The Drama Review* 25 (Reinterpretation) no. 2, (Summer 1981): 125.

22. A fascinating book to read on this subject is Joseph Chilton Pearce, *Magical Child: Rediscovering Nature's Plan for Our Children* (New York: E.P. Dutton, 1977).

23. Charles Olson, *Proprioception* (San Francisco: Four Seasons Foundation, 1965), 2.

24. Here the Alexander technique is an exception. It traditionally begins with sitting in and then rising from a chair. Perhaps this is because some of the technique is wedded to the Edwardian ambience in which it was conceived. This is changing with contemporary Alexander teachers.

25. Suzanne Hellmuth, interview with author, spring 1983, San Francisco.

26. James H. Bierman, "The Alexander Technique 'Gets Its Directions,'" *Dance Scope* 12, no. 2 (Spring/Summer 1978): 32.

27. Dana Reitz, interview with author, spring 1983, New York City.

28. Nancy Stark Smith, "Living Anatomy of Vision: Interview with Bonnie Bainbridge Cohen," *Contact Quarterly* (Winter 1981):5.

29. *Ibid.*

30. Moshe Feldenkrais, *Awareness Through Movement* (New York: Harper and Row, 1972), 21.

31. Knud Rasmussen, *Intellectual Culture of the Iglulik Eskimos, Report of the Fifth Thule Expedition 1921-1924* (Copenhagen, 1929), 7, no. 1: 114. Quoted in *artscanada: Ritual and Shamanic Art* (December 1973/January 1974).

32. Margaret Fisher, interview with author, spring 1983, Emeryville, CA.

33. Lisa Nelson and Nancy Stark Smith, "Interview with Bonnie Bainbridge Cohen," *Contact Quarterly* (Winter 1980): 21.

34. Richard Grossinger, *Planet Medicine*, 37.

35. Quoted in Martha Myers, "Body Therapies and the Modern Dancer," *Dance Magazine* 8 (August 1983): 20.

36. Irene Dowd, *Taking Root to Fly: Seven Articles on Functional Anatomy* (New York: Contact Collaborations, I.c., 1981), 31.

37. Trisha Brown and Yvonne Rainer, "A Conversation about *Glacial Decoy*," *October* 10 (1979), 34.

CHAPTER TWO

1. Whoopi Goldberg, interview with author, spring 1983, Berkeley, California. All other quotes from Whoopi Goldberg are from this same interview.

2. C. G. Jung, *The Vision Seminars* (Zurich: Spring Publications, 1976), 1: 62-63.

3. Howard A. Norman, trans., *The Wishing Bone Cycle: Narrative Poems from the Swampy Cree Indians* (New York: Stonehill Publishing Company, 1976), 3-4.

4. Laurie Anderson, interview with London Weekend Television, South Bank Show, 1982. Color video with sound, 25 minutes.

5. Bob Ernst, interview with author, spring 1983, San Francisco. Unless otherwise noted, all statements by Ernst are from this interview or other informal conversations 1979-1984.

6. Quoted in Eleanor Rachel Luger and Barry Laine, "When Choreography Becomes Female (Part I)," *Christopher Street* (November 1978): 68.

7. Louise Steinman and Susan Banyas, "Lanny Harrison: An Interview," *Prologue* I, no. 2 (September 1979): 31.

8. Curt Sachs, *World History of the Dance* (New York: W.W. Norton & Co., 1963), 224.

9. *Ibid.*, 50.

10. Catrina Neiman, "An Introduction to the Notebook of Maya Deren, 1947", *October* 14 (1980): 30,31.

11. Quoted in Robert Hurwitt, "Dancers Who Thrive on Solo Risks," *San Francisco Sunday Examiner & Chronicle.*

12. Dana Reitz, interview with author, spring 1983, New York City.

13. Doug Skinner, interview with author, spring 1983, San Francisco.

14. James Hillman, *Re-Visioning Psychology* (New York: Harper Colophon Books, 1977), xii, xiii.

15. Monk clippings, Lincoln Center Dance Collection, New York City.

16. Quoted in Marianne Goldberg, "Transformative Aspects of Meredith Monk's 'Education of the Girlchild.' " Unpublished M.A. thesis, New York University.

17. Robert Benedetti, *Seeming, Being, and Becoming: Acting in Our Century* (New York: Drama Book Specialists, 1976), 64.

18. John Berger, *And our faces, my heart, brief as photos* (New York: Pantheon Books, 1984), 55.

19. Curt Sachs, *History of Dance*, 220.

20. Jamake Highwater, *The Primal Mind: Visions and Reality in Indian America* (New York: New American Library, 1981), 138–140.

21. D.H. Lawrence, *Mornings in Mexico* (Salt Lake City: Gibbs M. Smith, Inc., 1982), 118, 119.

CHAPTER THREE

1. John Pfeiffer, *The Creative Explosion: An Inquiry into the Origins of Art and Religion* (New York: Harper and Row, 1982), 132-134.

2. Carl G. Jung, *Man and His Symbols* (New York: Doubleday & Co., 1964), 101.

3. Antonin Artaud, *The Theatre and Its Double* (New York: Grove Press, 1958), 60.

4. Pfeiffer, *Creative Explosion*, 165.

5. Ping Chong, interview with author, January 1983, Seattle. Unless otherwise noted, all remarks by Chong are from this interview or other informal conversations, 1980-84.

6. Sigmund Freud, *Collected Papers*, ed. James Strachey (London: Hogarth Press, 1950-1952), 4: 369-370.

7. Ping Chong's "Nosferatu" premiered in the spring of 1985 at La Mama Theatre, New York City.

CHAPTER FOUR

1. Charles Olson, "Projective Verse" in *The New American Poetry*, ed. Donald M. Allen (New York: Grove Press, 1960), 388.

2. Anna Halprin, experimental dancer and choreographer who taught workshops which had great impact on improvisation and choreography on both East and West Coasts. Among her students were Simone Forti, Trisha Brown, Yvonne Rainer. Her Dancer's Workshop in San Francisco has been an important meeting ground for artists of varying disciplines since the sixties.

3. Elizabeth Kendall, "The Grand Union: Our Gang" in *Ballet Review* 10, no. 1 (Spring 82): 47.

4. Ruth Zaporah, interview with author, spring 1984, Berkeley, CA. Unless otherwise indicated, all quotes from Ruth Zaporah are from this interview.

5. Grand Union clippings, Lincoln Center Dance Collection, New York City.

6. Quoted in Robert Coe, "Buddhist Dancing in America" in *Eddy* 9 (Winter 1977):29.

7. Wendy Perron, "Improvisation Part I: The Man Who Gets Away With It" in *Soho Weekly News*, January 6, 1977, p. 23.

8. Barbara Dilley, "The Contemplative Dance Intensive" in *Contact Quarterly* 6, no. 1 (Fall 1980):15.

9. Deborah Jowitt, "Dana Reitz" in *The Drama Review* (Dance/Movement) 24, no. 4, T88 (December 1980):29.

10. Burt Supree, "Dana Reitz Steps into the Same River" in *Village Voice*, (February 15, 1983), p. 79.

11. Dana Reitz, interview with author, spring 1983, New York City. Unless otherwise indicated, all quotes from Reitz are from this interview.

12. Barbara Dilley, "The Contemplative Dance Intensive," 16.

13. Nancy Stark Smith, "Where Nothing is Beside the Point: Contact Improvisation at Naropa Institute," *Naropa Bulletin* (Fall 1982/Winter 1983): 3.

14. Marcia B. Siegel, "And Now the Weather Report" in *Soho Weekly News*, December 30, 1976, p. 19.

15. Susan Banyas, "Skylight: reflections on performing and teaching improvisation. interviews with Terry Sendgraff and Ruth Zaporah," *Contact Quarterly* 9, no. 3 (Fall 1984): 48.

16. Tim Page, "The Filtered World: A Final Interview with Glenn Gould," *Vanity Fair* (May 1983): 98.

17. Deborah Slater, interview with author, spring 1983, San Francisco.

8. Quoted in John Barlow, *German Expressionist Film* (Boston: Twayne Publishers, 1982), 110.

9. James Hillman, *Re-Visioning Psychology* (New York: Harper Colophon Books, 1975), 92.

10. *Ibid.*, 90-91.

11. Claude Lévi-Strauss, *The Savage Mind* (Chicago: University of Chicago Press, 1966), 17.

12. Eugene Ionesco, *Present Past Past Present: A Personal Memoir* (New York: Grove Press, 1971), 116.

13. Meredith Monk, "Quarry," unpublished script. Courtesy of Meredith Monk.

14. Jane Kramer, "Letter from Europe," *The New Yorker*, May 16, 1983, 49-55.

15. Jorn Mekert, "Ed Keinholz and the Language of Objects" in *Edward Keinholz: Volksempfängers*, Nationalgalerie Berlin, Staatliche Museen Preußischer Kulturbesitz (1977), 30.

16. Liza Bear, "invocation/evocation: Interview with Meredith Monk," *Avalanche* (Summer 1976): 33.

17. Anne Grosshans, ed. "Meredith Monk," transcript of a slide presentation and lecture by Meredith Monk on March 24, 1979. *and/or* (1979). no pagination.

18. Aldous Huxley, *The Doors of Perception and Heaven and Hell* (New York: Harper and Row, 1963), 55.

19. Laurens van der Post, *Lost World of the Kalahari* (New York: William Morrow, 1958), 260.

20. Meredith Monk, unpublished notes for "Vessel." Courtesy of Meredith Monk.

21. Wendy Perron and Paula Clements, "Dialogue" *Contact Quarterly* 8, nos. 3/4 (Spring/Summer 1983): 10.

22. Trisha Brown and Yvonne Rainer, "A Conversation about Glacial Decoy," *October* 10 (Fall 1979): 31.

23. Marguerite Yourcenar, "Recurring Landscapes: the varieties of oneiric experience" in *Parabola* 7, no. 2:91.

24. Irene Dowd, *Taking Root to Fly: Seven Articles on Functional Anatomy* (New York: Contact Collaborations, Inc., 1981), 28.

25. Sarah Greys, "Autobiography of a Cree Woman", trans. by Howard Norman, excerpted in *New Wilderness Letter: Special Dream-Work Issue* 10 (September 1981): 2-3.

18. Steve Paxton, "The Grand Union", *The Drama Review* 16, no. 3, T55 (September 1972): 134.

19. Nancy Stark Smith, "Nothing Beside the Point," p. 3.

20. Erik H. Erikson, *Childhood and Society* (New York: W.W. Norton & Co., 1963), 236-237.

21. Mindy N. Levine, "An Interview with Pooh Kaye," *Millennium Film Journal* 10/11: 34.

22. Claude Lévi-Strauss, *The Savage Mind* (Chicago: University of Chicago Press, 1966), 30.

23. Walter Benjamin, *Reflections: Essays, Aphorisms, Autobiographical Writings* (New York: Harcourt Brace Jovanovich, 1978), 65.

CHAPTER FIVE

1. In Walter Benjamin, *Illuminations*, ed. Hannah Arendt (New York: Schocken Books, 1969), 86-87. All quotes from Walter Benjamin in this chapter are from this essay.

2. Quoted in Susan Sontag, "Approaching Artaud" in *Under the Sign of Saturn* (New York: Vintage Books, 1980), 35. Artaud's major work is called *The Theatre and Its Double* (New York: Grove Press, 1958).

3. Walter Ong, *Orality and Literacy: The Technologizing of the Word* (London: Metheun, 1982), 32.

4. Terry Fox, interview with Robin White at Crown Point Press, published in *View* 11, no. 3 (June 1979), 4.

5. Marcel Griaule, *Conversations with Ogotemmeli: an Introduction to Dogon Religious Ideas.* (London: Oxford University Press, 1975), 138.

6. Rudolf Steiner, "The Recovery of the Living Source of Speech," a lecture given on 13 April, 1923, republished in *The Golden Blade* 25 (1973), 9.

7. See Kenneth Lincoln, "Native American Literatures" in *Smoothing the Ground: Essays in Native American Oral Literature*, ed. Brian Swan (Berkeley: University of California Press, 1983), 3-38.

8. John Berger, *And our faces, my heart, brief as photos* (New York: Pantheon Books, 1984), 30.

9. Meredith Monk, "Notes on the Voice" in Sally Banes, *Terpsichore in Sneakers: Post-Modern Dance* (Boston: Houghton Mifflin Co., 1980), 167.

10. Spalding Gray, clippings file, Lincoln Center Theatre Archives, New York Public Library, New York City.

11. Spalding Gray, "Playwright's Notes" in *Performing Arts Journal* 3, no. 2 (Fall 1978): 88.

12. Laura Simms, interview with author, spring 1984, New York City. I would like to thank Laura Simms for many insights on storytelling that helped me enormously in writing the chapter. Also I would like to thank her brother Norman Simms, a scholar of oral literatures.

13. John Stands-in-Timber, "Cheyenne Memories," in Brian Swan (ed), *Smoothing the Ground*, frontspiece.

14. John Berger, *Pig Earth* (New York: Pantheon Books, 1979), 9.

15. Susan Banyas, "Tall Wheat," unpublished script.

16. Helen Dannenberg, interview with author, spring 1983, San Francisco.

17. James Hillman, *Healing Fiction* (Barrytown, NY: Station Hill Press, 1983), 45.

18. Virginia Woolf, *Writer's Diary* (New York: Harcourt Brace Jovanovich, 1954), 138.

19. Dennis Tedlock, "Tell It Like It's Right in Front of You," in *Symposium of the Whole: A Range of Discourse Toward an Ethnopoetics*, ed. Jerome Rothenberg and Diane Rothenberg (Berkeley: University of California Press, 1983), 366-380.

20. Roger Shattuck, *The Banquet Years* (New York: Vintage Books, 1968), 347.

21. Matthew Maguire, "The Site of Language," *The Drama Review* 27 no. 4 (T100) (Winter 1983): 66.

22. Sergei Eisenstein, *Notes of a Film Director* (New York: Dover Publications, 1970), 63.

23. Virginia Woolf, *Writer's Diary*, 93.

24. Victor Turner, *From Ritual to Theatre: The Human Seriousness of Play* (New York: Performing Arts Journal Publications, 1982),13.

25. Susan Banyas, "Mazoongoo," unpublished essay. Courtesy Susan Banyas.

26. Meredith Monk, "Mosaic: Between the Cracks," unpublished essay. Courtesy of Meredith Monk.

27. Joseph Campbell, *The Way of the Animal Powers, vol.1: Historical Atlas of World Mythology* (New York: Alfred Van Der Marck Editions, 1983), 52.

28. Spalding Gray, "Rumstick Road," *Performing Arts Journal* 3, no. 2, (Fall 1978): 114-115. All quotes from the play are taken from this script.

29. Susan Banyas, "Artists Statement," unpublished essay. Comments by Susan Banyas on her work are taken from this essay and from interview with author, spring 1984, San Francisco, informal conversations 1980-84, and from interview with Robert Strini, spring 1984, Athens, OH.

30. Statements by Leeny Sack, unless otherwise noted, are from her

unpublished writing on "The Survivor and the Translator" and from interviews with the author, spring 1983 and spring 1984, New York City.

31. Quoted in Don Shewey, "Playing Around" in *The Soho Weekly News* August 27, 1980), 46.

32. Vera Frankel, "Discontinuous Notes On and After a Meeting of Critics, by One of the Artists Present," *artscanada* 38, no. 1 (March/April 1981): 39.

Index

Note: Page numbers in italic type refer to illustrations.